THE MAMMOTH BOOK OF

TATTOO ART

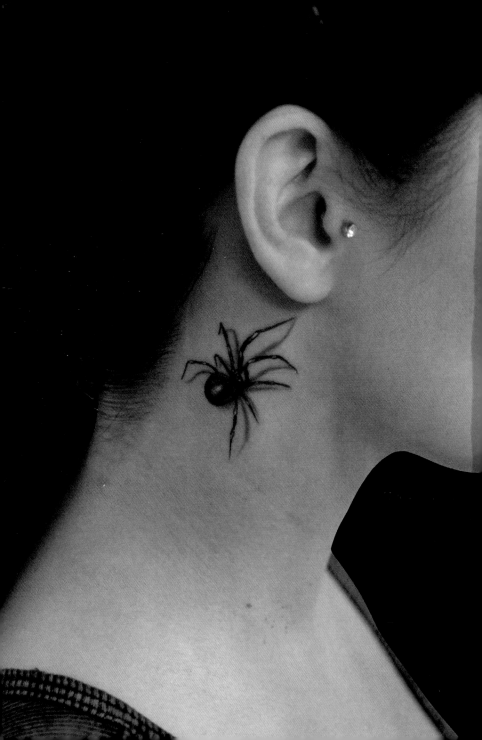

THE MAMMOTH BOOK OF

TATTOO ART

EDITED BY
LAL HARDY

ROBINSON

RUNNING PRESS
PHILADELPHIA · LONDON

Constable & Robinson Ltd
3 The Lanchesters
162 Fulham Palace Road
London W6 9ER
www.constablerobinson.com

First published in the UK by Robinson,
an imprint of Constable & Robinson Ltd, 2011

A copy of the British Library Cataloguing in Publication
Data is available from the British Library

UK ISBN 978-1-84901-568-4

1 3 5 7 9 10 8 6 4 2

First published in the United States in 2011 by Running Press Book Publishers

9 8 7 6 5 4 3 2 1
Digit on the right indicates the number of this printing

US Library of Congress number: 2010941476
US ISBN 978-0-7624-4098-6

Running Press Book Publishers
2300 Chestnut Street
Philadelphia, PA 19103-4371

Visit us on the web!
www.runningpress.com

Designed by Susan St. Louis

Printed and bound in China

*Front cover photograph of Nikole Lowe by Ester Segarra.
Tattoo on Nikole's arm by Filip Leu; tattoo on thigh by Jason Saga RIP.
Tattoo on spine by Paul Naylor.
Tattoo on back cover by Sarah Schor.
Tattoos on preceding pages by Mike DeVries (spider) and Keet D'Arms (skull).*

\mathcal{L}ist of tattoo artists

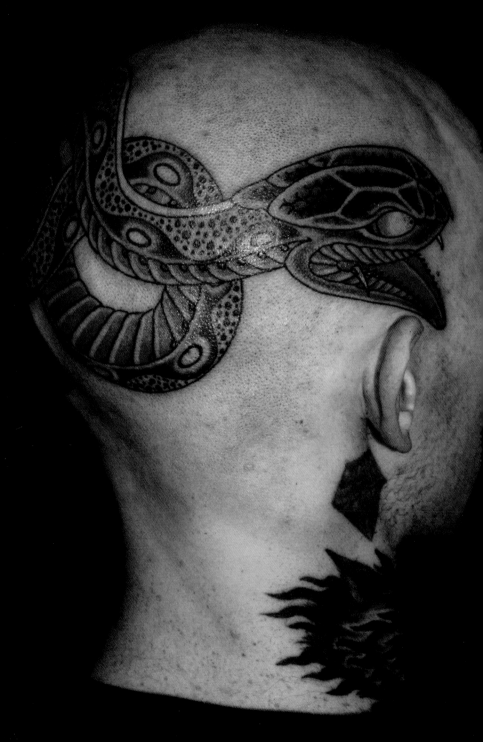

\mathcal{I}ntroduction

During my first venture into the world of book editing with *The Mammoth Book of Tattoos* (2009) it became evident from the numerous discs of tattoo photos I received from various artists around the globe that tattooing is riding the crest of a wave, with artistic levels higher than ever before. Following the success of that volume it became evident that one book was not enough to slake the general public's and tattoo community's thirst for all things tattoo related, so it was with great relish that I grasped the opportunity to compile and edit this the second tattoo volume of the immensely popular Mammoth Book of series; *The Mammoth Book of Tattoo Art*.

Having been involved in the tattoo scene in one way or another for over three decades, as a tattooist, tattoo collector, tattoo historian, convention organizer and visitor, secretary of the Association of Professional Tattoo Artists, editor of *Tattoo Buzz Magazine*, contributor to numerous tattoo publications, "defender" of the art in the British Parliament (when an overzealous MP tried to introduce a law that would have virtually outlawed tattooing) and now considered by contemporaries to be, in tattoo parlance, an "Old Timer" (this term applies to someone who has been tattooing for twenty years or more) I have been able to observe the immense changes that have occurred in the tattoo world over the last thirty years and in some

way document an old and ancient art that tattoo folklore deems "as ancient as time and modern as tomorrow".

Many things have contributed to the growth of a practice that was once thought to be the preserve of the under, working and criminal classes (although this is far from the truth): these range from the fall of the Iron Curtain to greater Western influences in the Far East and the rise of the internet. It has to be said that reality TV shows such as *London Ink, LA Ink, Inked* and, perhaps the show that first bought tattooing to a worldwide audience, *Miami Ink* are responsible for an interest in tattooing that has been unsurpassed in its history. In the United Kingdom, Phil Kyle, Nikole Lowe, Louis Molloy (creator of the famous Beckham angel) and the somewhat erratic but lovable Dan Gold have become household names. On a wider screen, Corey Miller, Kim Saigh, Darren Brass, Chris Nunez, Ami James, Chris Garver, Hannah Aitchison and Kat Von D are now known worldwide for their tattoo art which was showcased through such shows. The drama series *Prison Break* where the character Michael Scofield (Wentworth Miller) was elaborately tattooed caused much interest. Such is the impact of tattoo television shows that many of the documentary channels now show tattoo documentaries such as *The Tattoo Hunter* and *Marked*.

The popularity of these shows has

Figure 1 Ian Flower

spawned literally hundreds of tattooists and tattoo shops. Many have made the grade but, sadly, many have not, for, while television can, for the general public, create the illusion that the skills of tattooing can be achieved in a relatively short time, the truth is that tattooing is easy to do badly and hard to master. All the artists on the shows are accomplished tattoo artists with years of experience at decorating the human form.

However, I see tattooing now at a peak that, back in the day those thirty years ago, one could not have envisaged. The quality of equipment, the range of pigments from pastel shades through the spectrum to super bright colours (fig. 1) and hygiene procedures are at an all-time high, as is the quality of artistic workmanship. The pages of this book are testament to the ever-increasing range of tattoo styles now being created. Over the years styles emerge that push the boundaries – these range from the full colour portraiture, both human and animal, from established names, like Andrea Afferni, Cecil Porter and Mike DeVries, to name but three, and new emerging talents like David Corden and Lianne Moule, to the masterful black-and-grey realism of the internationally acclaimed Bob Tyrrell. Japanese tattooing (fig. 9) is a powerful and beautiful style that continues to inspire, with Horiyoshi III being the greatest living exponent of this art. In Europe, Filip Leu and Mick from Zurich are established names of this wonderful style and, in the UK, the likes of Lee Symonds, Ian Flower, Aaron Hewitt, Luca Ortis and Diego Azaldegui create their versions of this timeless art form. Tribal style, with its influences from

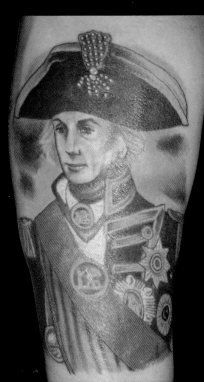

Figure 2 Brad Sims

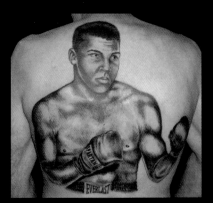

Figure 3 Brad Sims

Polynesia, Borneo and Samoa, is now an integral part of the tattoo world. Religious tattooing is now at an all-time high and, with the influences once again of the reality shows, where for TV purposes most clients had to have a story to explain why they are tattooed, "the memorial tattoo" is an everyday request in studios. Calligraphy and script primarily influenced by "the East LA black-and-grey /fine line / jailhouse style" is much favoured. Artists like Robert Pho, Jose Lopez, Boog, Mark Mahoney, Freddy Negrete, Mr Cartoon and Jack Rudy are world renowned for this style.

Calligraphic and literary tattoos have become a genre all of their own with books and magazines dedicated to all types of word tattoos in both English and other languages (figs. 4 and 6).

The portrait tattoo is another important style in the tattoo repertoire, with portraits of loved ones, pets, film stars, pop stars, and sports heroes all being etched into people's skin (figs. 2 and 3). It is reckoned that Marilyn Monroe, Jesus, Bob Marley and Elvis Presley are the most tattooed portraits.

It seems boundaries are constantly being torn down, with different influences being drawn from other arts and different interpretations being mixed with tattooing. The beautiful work of Amanda Wachob is a prime example of this.

It is noticeable how the public's attitude towards skin art has changed. When I first started to get tattooed the practice seemed to be treated by many with suspicion,

Figure 4 Ian Flower

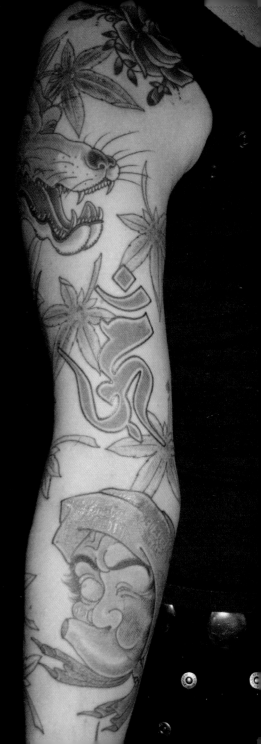

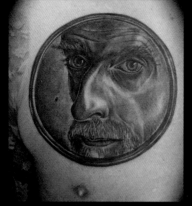

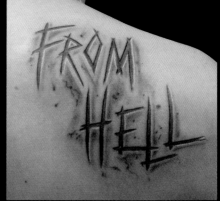

Figure 5 Slvia Z

Figure 6 Mark B

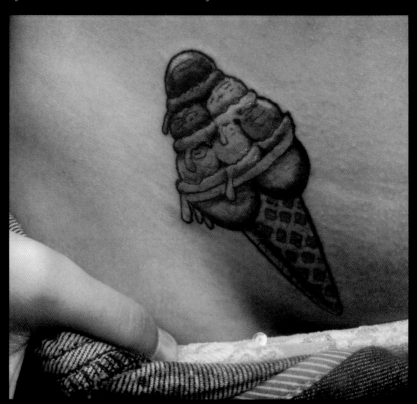

Figure 7 Mark B

contempt and, in some cases, hostility. This was probably due in some part to the type of stereotyped wearers of tattoos; bikers, villains, football hooligans, sailors etc. but probably had more to do with the fact that tattooing was a very secretive art, with the old-time practitioners guarding the secrets of the trade as if they were the Holy Grail. The world in which we now live has its global communications, internet, websites, e-zines and satellite television, right through to the newly launched iPad which features tattoo apps ranging from tattoo design and photo apps to games where you become the tattooist! All these factors have served to increase the popularity of the art and dispel many of the misunderstandings which surrounded it . Tattooing is now acceptable, fashionable and accessible.

It is still a mystery in many ways to me why human beings have this urge to alter or change their bodies – nowadays we see more and more people undergoing cosmetic surgery, piercing, dermal implants, branding, scarification and tattooing – but someone once said about tattoos "the naked body is just too naked without them".

It is unclear when, where or how the first type of tattooing took place but evidence of tattooing dating back to 2000 BC has been found on an Egyptian (female) mummy (2160 BC). And on 19 September 1991 an incredible discovery was made by two German tourists walking on the Schnalstal Glacier in the Alps near the border with Austria and Italy when they came across a body partly exposed after being frozen in ice. The body, it transpired,

was that of a man who was born around the year 3300 BC and on his body were fifty-seven tattoos. The ice mummy was named "Otzi" after the Otzal Alps region where he was found. Academics believe that the markings on the Egyptian mummy may have been linked to fertility, as they were on the lower abdomen, and that the tattoos Otzi had were somehow linked to his arthritis and may have been some kind of mark to help with a primitive form of acupuncture treatment .

Aside from medical reasons, the ancients also used tattooing to brand slaves and criminals, and as marks of ritual, travel, rank, courage, passage, protection, belief and to make themselves appear frightening to the enemy.

In the modern world, tattooing is found within many subcultures where it once again can denote membership, brotherhood, allegiance or rank. However, with the ever-increasing popularity of tattooing, its appeal has reached out into the mainstream where it seems everyone wants "some ink" .

Once again, the media and celebrity can influence the choices of design to the greater tattoo public, and so can world events . In the film *From Dusk Till Dawn* (1996), George Clooney's character, Seth Gecko, sported a full sleeve tribal tattoo on his left arm and tattoo studios were inundated with people wanting to replicate the design. To a lesser degree the tattoos worn by Vin Diesel in *Triple XXX* led to an interest in people having renditions of the artwork sported by his character, Xander Cage.

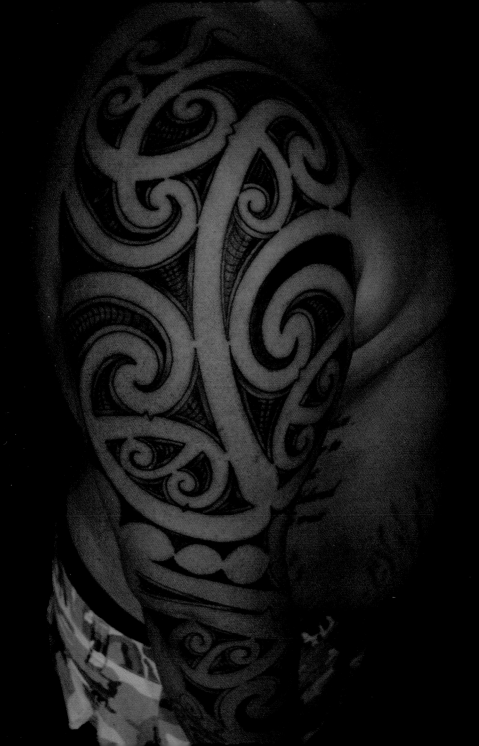

It is well documented how the "Guardian Angel" inked on David Beckham's back by Louis Molloy has been copied literally thousands of times, such is the impact of celebrity tattoos. The cover for the best-selling book by Stieg Larsson, *The Girl with the Dragon Tattoo* (2005), is one of the latest influences on a public eager to be tattooed, although it must be said, copying a design such as this is hardly a sign of originality!

World events can lead to an increase in tattoo demand. Early in my tattoo career, the Falklands War of 1982 saw a huge increase in requests for patriotic designs from both military and civilians in the UK. The World Trade Center terrorist attack of 11 September 2001 was an event that led to numerous tribute tattoos. Nearly 3,000 people lost their lives in this outrage, including 343 firefighters of the NYFD. Such was the shock and sense of loss that thousands of people underwent the tattooist's needle to permanently record their tributes. There are websites now dedicated to 9/11 tattoos.

Another of the major changes I have witnessed since my early days as a tattoo whippersnapper is the rise of the female tattoo artist. There were very, very few female tattooists back then in the late 1970s, in fact the only names I can recall are Jessie Knight (reputedly Britain's first female tattooist) who worked in the naval port of Portsmouth, and Rusty Skuse (1943–2007) who worked in the town of Aldershot (home of the British Army). Both these ladies tattooed in the UK. The most

Figure 8 Matt Black

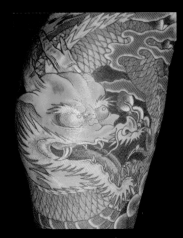

Figure 9 Brad Sims

famous female tattoo artist was Cindy Ray, who tattooed in Australia.

By the late 1970s and early 1980s, women were tattooing a swathe through the tattoo jungle. Krystyne the Kolorful was a collector with an amazing body suit, a modern day tattooed lady, and artists like Kari Barba, Miss Roxy and Kandi Everett were gaining recognition for their beautiful tattoo works. This was the beginning of women leaving their mark on the tattoo world and the trend has continued with thousands of ladies now tattooing worldwide .

The pages of this book are a showcase for some of the greatest tattooing being created in the world today I hope you find it interesting, enlightening and fascinating.

Lal Hardy, London 2011

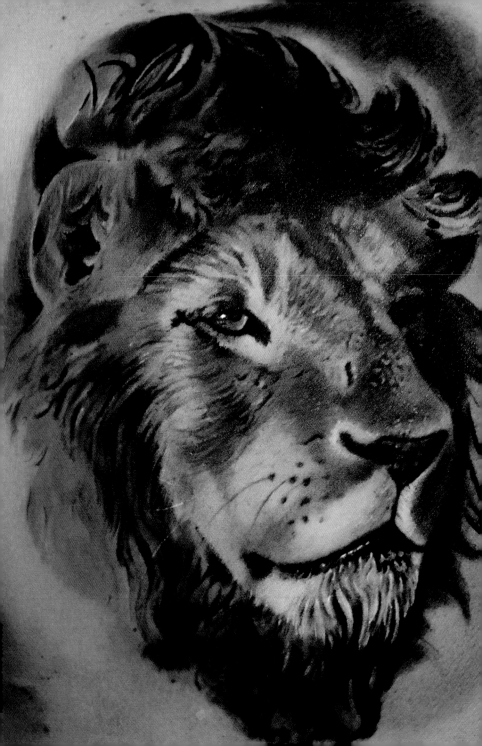

_A_ndrea Afferni

Andrea Afferni is an Italian tattooist who is passionate about detailed realistic work – portraits, animals, famous people, film scenes, landscapes and figurative work – in both black-and-white and colour, aiming always for perfection in every minute detail. No other style has ever really interested him. He started tattooing, thanks to an uncle, at the age of eighteen and knew immediately that tattooing and painting were going to dominate his life. The techniques of painting with oils on canvas and its nuances of shade have encouraged Andrea to regard skin decoration techniques in a similar light. He regularly attends international conventions and runs seminars on portraiture and realism for professional tattoo artists in his private studio.

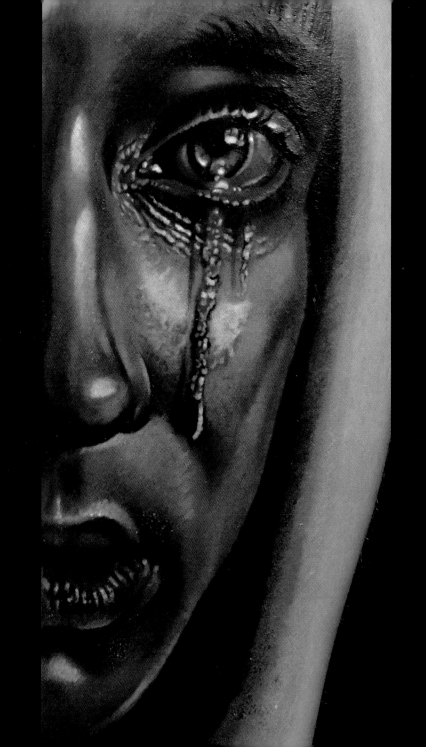

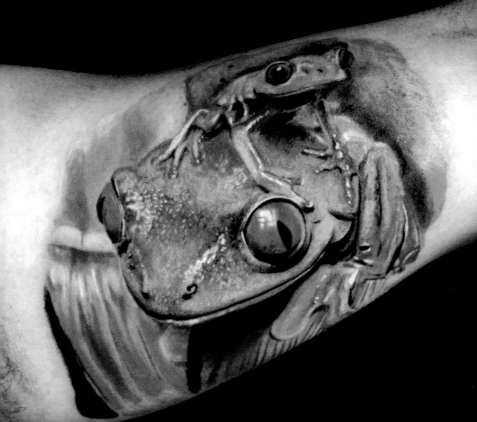

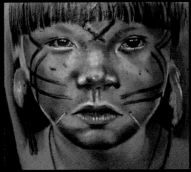

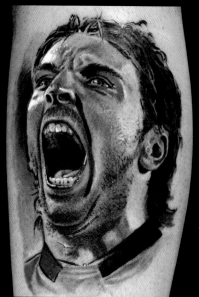

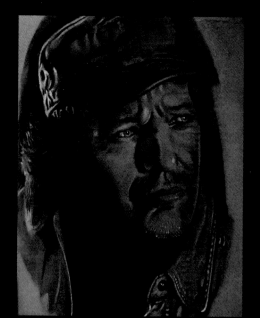

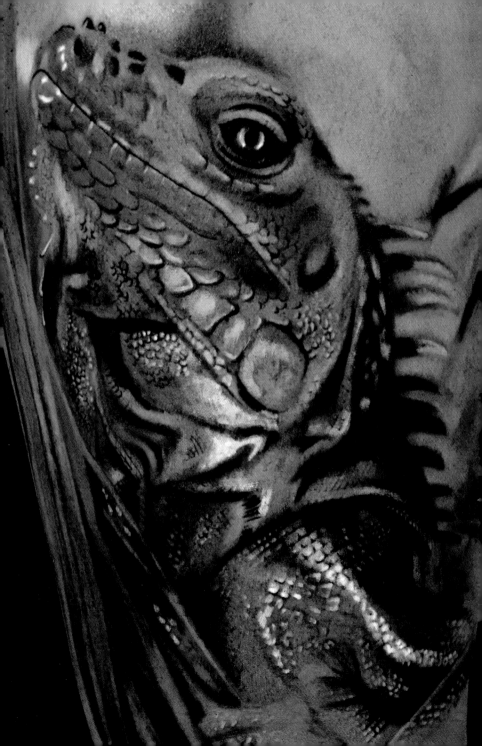

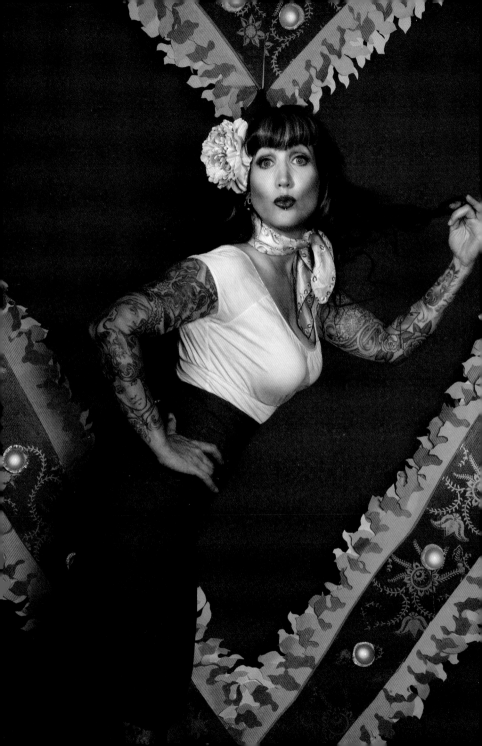

Hannah Aitchison

Chicago native Hannah Aitchison currently splits her time between the two weather systems of Chicago and Los Angeles. She has spent the last twelve years developing a distinctive artistic style that showcases elements of classical illustration, mid-century American propaganda, art nouveau and pin-up art. When not "dermatologically decorating" other people, Hannah enjoys activites as diverse as knitting, repairing vintage cars, attending art gallery openings and live music events, gardening and boxing. Her theory is that good art comes from good experiences. She also enjoys long moonlit walks on the beach, piña coladas and lawn darts.

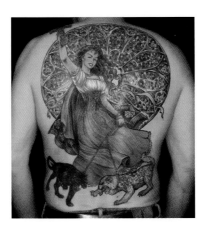

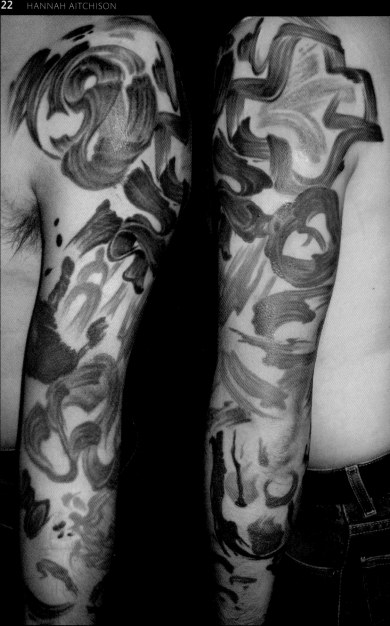

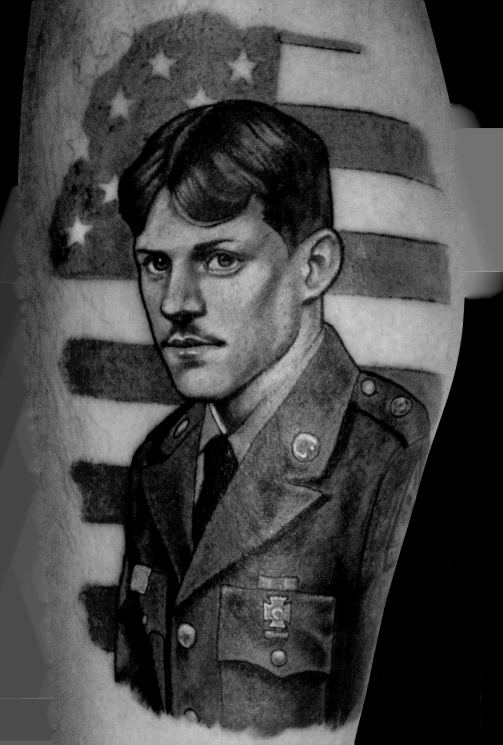

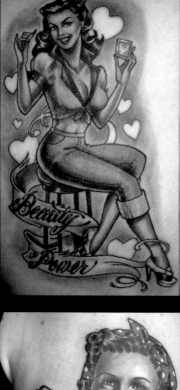

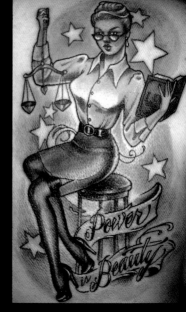

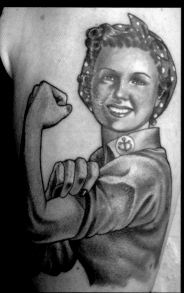

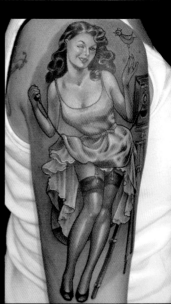

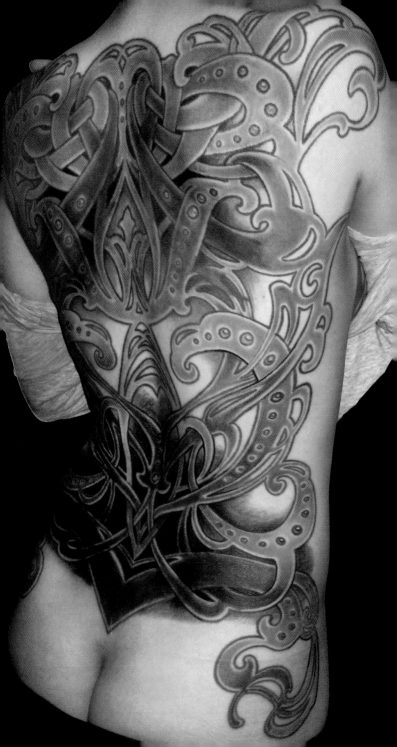

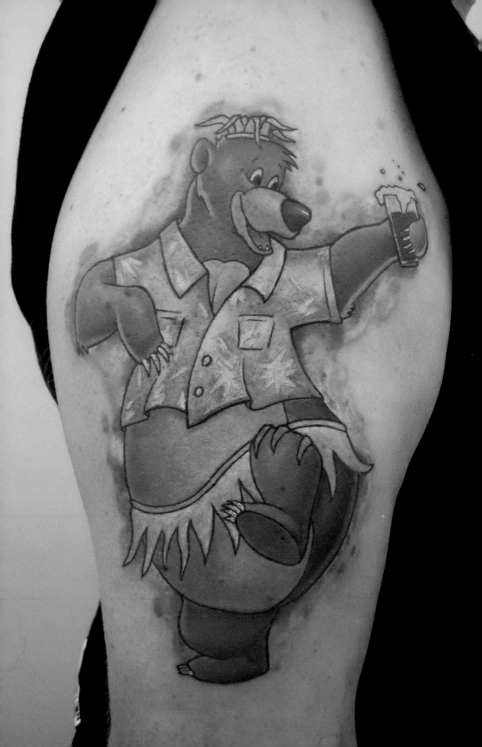

\mathcal{J}ohn Anderton

John Anderton has been tattooing for just under three years.
He prefers realism in his tatto art, although he likes to experiment
with many different styles. As an artist, he is always pushing himself
by trying to make every new tattoo better than the last. He has enjoyed
working at conventions and doing guest spots at various studios,
"making some great friends along the way". When he has time
away from the studio he likes to cycle and to play the guitar
and in the future he hopes to record music.

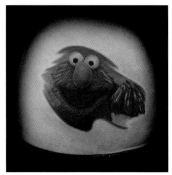

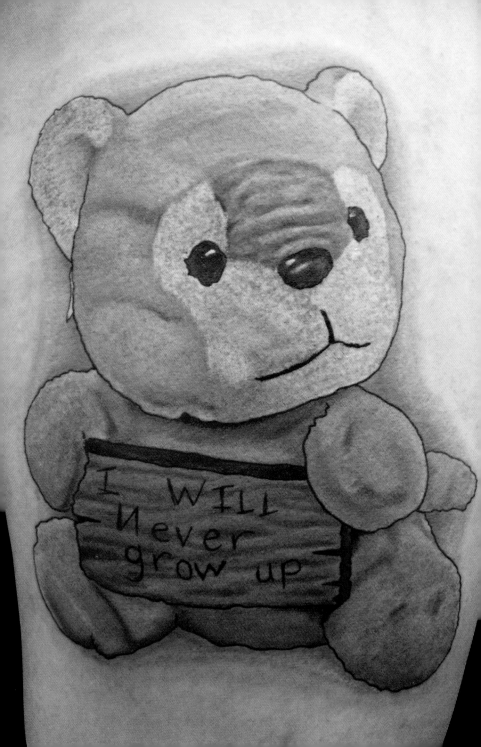

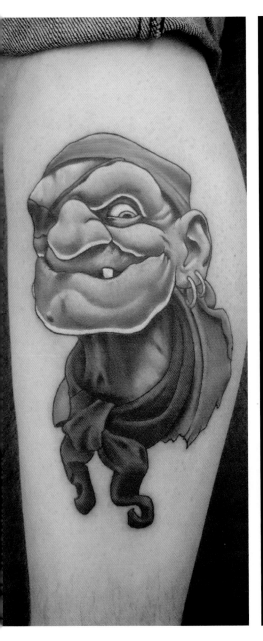

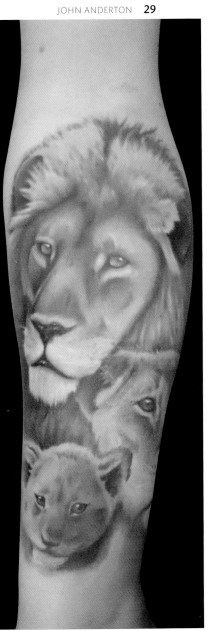

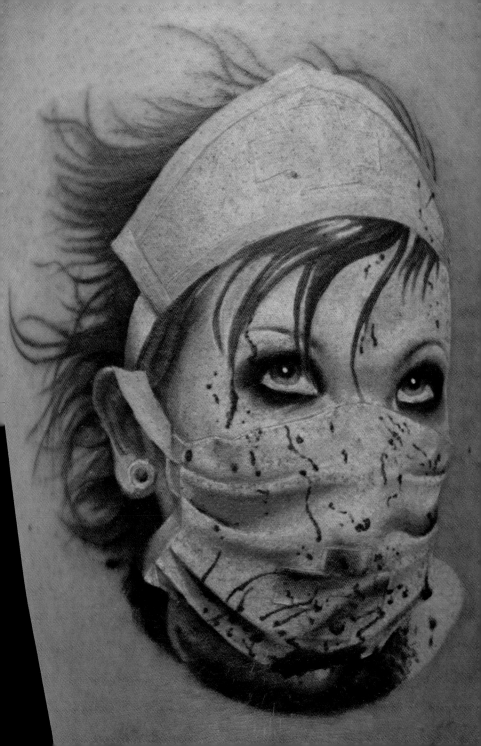

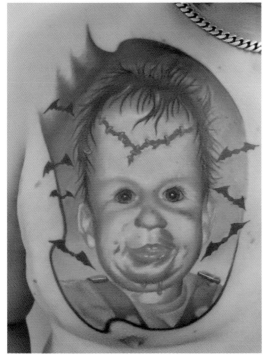

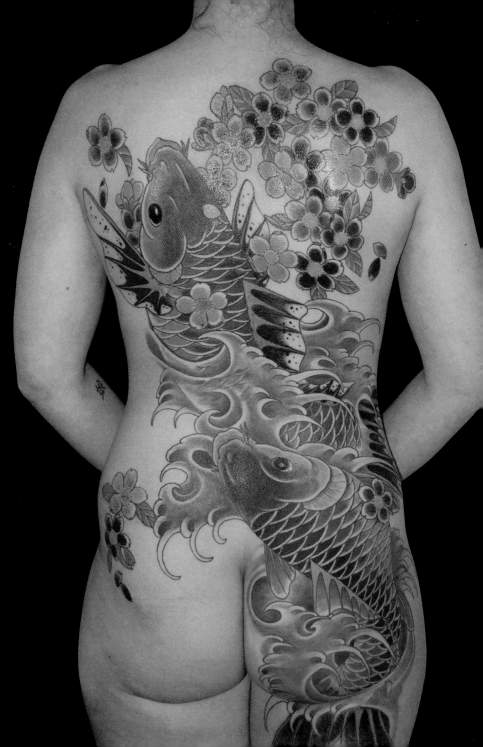

\mathcal{D}iego Azaldegui

Diego Azaldegui began his "amazing trip into tattooing" thirteen years ago. Mostly it's been good, some of it less so, but he still loves his job and feels it's the best thing he could possibly be doing as it gives him and his family the freedom they need to be happy. Diego's studio, MVL Tattoos, has operated in many different countries. At present it is based in Leeds, England, but Diego hopes to be on the move again soon.

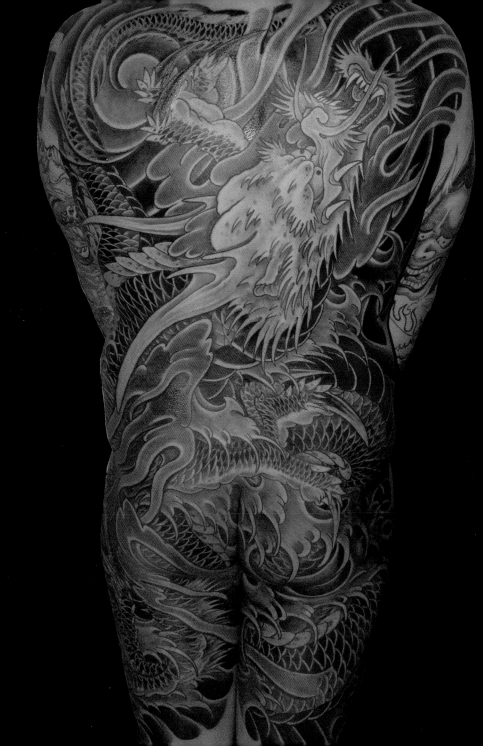

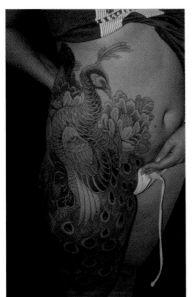

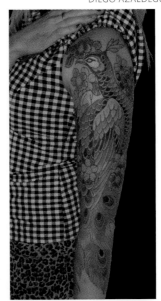

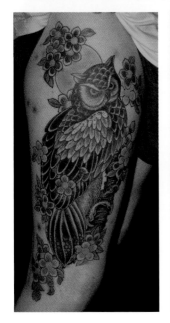

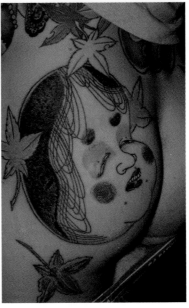

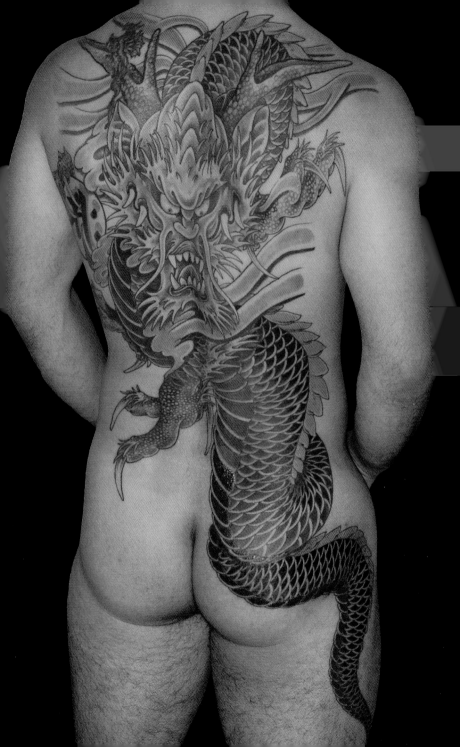

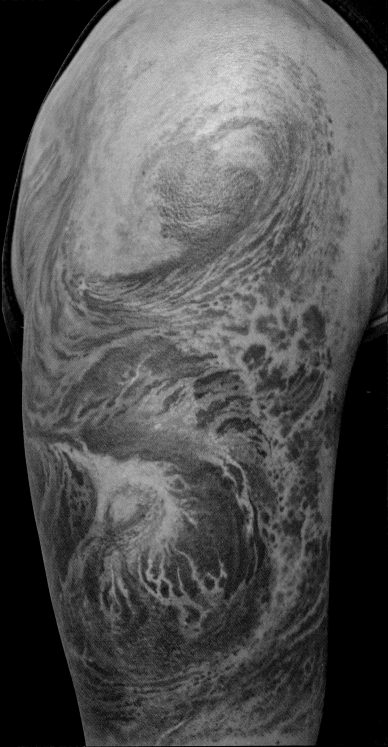

ℋari Barba

Kari Barba's first Outer Limits Tattoo and Body Piercing studio, originally called Twilight Fantasy, was opened in 1983. It is still operating in its original location in Anaheim, California, while new branches of the studio have opened in Long Beach, Costa Mesa and Orange. Kari has been tattooing for more than 30 years, and has won more than 500 awards, including Best Tattooist (twice) and Best Overseas Tattooist. She loves what she does, collaborating with clients to create their ultimate artwork that will last a lifetime. In 2005, Kari bought and modifed what used to be Bert Grimm's world-famous tattoo studio, established in 1927, the oldest in the United States and the second oldest in the world. Now, Kari, her son, Jeremiah, and eight other artists, along with two piercers, are creating a new future for the studio.

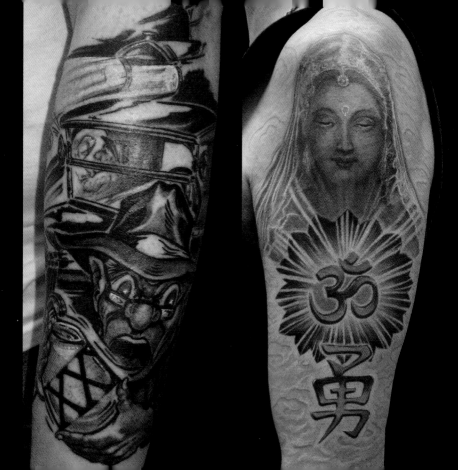

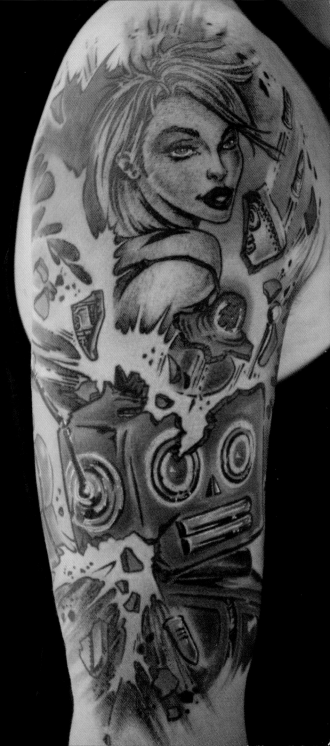

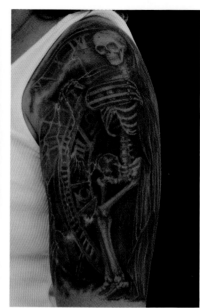
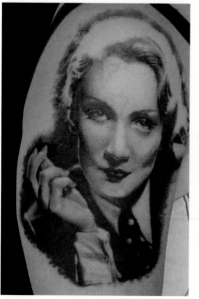
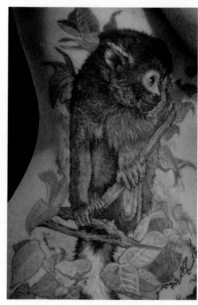

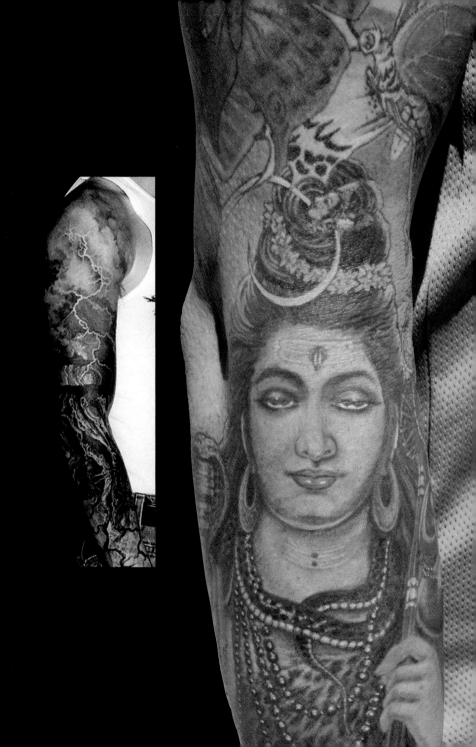

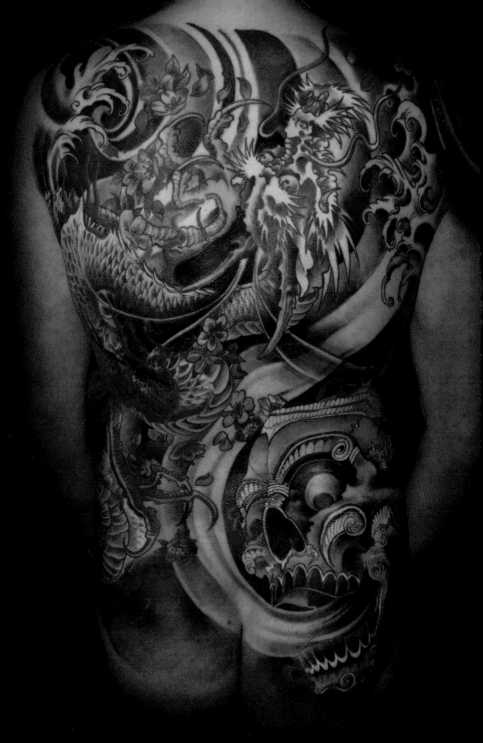

Buena Vista Tattoo Club

Over 15 years, Simone Pfaff and Volker Merschky have developed a completely new style of tattooing, "realistic trash polka", which combines realistic images with graphic elements. Much of their work makes use of striking contrasts between black and red, though they do sometimes use small quantities of other colours. Customers may provide a rough idea of what they would like, but have no influence on the final, unique design. Having a realistic trash polka tattoo done is like buying a picture by a particular artist from a gallery. Volker and Simone have left behind the old-fashioned model of a tattoo business offering a service to create art of their own. They have also abandoned the classical tattoo design repertoire in favour of their own original images. In their spare time Volker and Simone compose songs and paint. They intend to exhibit their art at some point in the future.

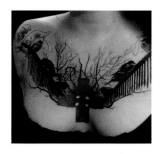

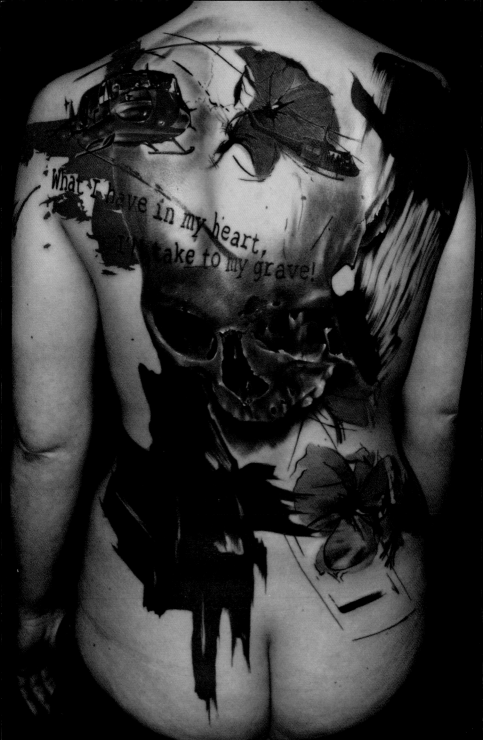

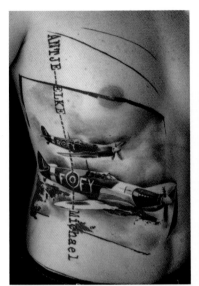

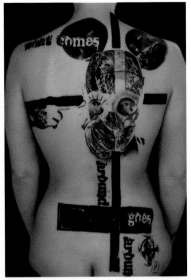

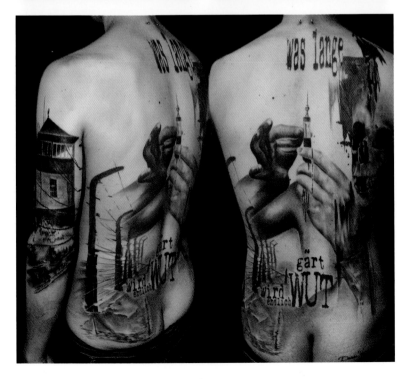

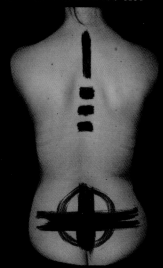
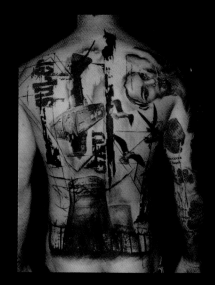
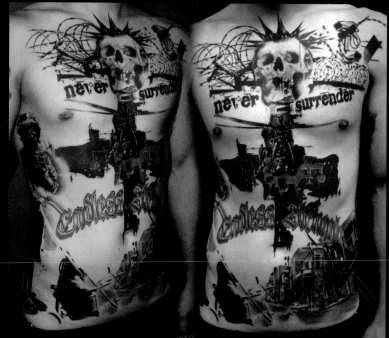

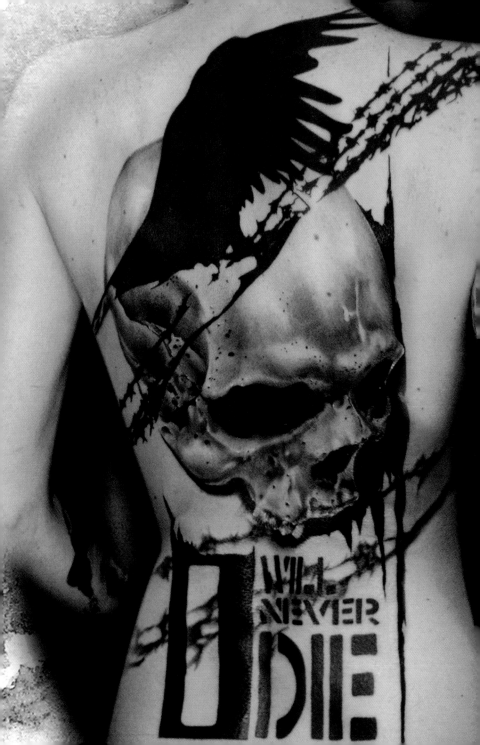

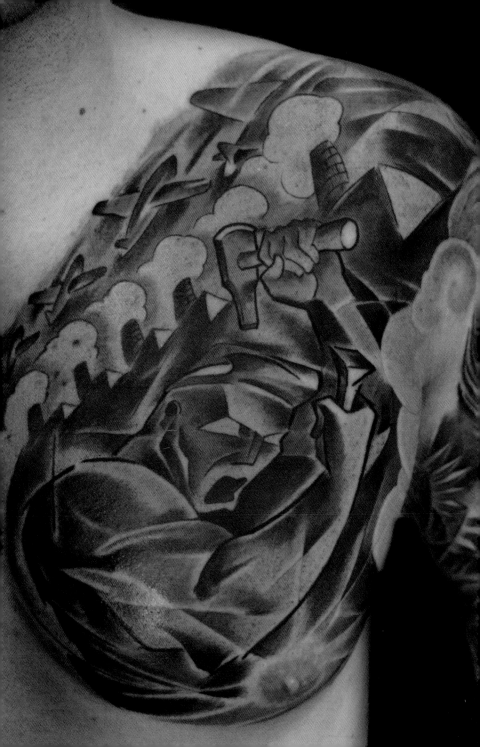

\mathscr{B}ugs

Bugs was born in Perpignan, France, a region known for its Catalan culture and an area which has inspired many artists before him. After attending fine art school, Bugs decided to travel to London where there were opportunities for tattoo artists which were not available in France at the time. Although Bugs enjoys designing unique tattoos, it is painting that is his real passion. Since moving to Los Angeles in 2005 most of his creative energy has been directed towards his painting and he has produced some of his finest work following his move to the United States.

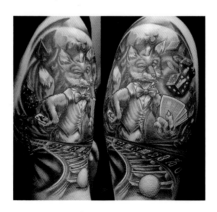

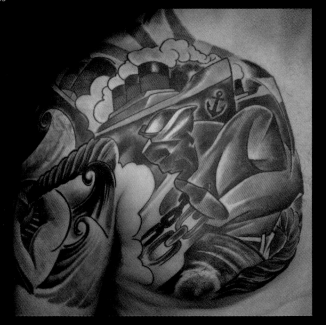

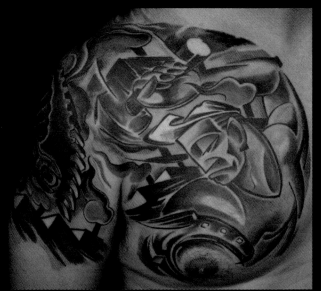

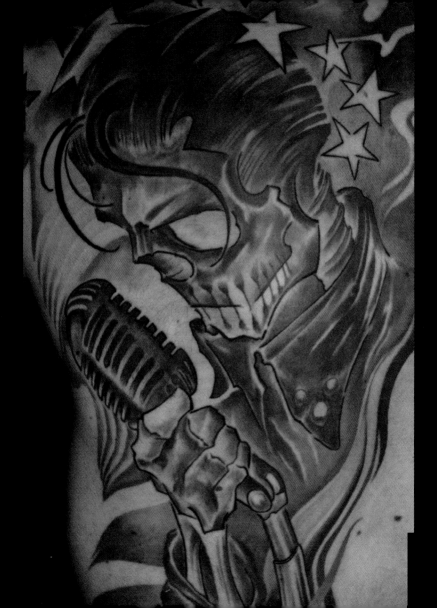

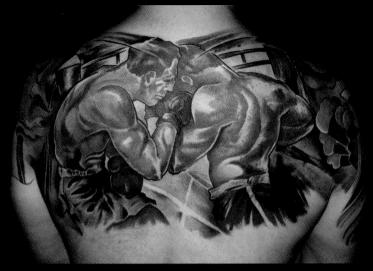

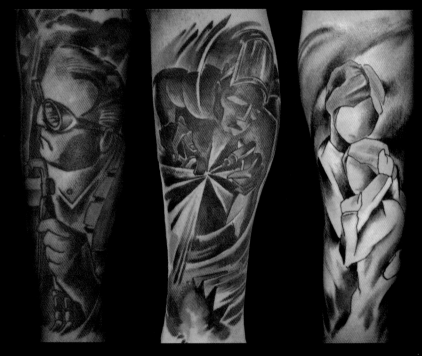

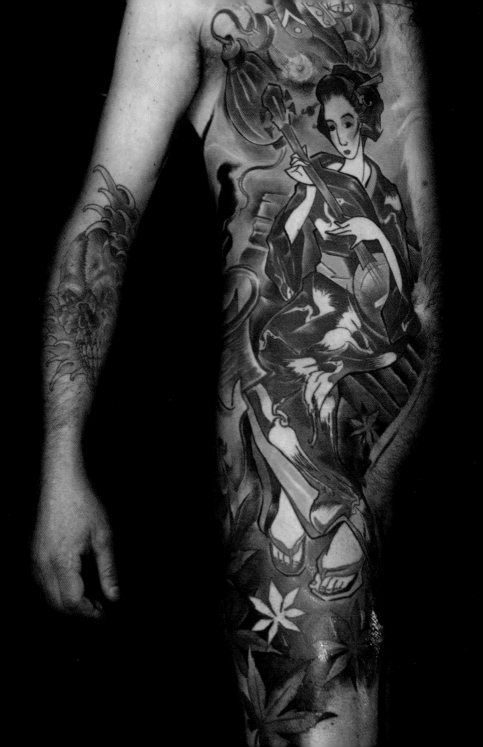

\mathcal{M}artin Clark

Martin Clark has been tattooing for around twenty years, beginning his
tattoo career at New Wave Tattoo in North London. As a kid he loved
the tattoos that came in packets of bubblegum; now he owns and runs
his own studio, Bluebird Tattoo, in Watford, Hertfordshire.

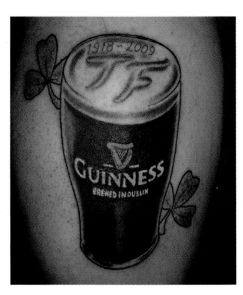
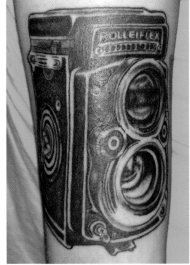

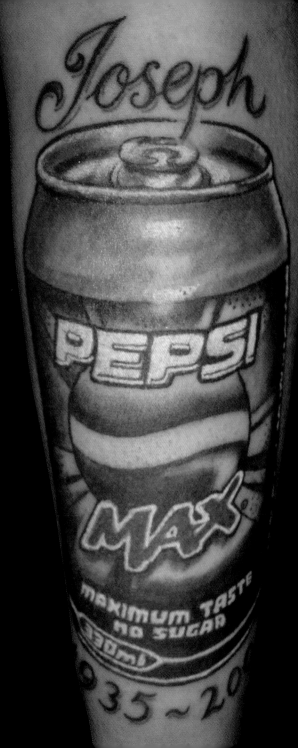

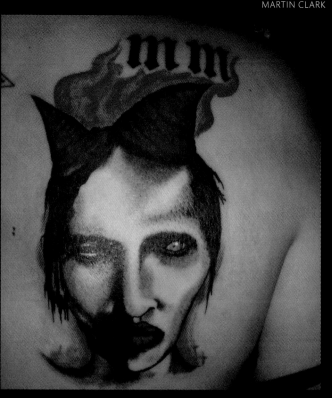

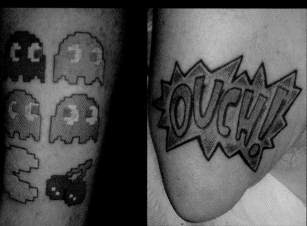

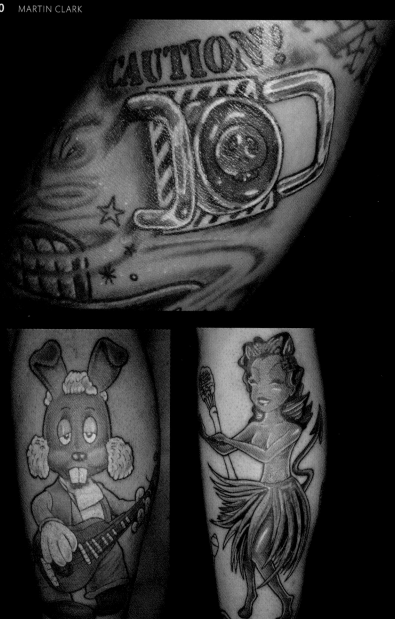

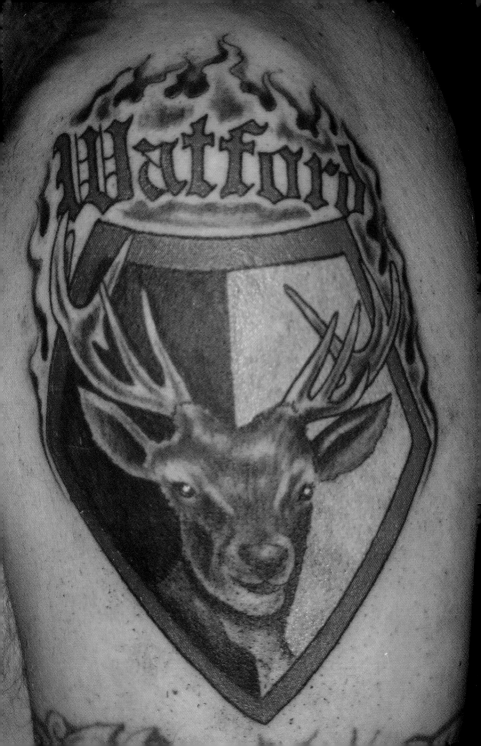

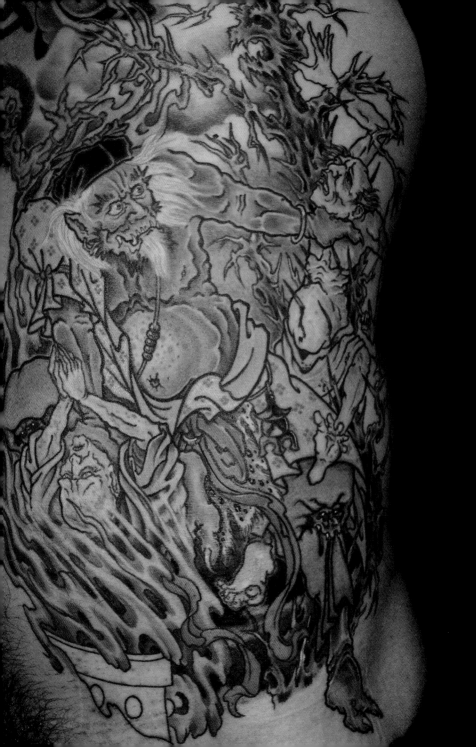

Geordie Cole

Geordie Cole began tattooing in 1990. Over the years he has travelled extensively, meeting people "resulting in friendships that will last a lifetime". He has owned his studio, Tattoo Magic, since 1996 and has "been fortunate enough to work with some amazing artists there". His tattoo designs have been used by some of the great tattooists, and he feels that "life is good".

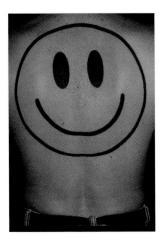

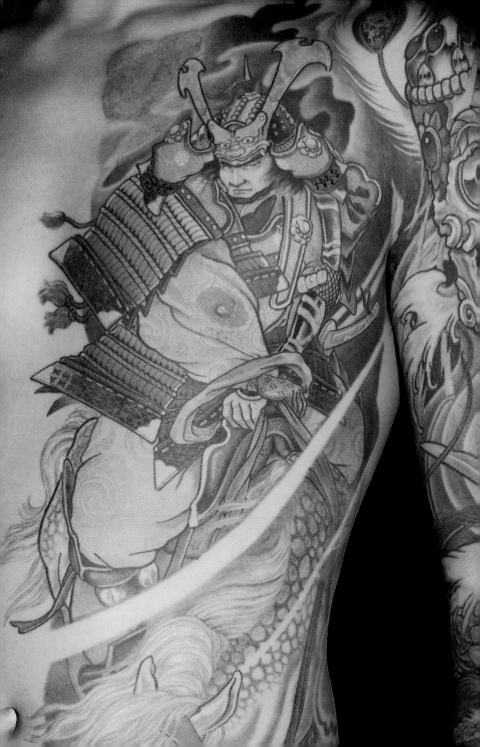

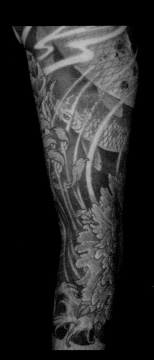

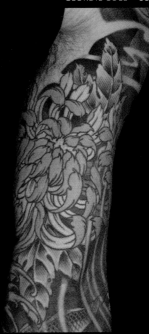

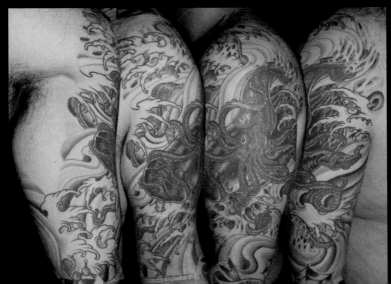

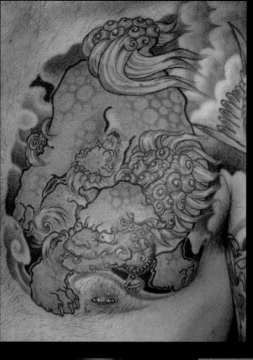

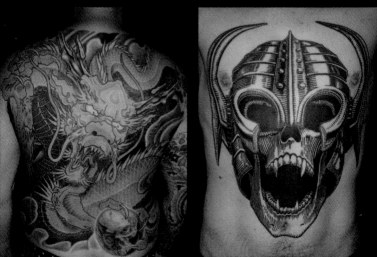

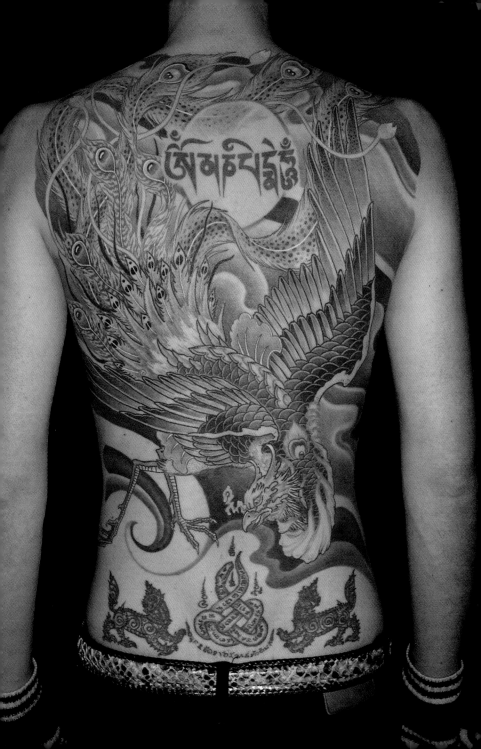

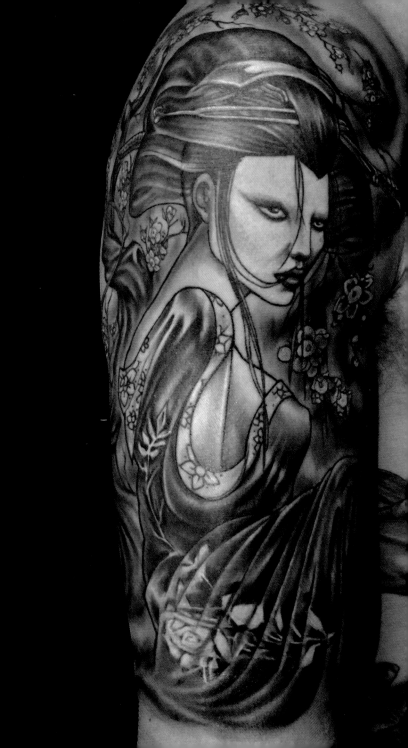

\mathcal{A}dam Collins

"Tattooing . . . It's got me in and out of all sorts of trouble!"

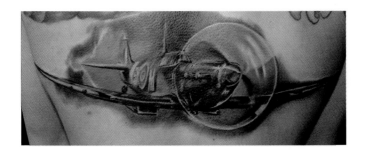

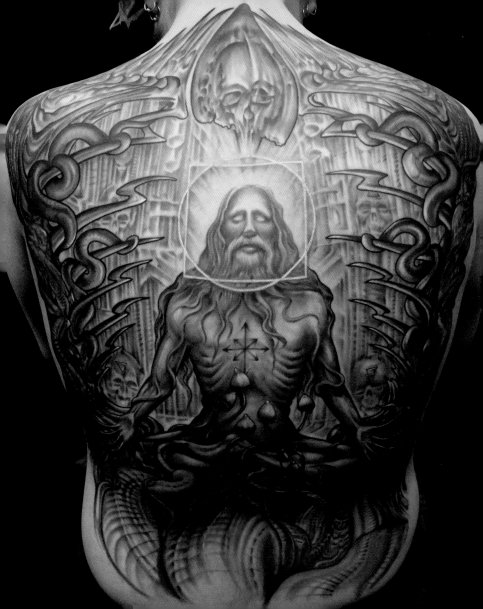

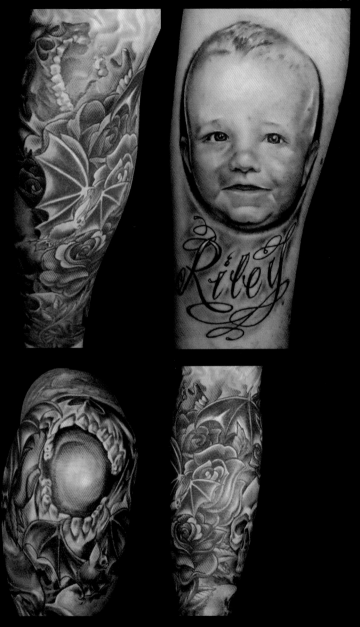

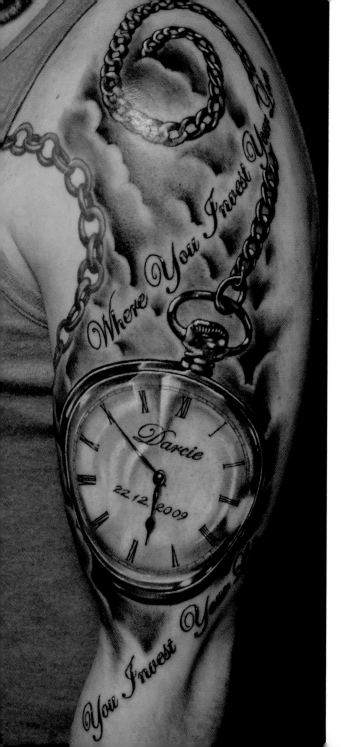

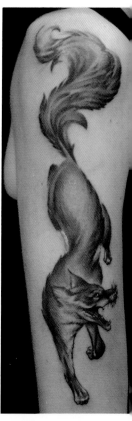

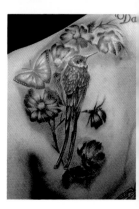

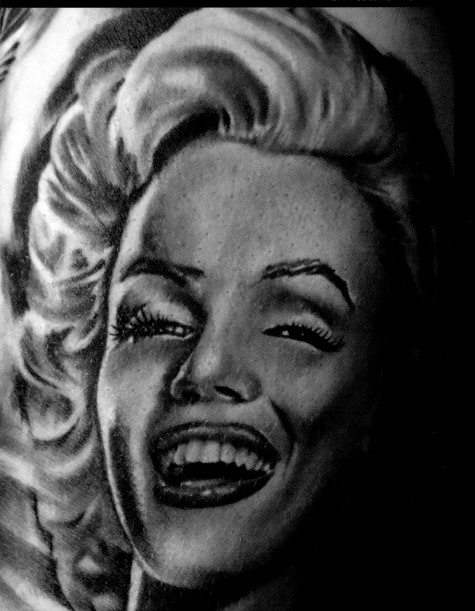

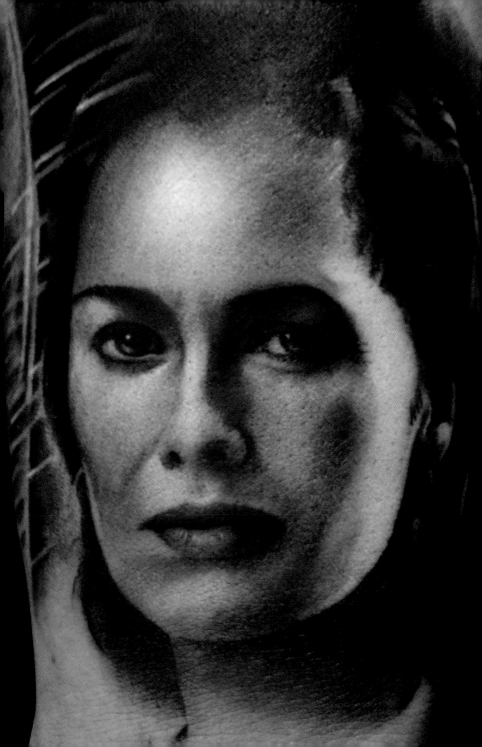

\mathcal{D}avid Corden

"I did my first tattoo in April 2006; before that I was a ventilation engineer. I work at Ritual Art Tattoo in Rainham, Kent, and began there after I went with a drawing of mine that I wanted for my first tattoo and was offered a job. I wasn't looking for an apprenticeship so had no idea how lucky I was, but now I can honestly say that I have found my dream job. I specialize in realism, preferring to do pin-ups, wildlife and portraits. I love to copy things, always have, and now I'm lucky enough to get paid for it!"

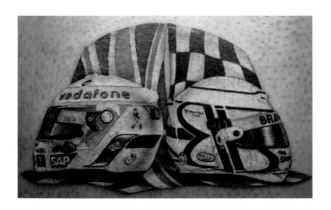

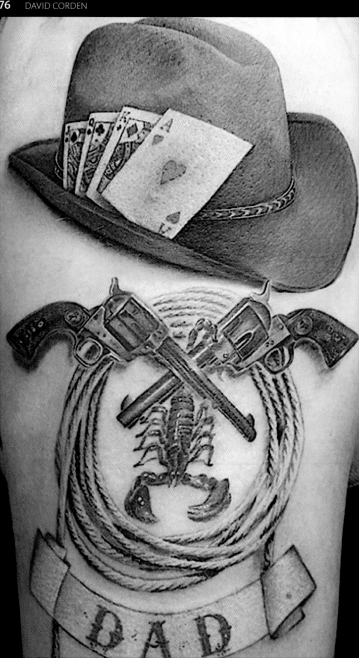

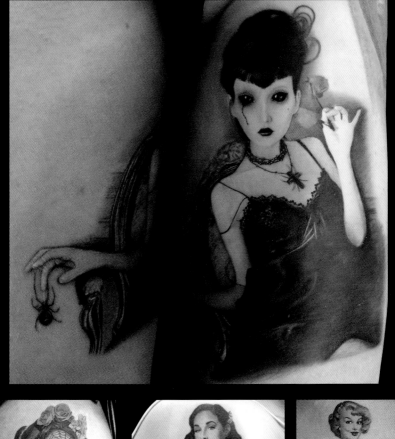

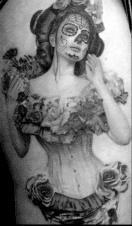

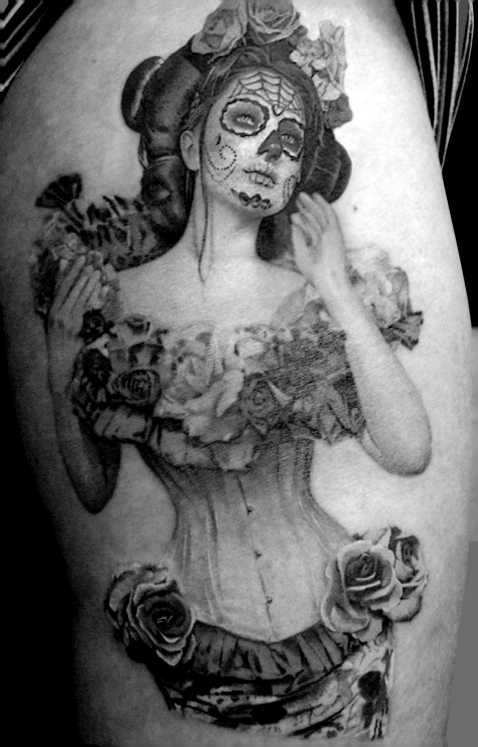

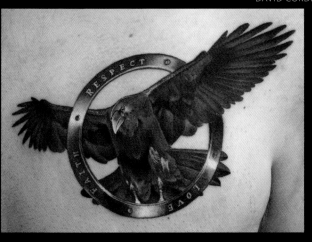

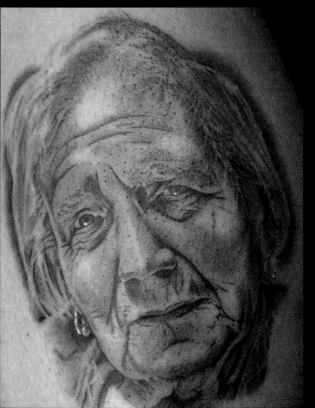

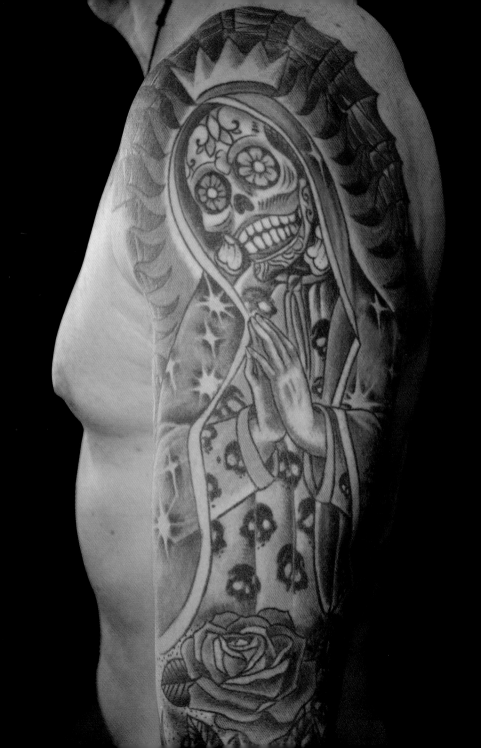

𝒦eet D'Arms

"Tattooing doesn't have to be complicated. Most of the power
of a well-executed tattoo comes from its simplicity and directness."
Keet D'Arms strives to make his work unencumbered by his own ego, and
to have a quality that will suit the wearer for many years to come. He wants
to make the guys feel tougher and the ladies feel prettier. He combines
a number of sources in his work: Americana and the traditions of classic
tattooing, the design principles of traditional Japanese Tebori, as well
as imagery of gang culture which was all around him as he grew up.
He prefers to make "the best tattoo for the client", rather than to make
a great portfolio photo. He believes that "if you take care of tattooing, it will
take care of you".

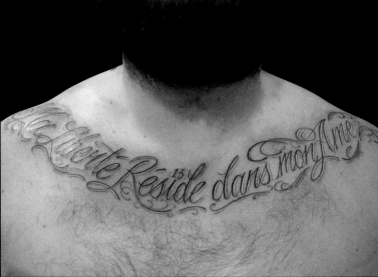

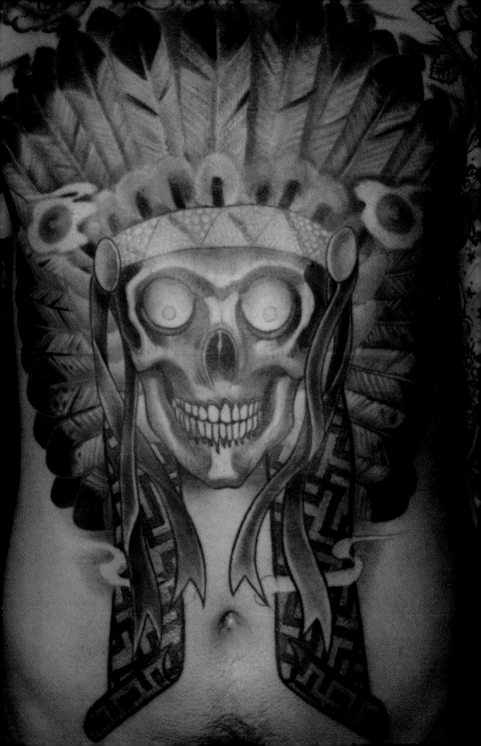

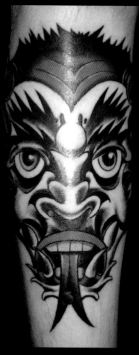
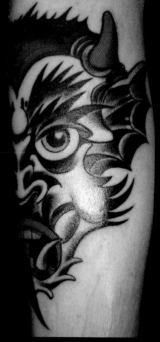
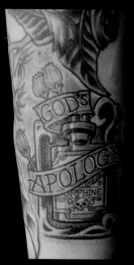
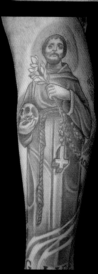

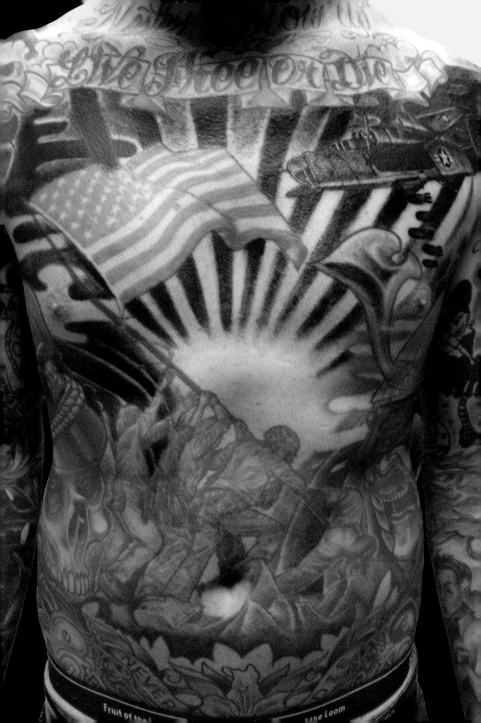

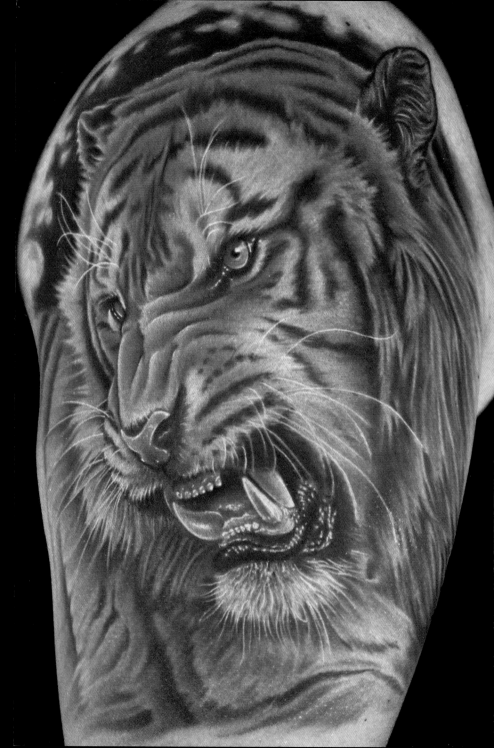

\mathcal{M}ike DeVries

"I acquired my first tattoo when I was sixteen and started spending a lot of time hanging out at the local street shop. I own and operate MD Tattoo Studio in Northridge, California, and am involved with Memento Publishing, Reflected Art and Stencil Stuff. I am honoured to be an award-winning artist, having garnered approximately 130 awards in the first seven years since I began tattooing. But I am most proud of being happily married to my beautiful wife Serena, and being father to our awesome son, Kyle. I am inspired by artists such as M.C. Escher, Salvador Dali, Kunio Hagio and Michael Godard and by tattooists such as Bob Tyrrell, Robert Hernandez, Tom Renshaw, Guy Aitchison and Nick Baxter."

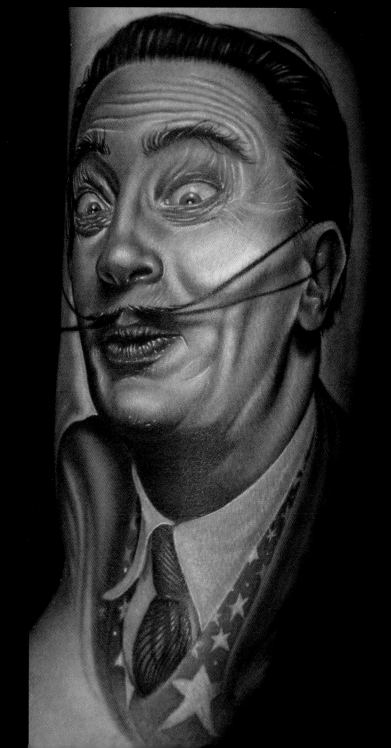

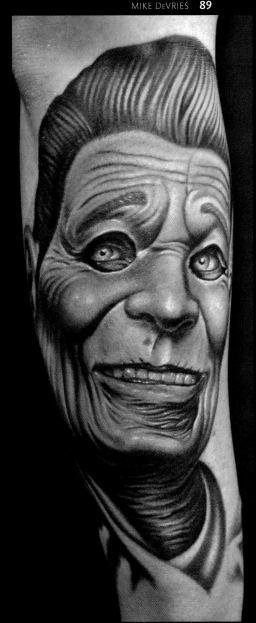

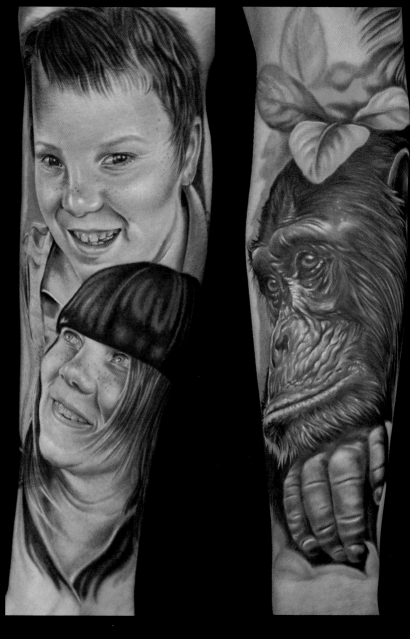

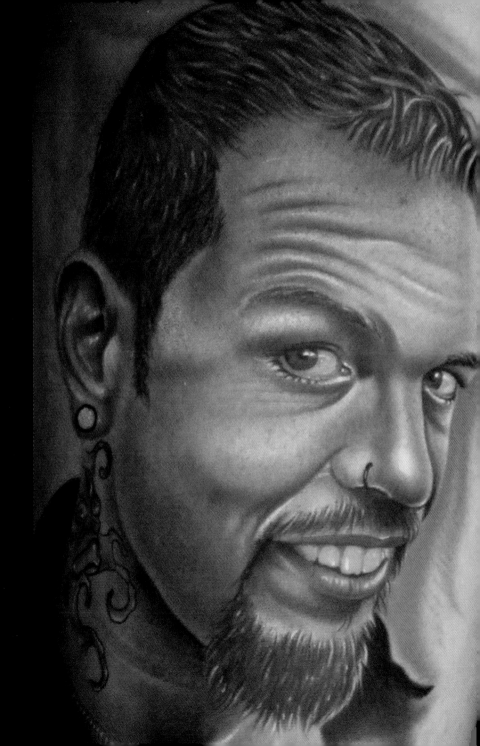

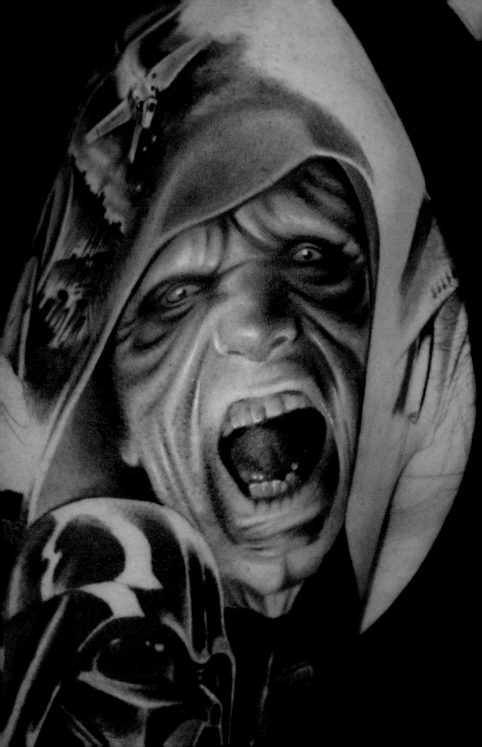

\mathcal{M}att Difa

"I was into tattoos at a pretty young age
and was pretty well tattooed while still underage!"

Matt Difa became a tattoo artist when Danny of Frith Street Tattoo
(formerly Camden Market) introduced him to Jason Saga, who was
working at Evil from the Needle at the time. He learned the basics in
Jason's front room, had a few weeks tattooing with friends and within a
month he had managed to land a job at Tribalize with Andi Bone. He
spent two years there before going on the road and doing guest spots
around Europe. On his return he began working at Tusk in central London,
spending five years building "a very cool client base of geeks, comic lovers
and other like-minded people". After eight years he decided to open his
own shop, Jolie Rouge, which has been operating for four years now.

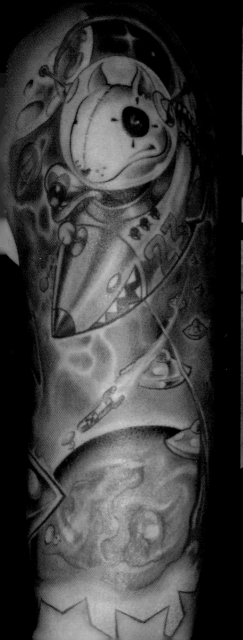

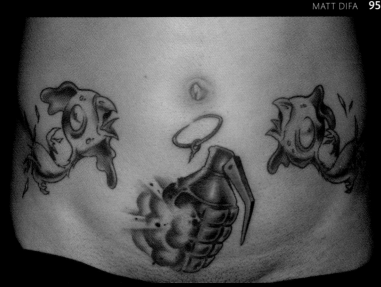

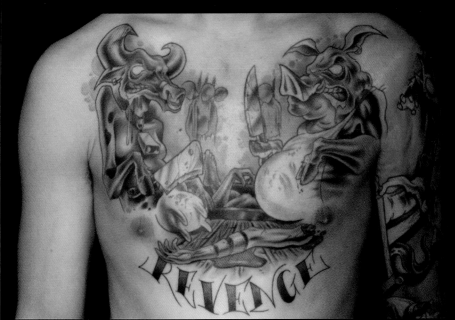

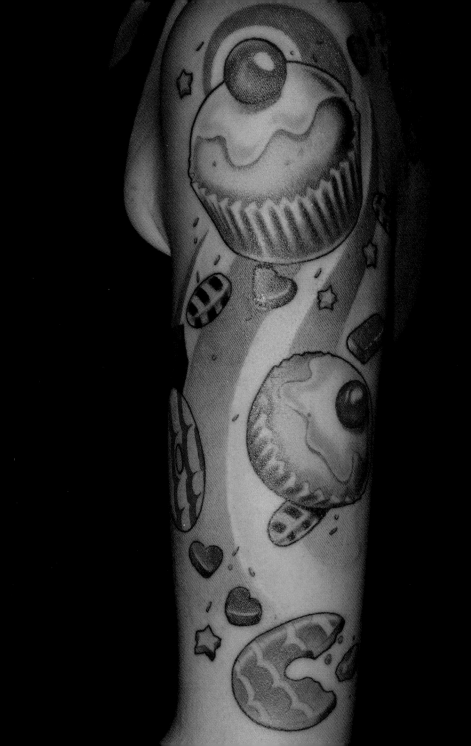

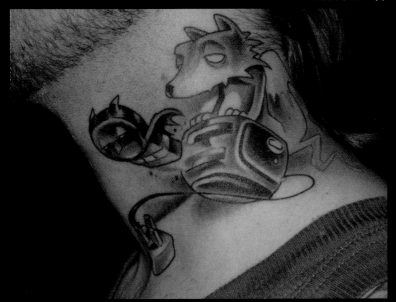

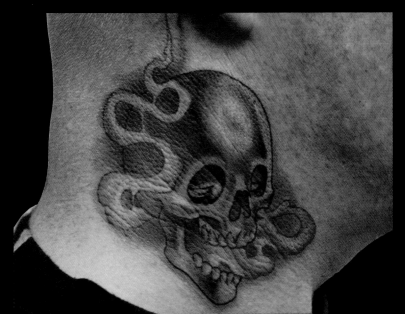

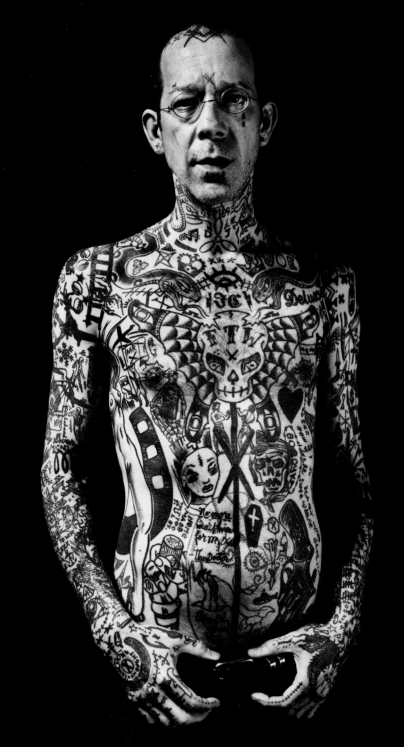

𝒟uncan X

"If you want something cool, unique and better than all the other shit you see, big or small, then I am your man." Duncan X was born in London in1965 – he changed to his present name by deed poll in 1993. Dennis Cockell taught him to tattoo in 1996 and he joined Into You the following year. His work has been showcased in the Victoria and Albert Museum and in thepermanent exhibition at the Greenwich Maritime Museum, London.

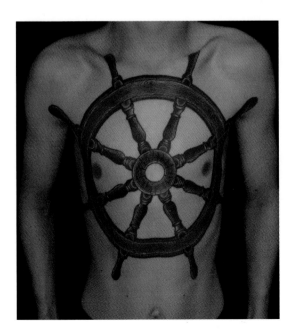

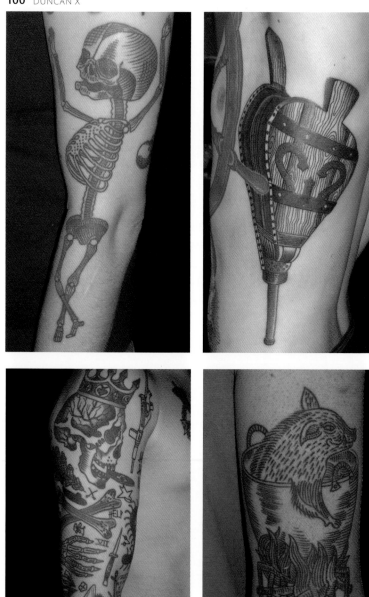

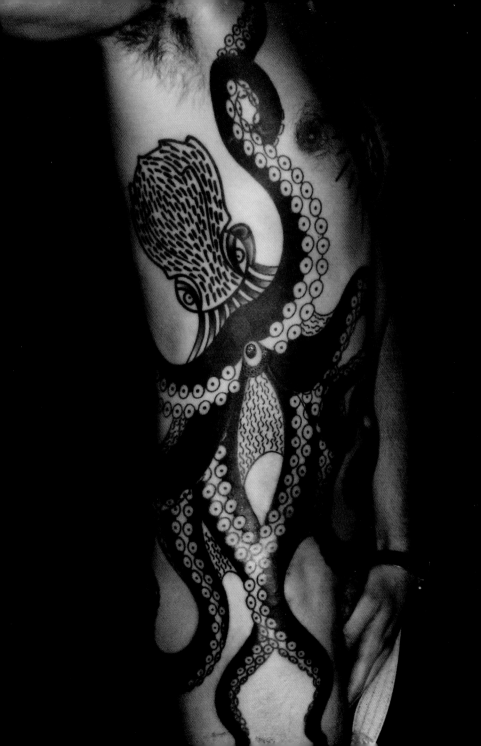

But we have lost the way.

...men's souls, has barricaded the world with hate,...
...misery and bloodshed. We have developed speed but we have shut our...
...machinery that gives abundance has left us in want. Our knowledge has made us...
...our cleverness hard and unkind. We think too much and feel too little. More...
...machinery, we need humanity. More than cleverness, we need kindness and gent...
Without these qualities, life will be violent and all will be lo...
...aeroplane and the radio have brought us closer together. The very nature o...
...nations cries out for the goodness in... ...cries out for universal brotherhood...
...of us all. Even now my voice is reaching millions throughout the world, m...
...suffering men, women and little children, victims of a system that makes men to...
...imprison innocent people.

Those who can hear me... ...despair... the misery that is...
...spreading of greed, the bitterness... ...who fear the way of human p...
...will pass and dictators die... ...the power that they took...
...to the people and so long as men die, liberty w...
...give yourselves to brutes, men who despise you... ...enslave y...
...tell you what to do, what to think and what to fe... ...drill...
...cattle, use you as cannon fodder. Don't give yourselves to th...
...men, with machine minds and machine hearts! You are n...
...You are men! You have the love of humanity in your hear...
...only the unloved hate, the unloved and the unnatural.
...don't fight for slavery! Fight for liberty! In the seventeenth ch...
...written, "the kingdom of God is within man" — not one man, nor a...
...but in you, you the people have the power, the power to cr...
...create happiness. You the people have the power to make this...
...beautiful, to make this life a wonderful adventure...
...name of democracy, let us use that power! Let us all unite...
...decent world that will give men a chance to work, that will...
...age a security. By the promise of these things, brutes have...
...but they do not fulfill their promise; they never will! Dicta...
...free, they enslave the people! Now, let us fight to fulfill that p...
...free the world, to do away with national barriers, to do away with...
...intolerance. Let us fight for a world of reason, a world where...
...progress will lead to all men's happiness.

Soldiers: In the name of democracy, let us all unite!

...hear me? Wherever you are, look up, Hannah. The clouds are...
...through. We are coming out of the darkness into the lig...
...a kindlier world, where men will rise above their hate,...
...brutality.

Hannah. The soul of man has been given wings, and at last he is beg...
...is flying into the rainbow — into the light of hope, into the f...
...Look up, Hannah. Look up... it is you, to me, and to all...

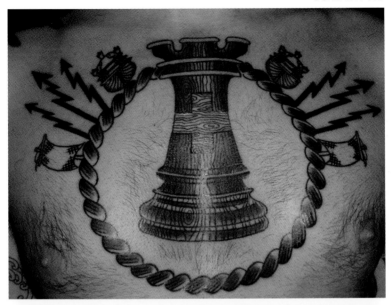

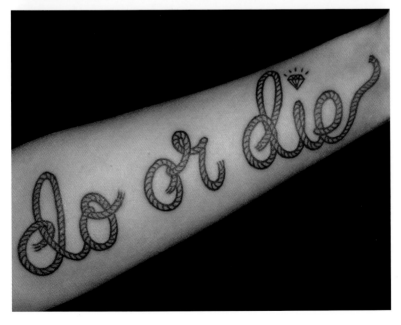

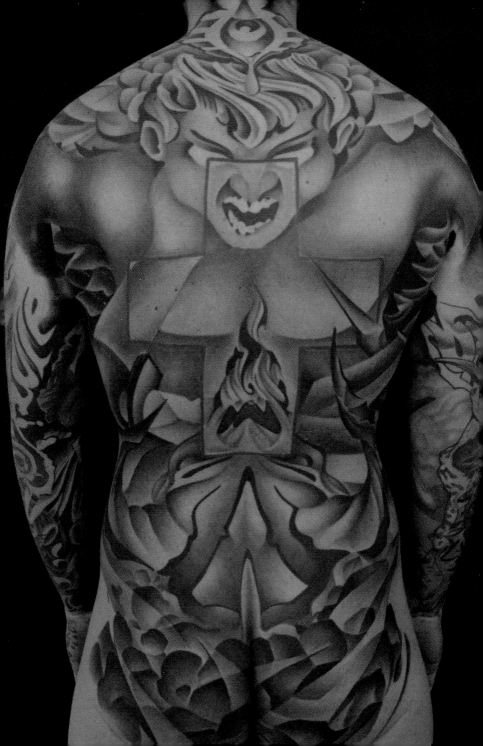

\mathscr{F}ace the Fact

Ulrich Krammer is a twenty-five-year-old tattoo artist from Linz, Austria. He started tattooing about six or seven years ago when he was studying and then working as an electrician. Some time later his reputation spread rapidly through the tattoo world due to his unique style of tattooing and art. With an ever-increasing client base, Ulrich decided to open his own tattoo studio and within a year he had opened a bigger studio and given up his job as an electrician. Ulrich undertakes only custom work designed to harmonize with the human form, making use of the natural shapes of the body.

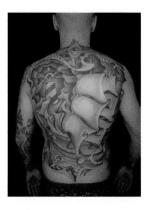

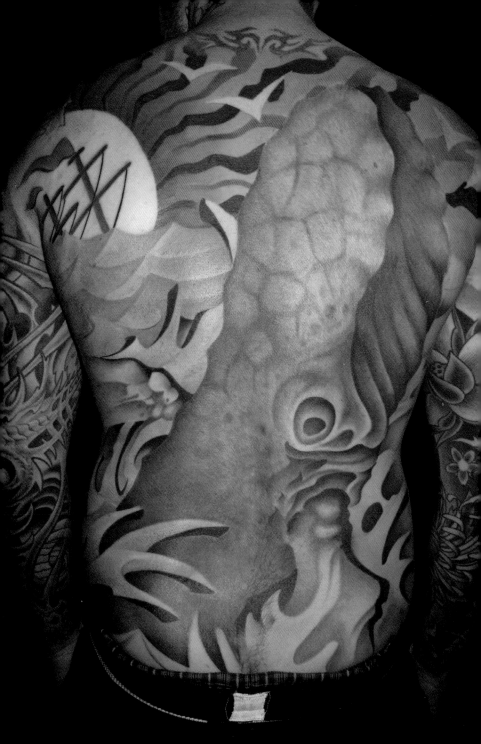

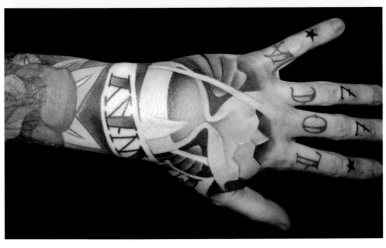

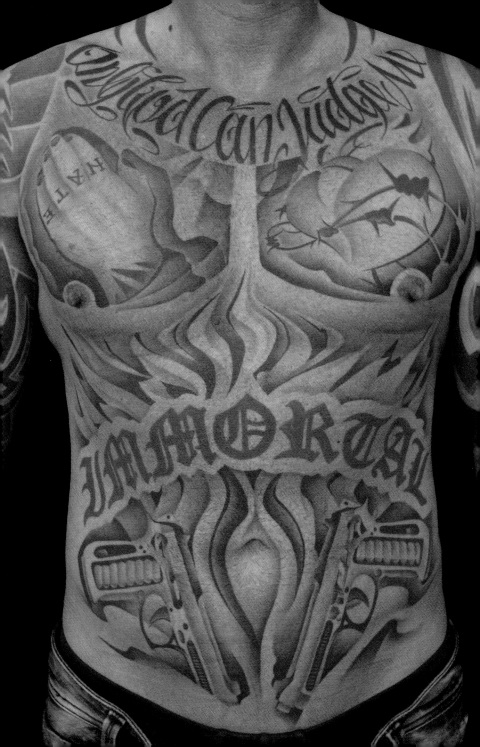

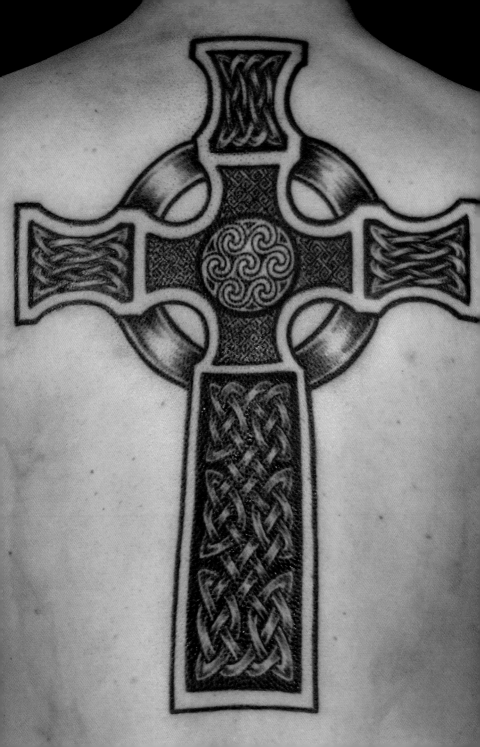

Pat Fish

Pat Fish's fascination with Pictish and Celtic art celebrates a personal bloodline that leads back to the ancient tattooed warriors of Scotland. The patterns on carved prehistoric Scottish standing stones and the illuminated manuscripts of Ireland have inspired Pat's tattoo art since 1984. At the Tattoo Santa Barbara location in southern California, and at numerous expos and conventions worldwide, Pat's unique form of tribal tattooing is enthusiastically acclaimed.

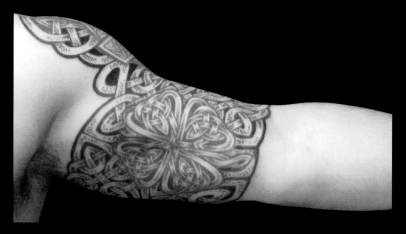

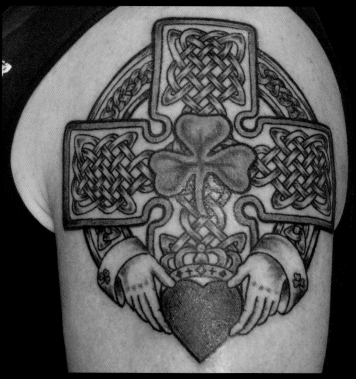

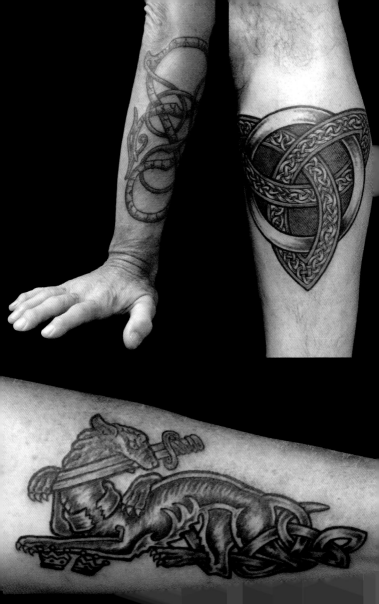

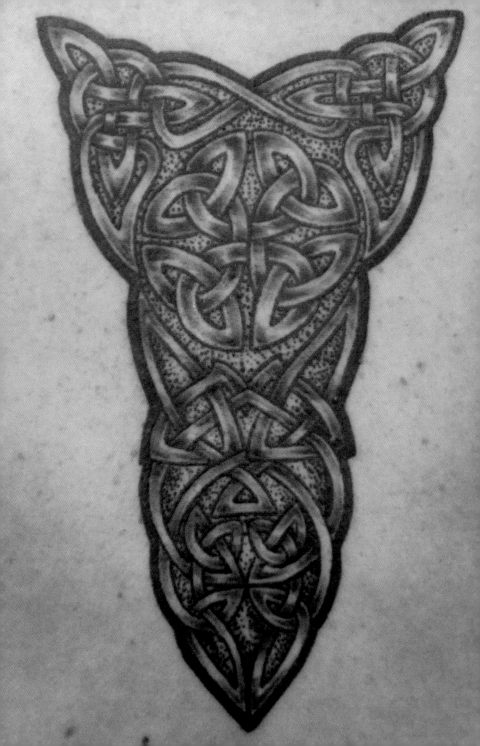

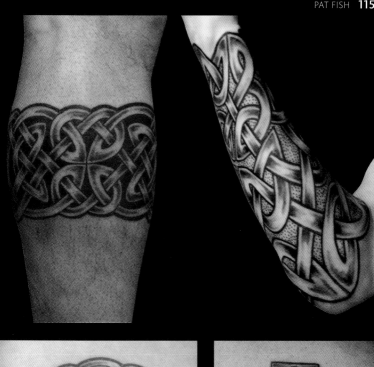

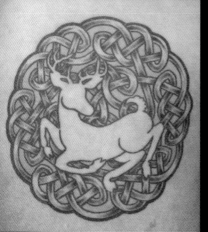

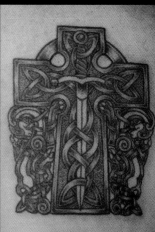

\mathcal{K}ore Flatmo

Kore Flatmo began his career as a tattooist in Hollywood in 1990. He eventually moved to Cincinnati, Ohio, and established a private custom studio there called PluraBella, tucked away in Northside. Kore's main focus is creating large format, full coverage tattoos tailored to the individual's form, but he also enjoys working in a variety of other media, including watercolour paintings, charcoal drawings and custom etchings. Most recently he has branched out into pyrography and wood engraving. Though Kore is based in the Midwest, he also works regularly in his native Los Angeles. When time permits, he works at international and domestic tattoo conventions and has done several guest spots at shops around the world.

Artist photograph © Steve Willis www.underpinphotography.com

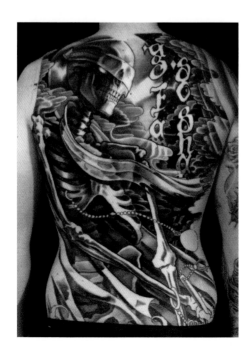

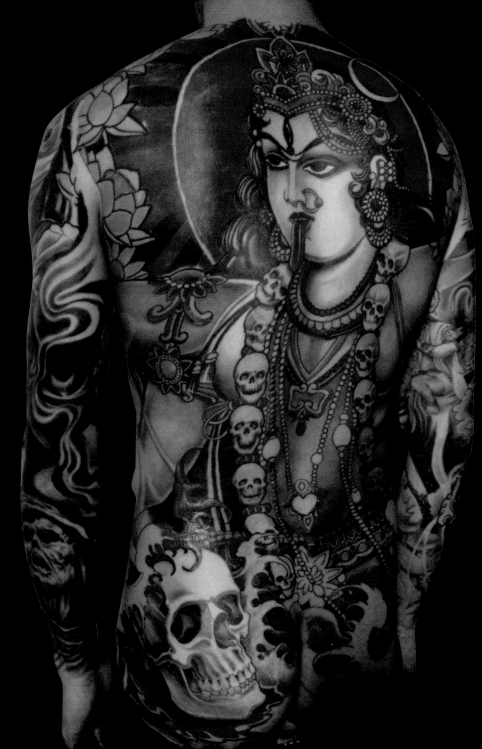

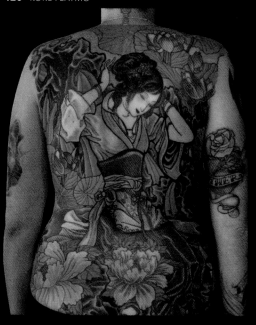
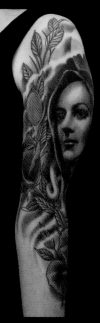
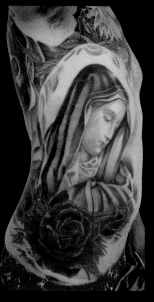
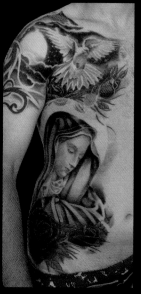
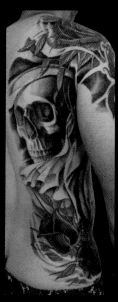

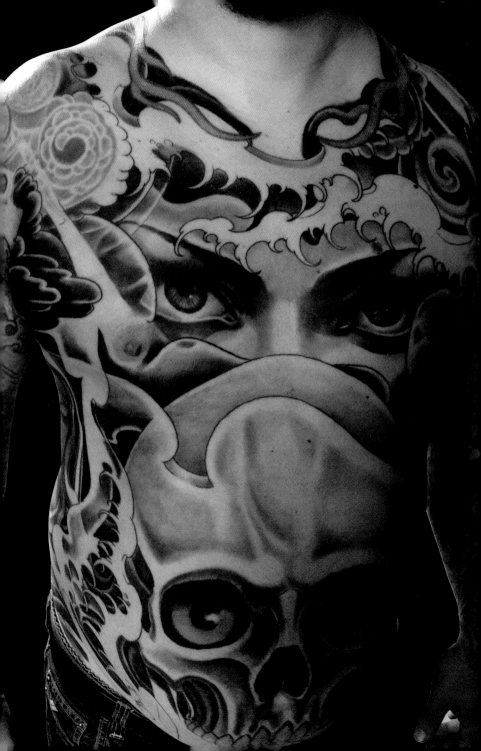

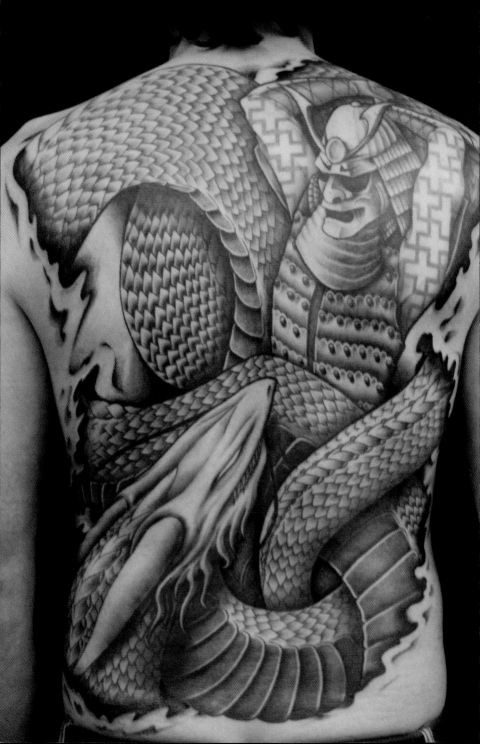

\mathcal{M}ark Gibson

Mark Gibson got his first tattoo at fifteen "in a mate's garden shed" and has since fallen in love with both the trade and the art of tattooing. He was eventually hired as a custom artist – knocking out designs in the back of a studio – which ultimately led to his apprenticeship: "a couple of years of cleaning the toilet, making tea, making needles, cleaning tubes, whilst fitting in time to tattoo and practise as much as possible". Mark started tattooing professionally in October 2007 and is now "very grateful to everyone who lets [him] abuse their skin" at Monki Do Tattoo Studio in Belper, Derbyshire.

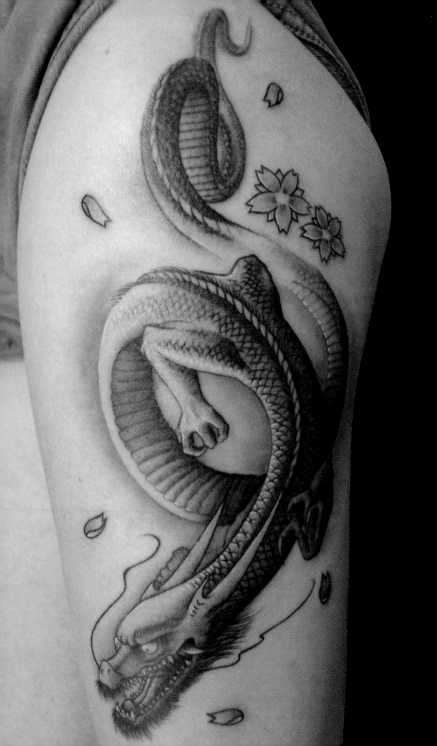

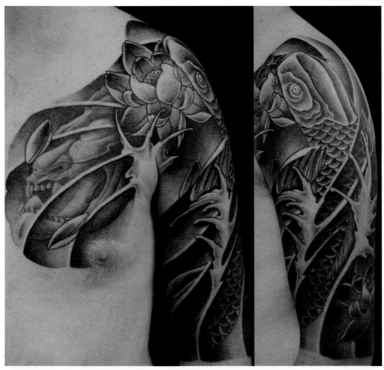

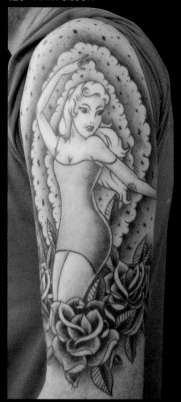

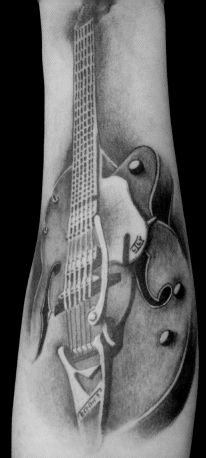

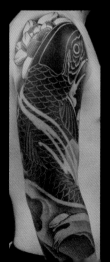

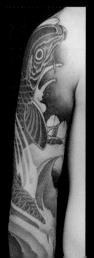

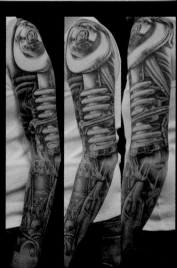

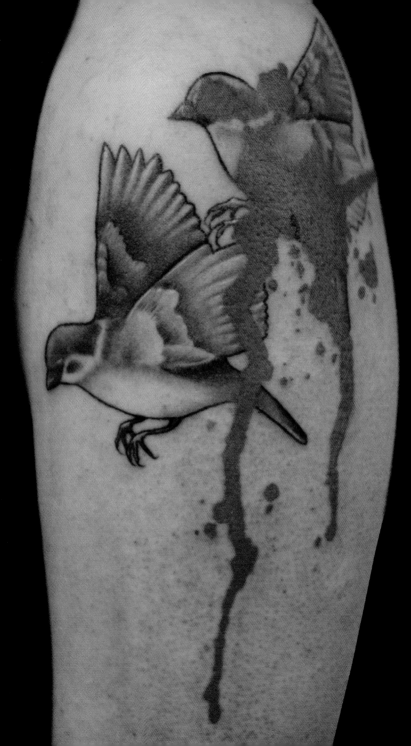

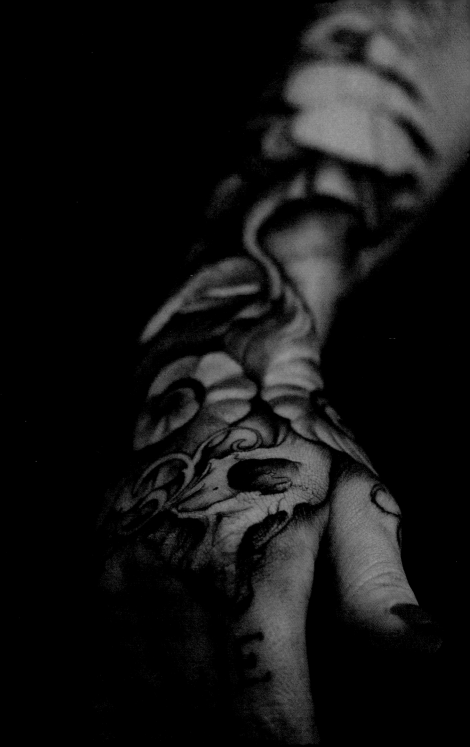

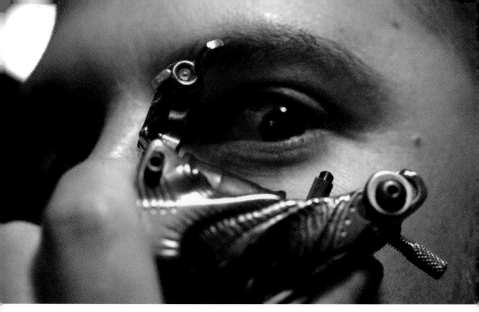

\mathscr{J}eff Gogue

Jeff Gogue began his full-time career as a tattoo artist in August 2000.
He is a self-taught artist and didn't follow the traditional apprenticeship
route. He strives for a creative and dynamic style, sometimes using
detail or a looser, more fluid style as appropriate. He is currently so
inundated with customers that he has stopped taking on any new
appointments. On his website he is now selling prints of his artwork so,
if you can't get on his waiting list, at least you can enjoy his art in
another form.

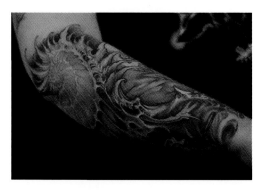

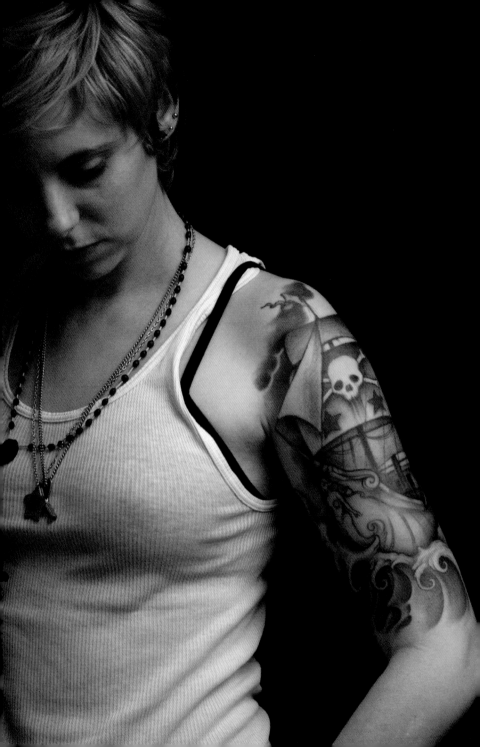

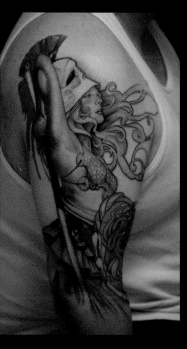

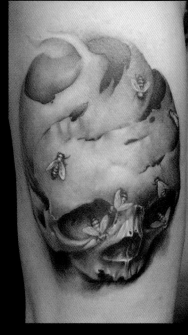

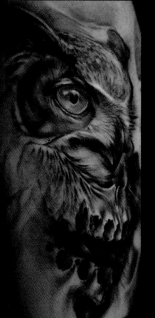

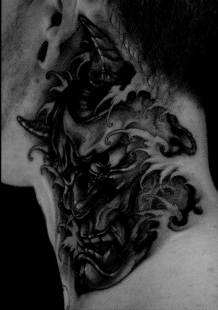

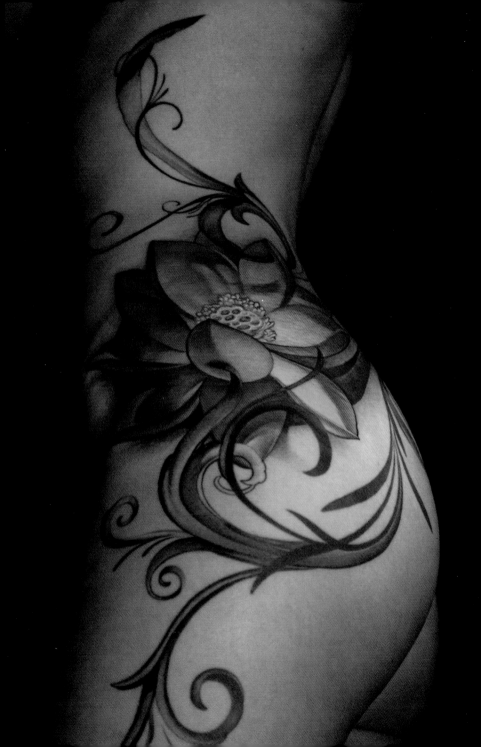

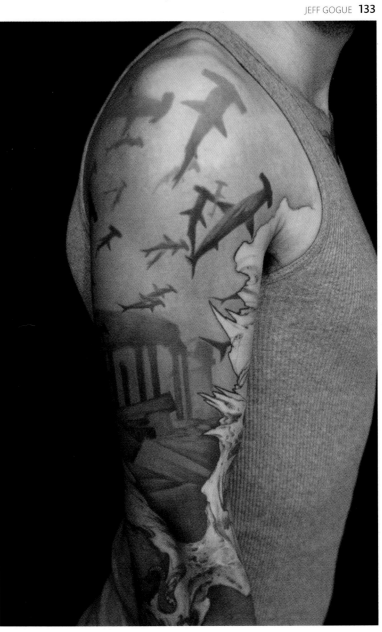

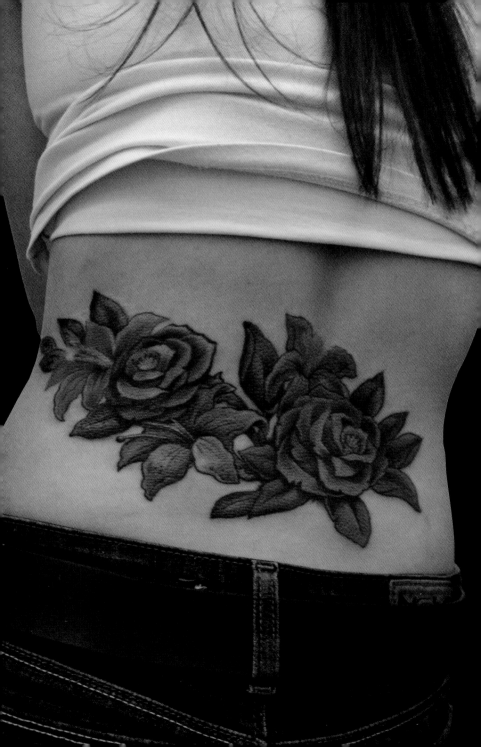

\mathcal{D}an Gold

Dan Gold was born sometime in the early 1970s and, having been given an early introduction to the world of art, began painting on canvases, walls and trains. In about 1992, after one too many brushes with the law, Dan decided that tattooing was the job for him. Dan has now been "fortunate to have been able to work with some of the world's greatest tattooists and to have attended numerous conventions" so that he still can't believe how lucky he has been. But he still worries that someone might say, "Oi, drawing robots on people isn't a real job!"

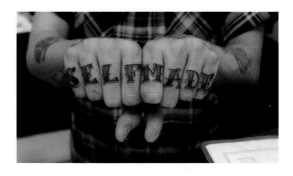

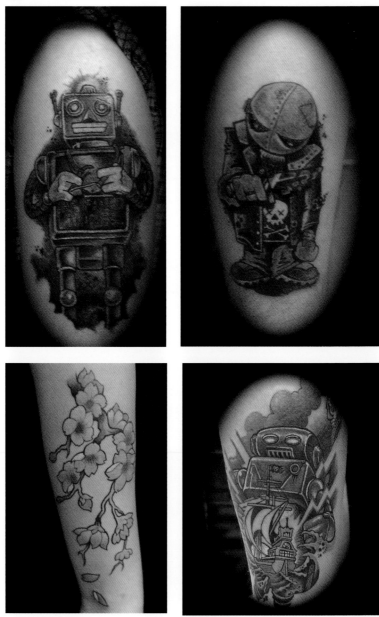

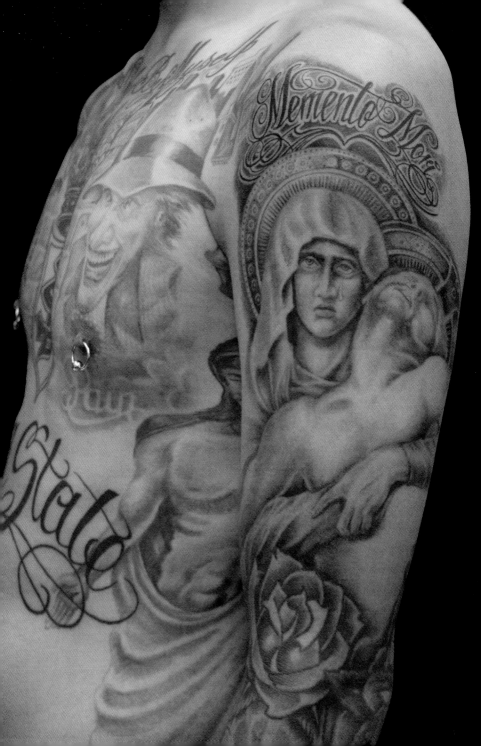

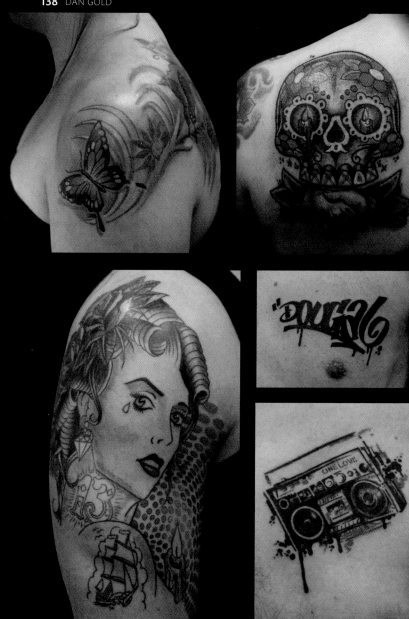

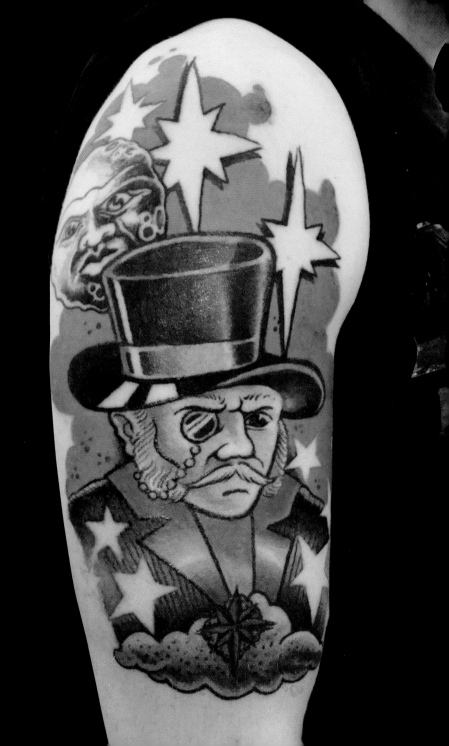

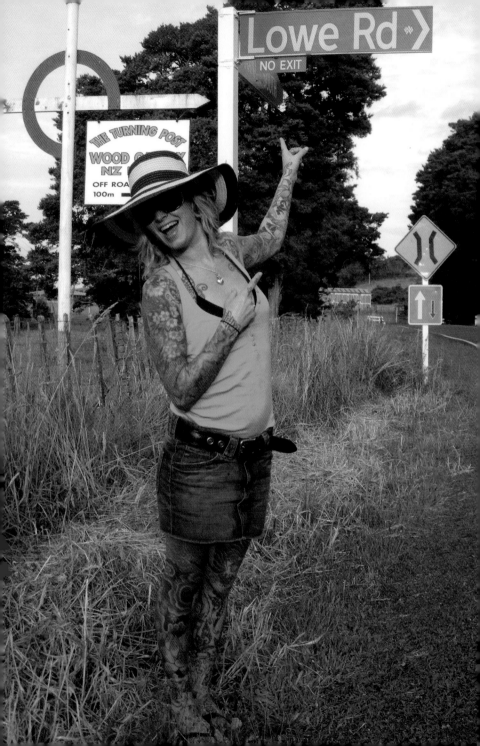

\mathcal{G}ood Times

Tucked away in the heart of London's Shoreditch is Good Times Tattoo's beautiful and spacious studio which is far removed from the average tattoo shop. Here Nikole Lowe (London Ink) has created a relaxing and friendly environment where strange curiosities adorn the walls. Some of London's top artists work here, including Nikole Lowe herself, Saira Hunjan, Piotrek Taton, Jamie Ruth, Nick Horn and Danny Kelly.

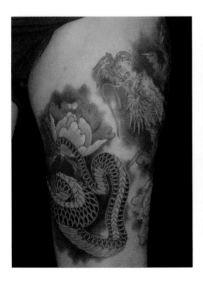 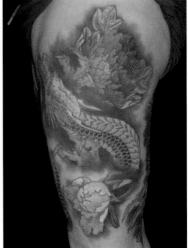

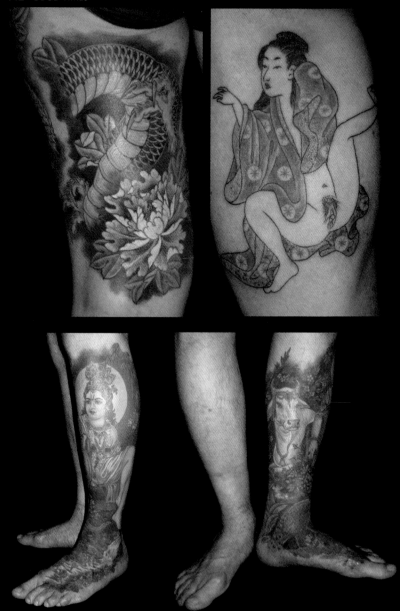

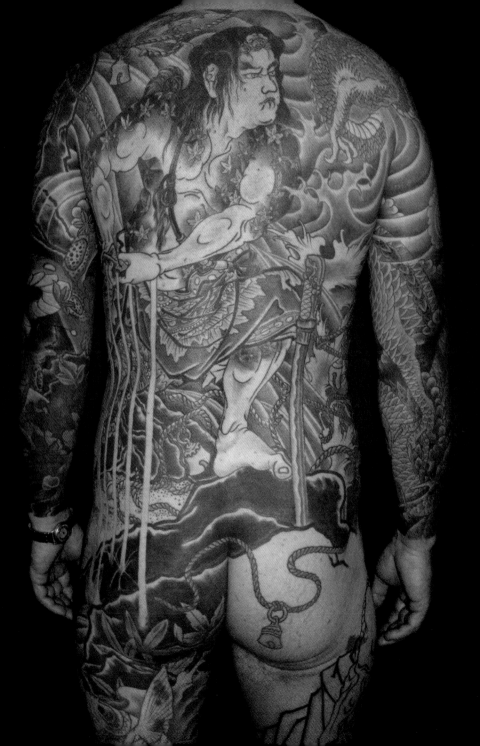

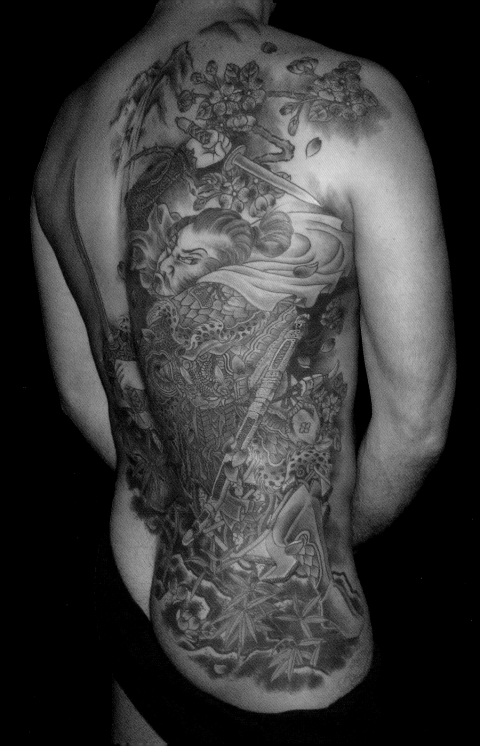

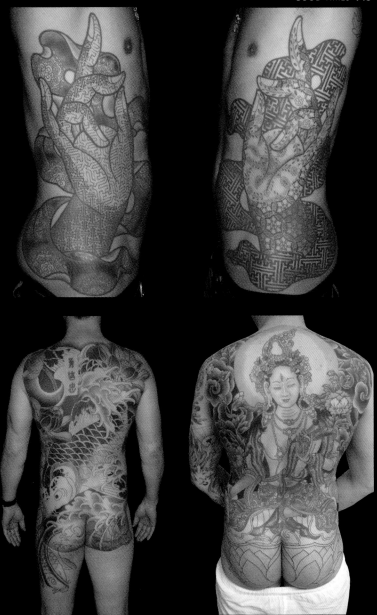

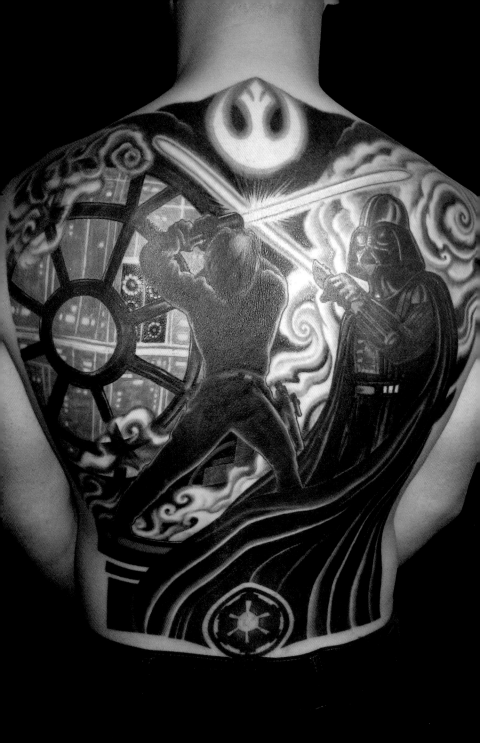

\mathcal{T}heresa Gordon-Wade

Theresa Gordon-Wade has been tattooing since 1991. She calls
Lifetime Tattoo in Derby, England, her tattoo home where she loves
to tattoo images of life such as animals, portraits, lovely ladies and
flowers as well as a softer form of Chinese/Japanese styles. Theresa
likes to tailor each tattoo to flow and fit over the contours of the
client's body and delights in both colour and monotone work.
A wife and mother, Theresa spends time with her family, friends,
cats and her horse when not drawing or working.

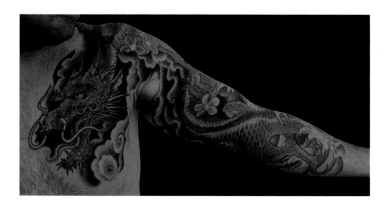

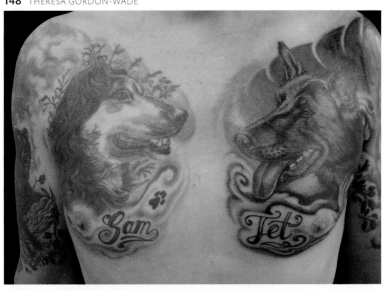

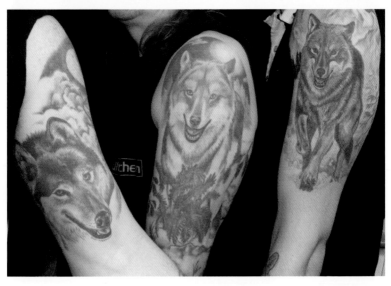

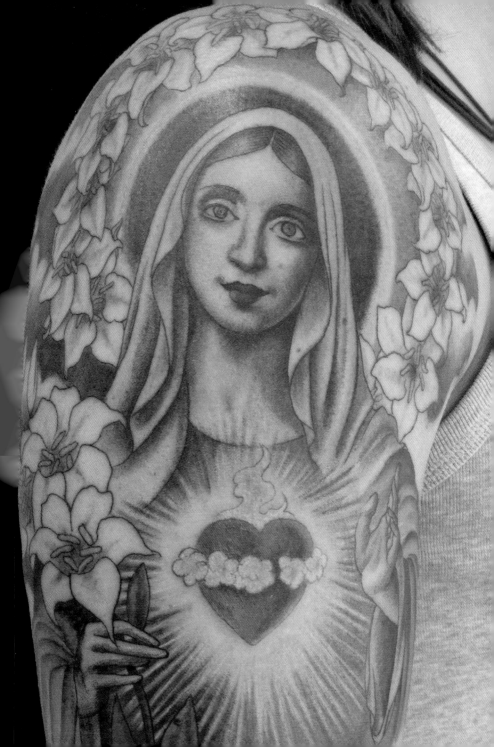

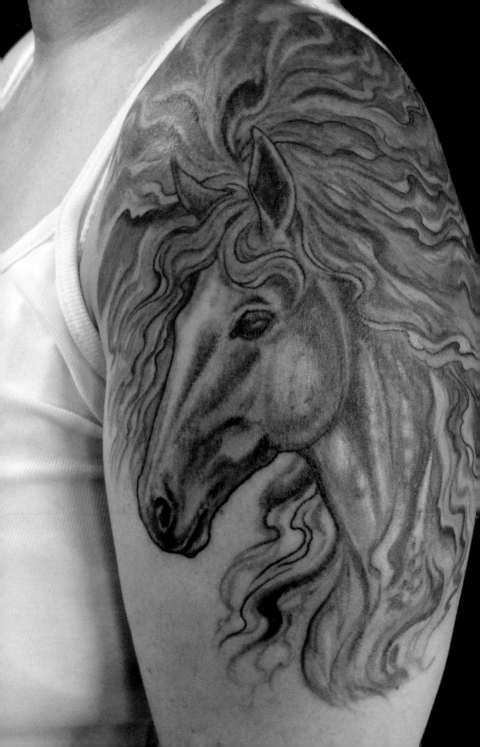

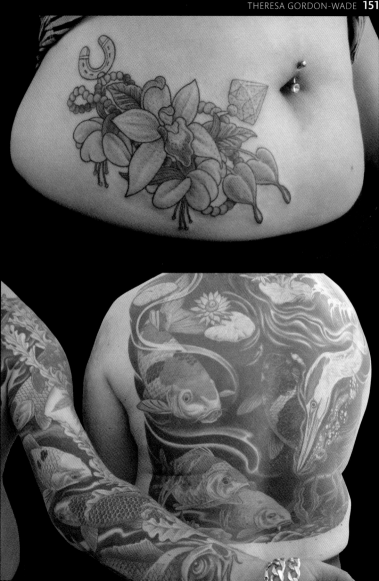

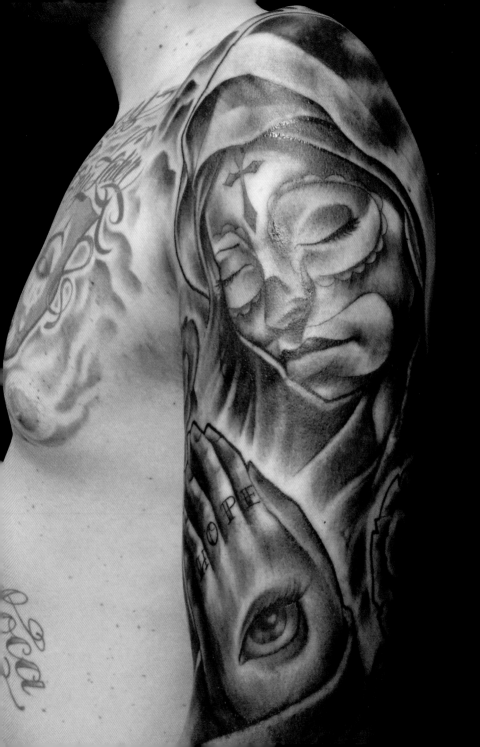

Grace Tattoo

Wayne Grace has been tattooing in London since 1998, working in a wide variety of styles, from new school to portraiture. He feels he has been extremely lucky to work with some of the world's best artists at New Wave Tattoo and is "always learning new tricks from the old timers who have taken [him] under their wings".

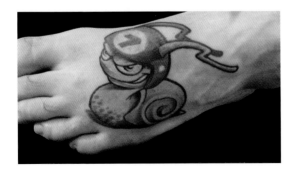

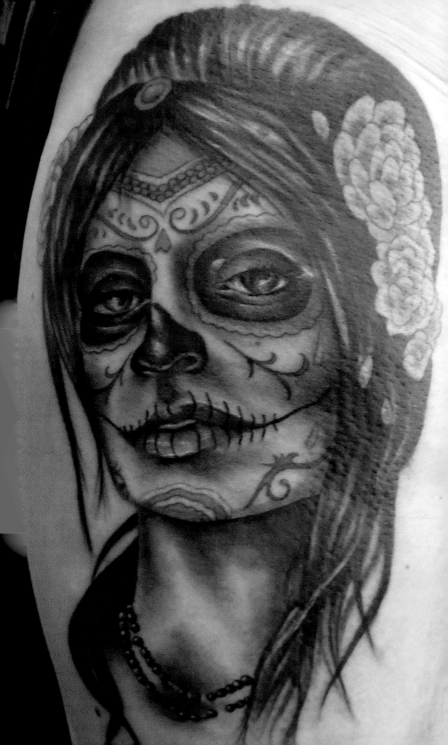

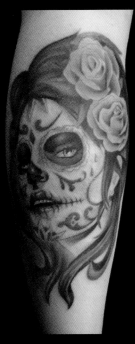

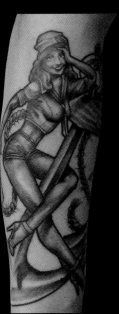

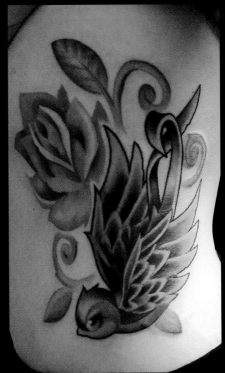

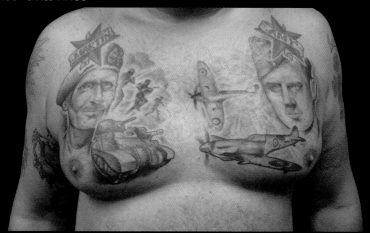

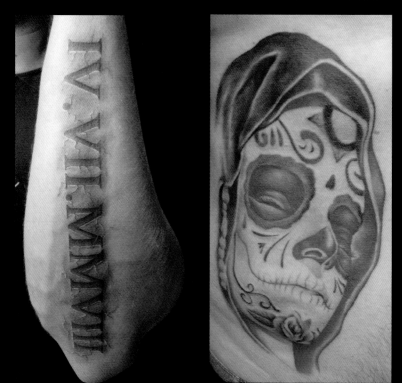

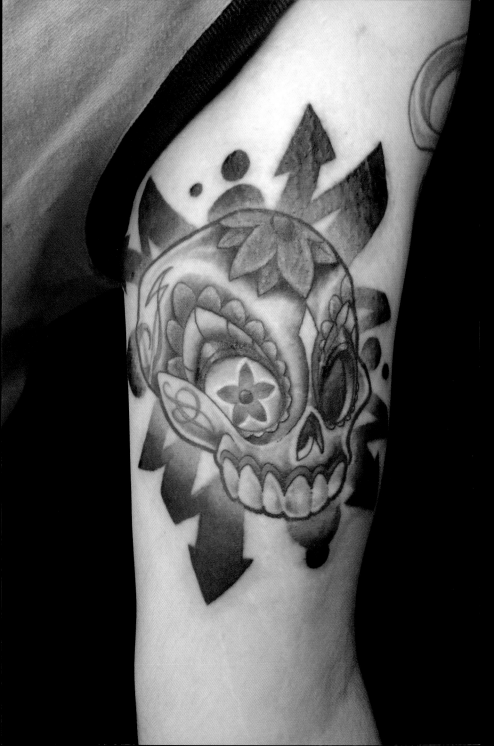

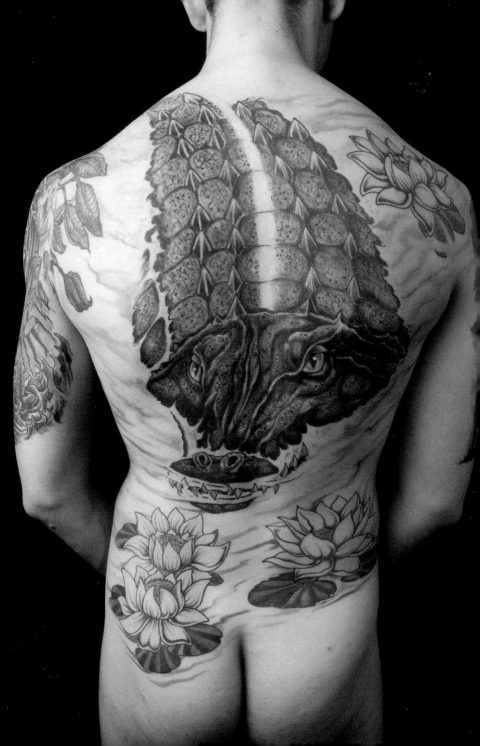

\mathcal{L}al Hardy

As a child of the late fifties, Lal Hardy was very aware of the military and naval tattoos commonly found on ex-servicemen. He says, "Ettle's, a little newsagent at the top of my road, sold lick and stick old naval type tattoo transfers that, once applied, looked inky and blurry, but as a kid they were great." Later, when the seventies Teddy boy revival took place in the UK, the tattoos on display at various music venues reignited his interest. On 8 February 1976 he got his first tattoo from an artist called Dave Cash, in a little studio in north London. Within three years he was tattooing, "first in my kitchen!", then in the studio he has now operated for over thirty years. In that time he has met and tattooed thousands of people from all walks of life, "ranging from murderers to millionaires".

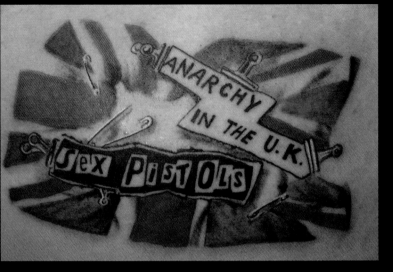

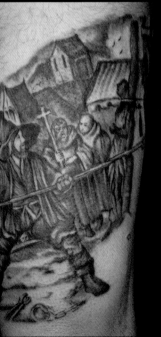

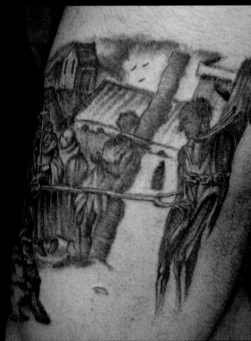

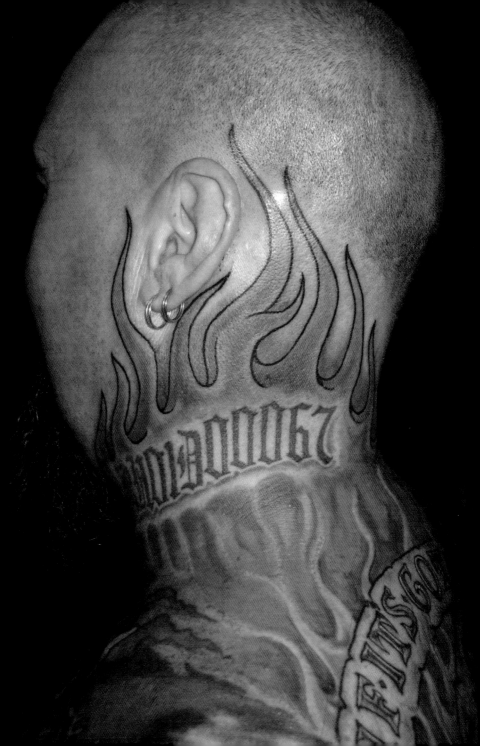

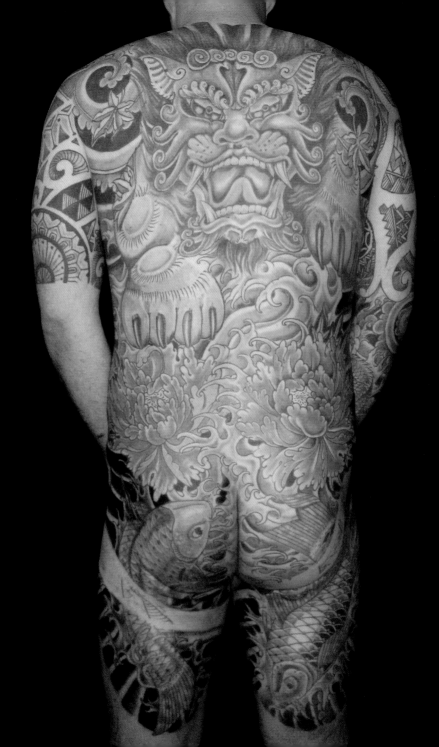

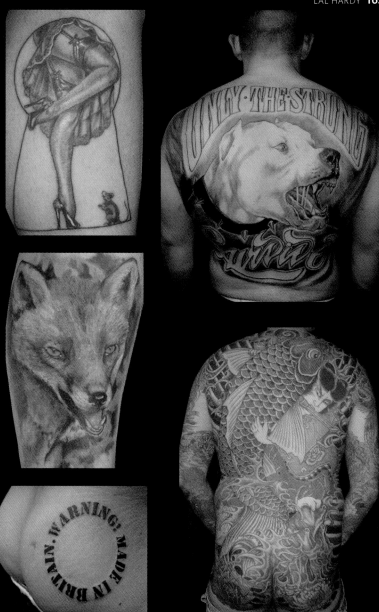

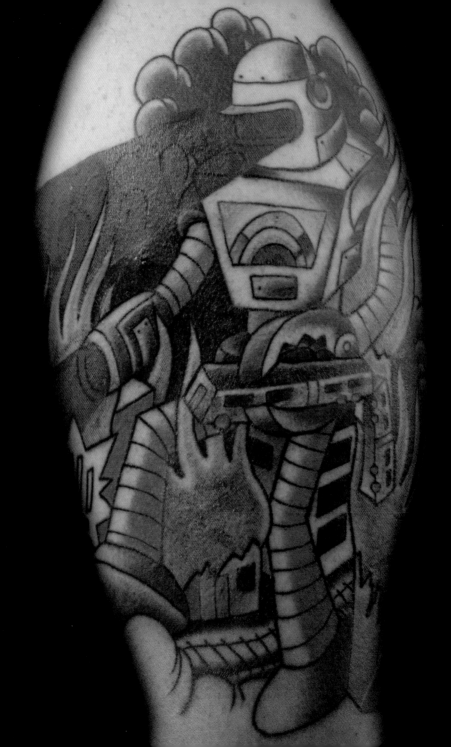

\mathscr{J}ed Harwood

Jed Harwood has been tattooing since 2005 and works at Blue Dragon Tattoo, "I try to consider how my tattoos will look in thirty years' time. They will be on there for a while so I want to insure them against the passage of time as best I can. I favour styles of tattooing that are boldly coloured with heavy black and line-work. All too often what people describe as a 'style' is merely a slavish adherence to one stylistic idiom. I believe that the notion of a style is being able to take on any subject matter and make it recognizably mine and I try to apply this to every tattoo." In addition to tattooing, Jed spends his time skating, playing guitar in the Plague Sermon, drinking and buying records he doesn't get time to play.

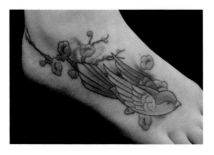

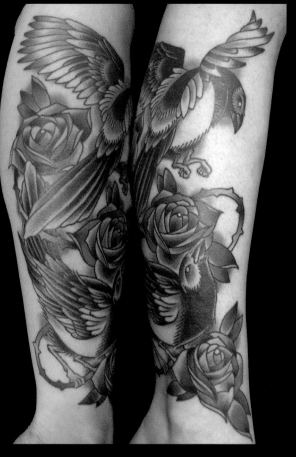

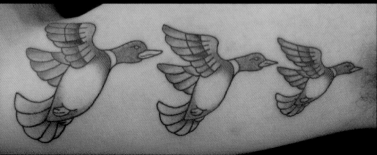

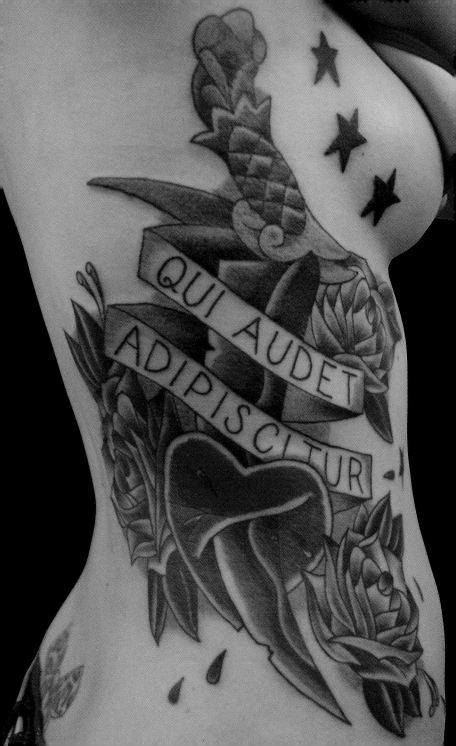

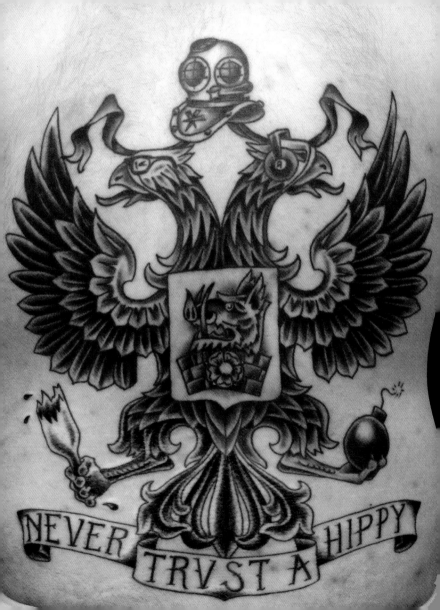

NEVER TRVST A HIPPY

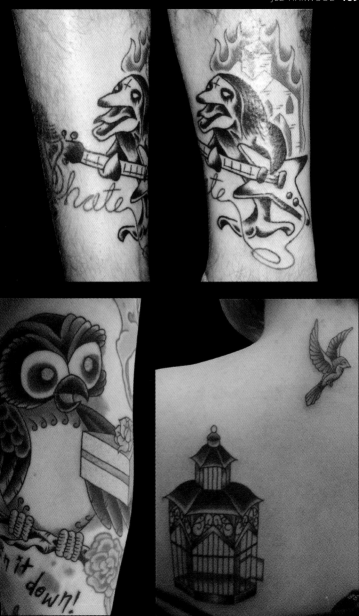

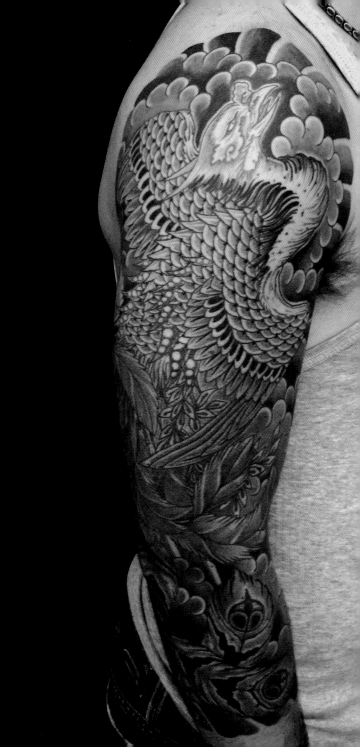

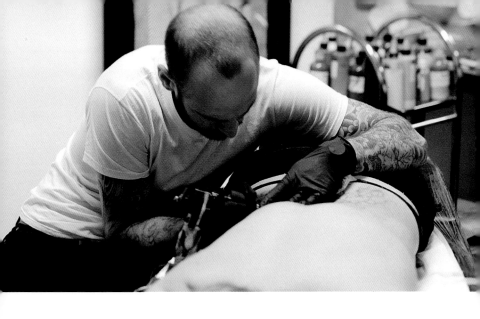

\mathscr{A}aron Hewitt

Aaron Hewitt, born in 1981 in Barking, Essex, started tattooing in 2000. In recent years he has been concentrating mainly on traditional Japanese style tattoos. He works out of his studio, Cult Classic Tattoo, in Romford, Essex.

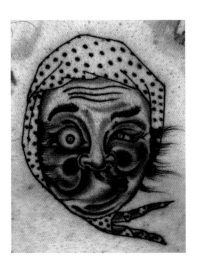

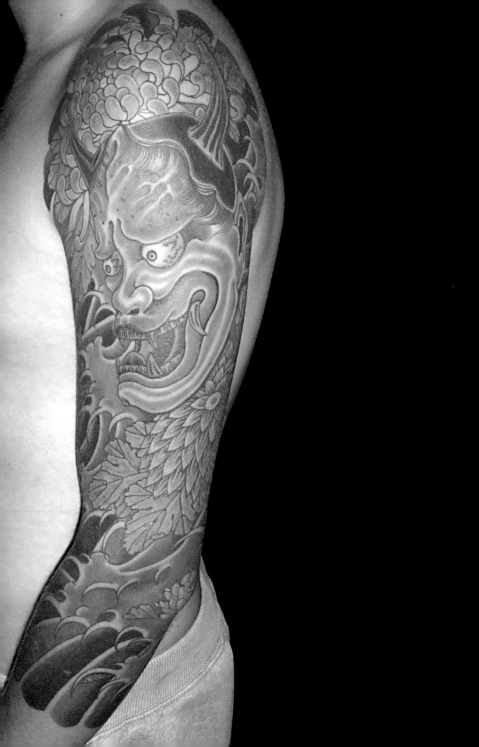

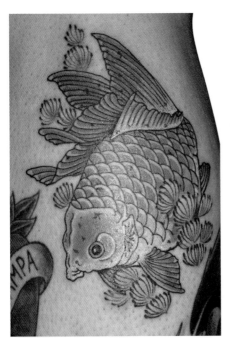

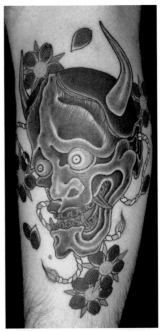

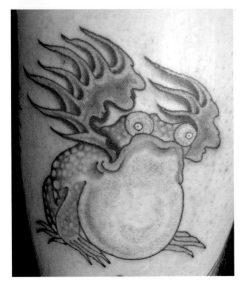

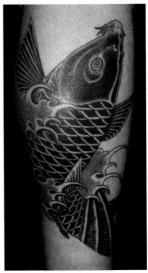

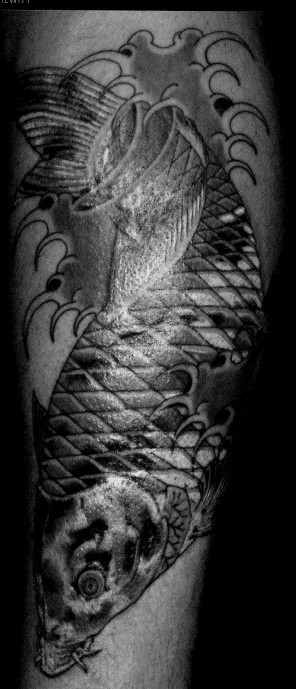

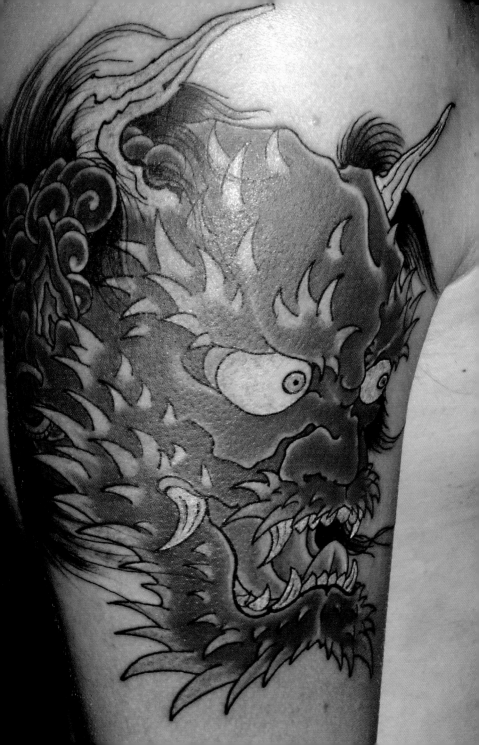

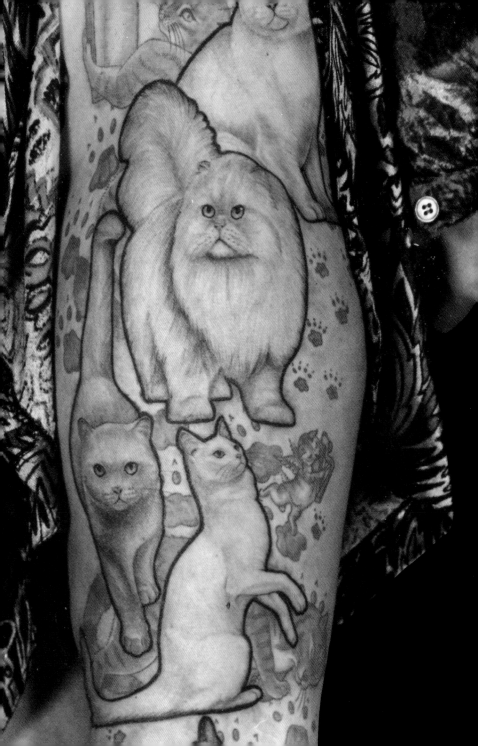

\mathcal{G}raham Hodgson

Graham Hodgson was born in Plumstead, south-east London, in 1966. He has been tattooing for over twenty years and has moved studios from place to place across the London Borough of Bexley. He has finally settled at 7 Star Tattoo in Bexleyheath. His future ambitions are for Charlton Athletic to win promotion in the English football league, Glasgow Rangers to win the Scottish football league, England to win the World Cup . . . and to knock out a few decent tattoos.

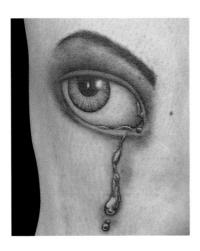

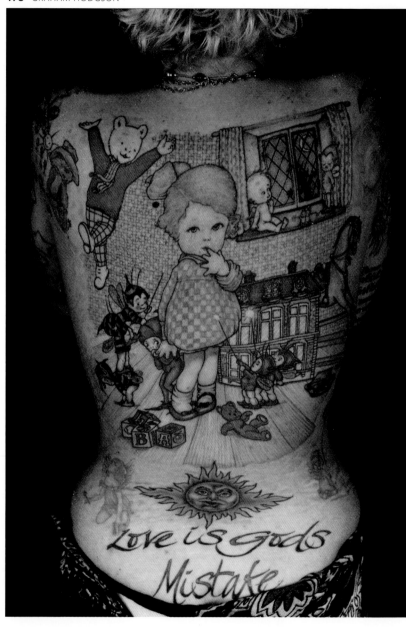

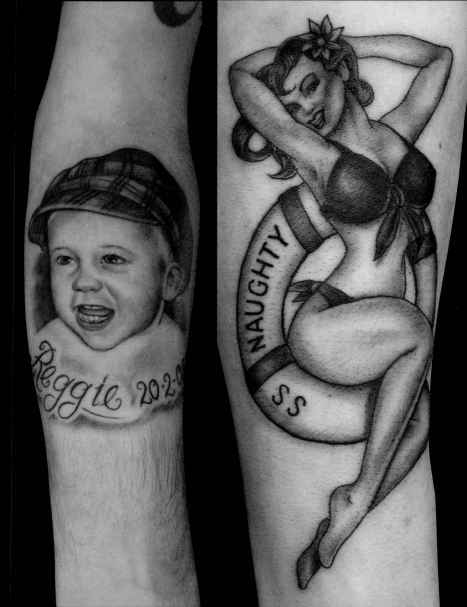

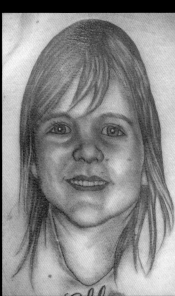

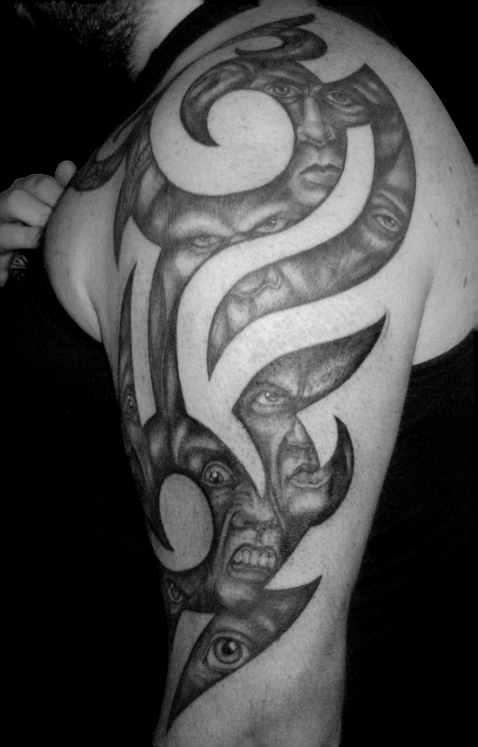

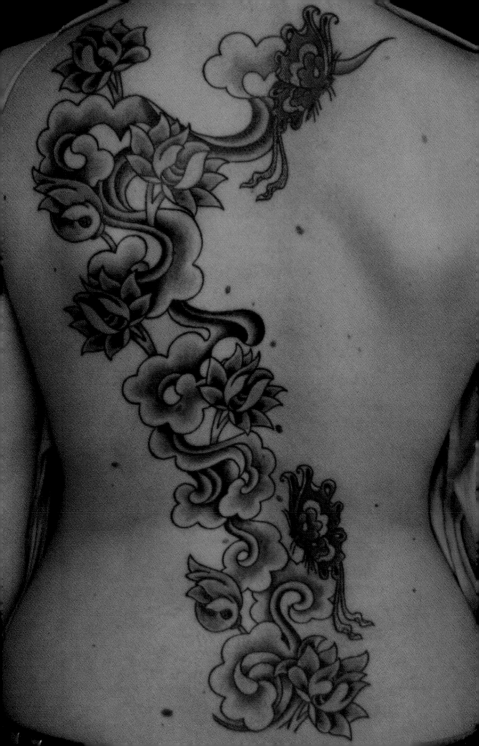

 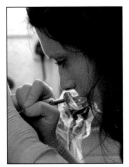

Yan Spencer *Alexis Camburn* *Lester Munns*

\mathscr{H}oly Cow

Off the beaten track in a regal retirement town with punky bohemian locals. Up an old fire escape with views of rooftops all around and every kind of good music drowning out the sound of seagulls, we let our imaginations run like a bull in a retro emporium.

Yan Spencer "I was lucky enough to have been trained by Jim MacAirt, whose bright and airy shop I took over a few years ago. When dreams come true, you don't complain. I'm glad to have made so many friends along the way."

Alexis Camburn "I was born in 1983, and grew up in Hastings, on the south coast of England. I have a great passion for ornamental/florid design, but also enjoy Japanese and detailed design. It's great to have found something I enjoy so much and to come home happy after a day at work, unlike most people."

Lester Munns *x* – The spirits increase, vigour grows through a wound.

"Rooted in Borneo. Catholic heart. Buddhist mind. Cut teeth ten years at Temple Tatu. Now losing them one by one at Holy Cow."

Artist photographs © Graeme Harris

Tattoo on facing page by Alexis Camburn

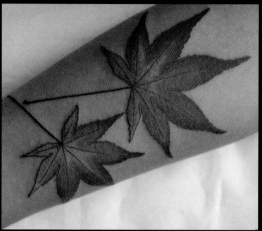

Alexis Camburn

Alexis Camburn

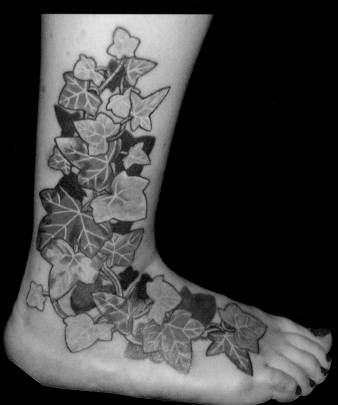

Alexis Camburn

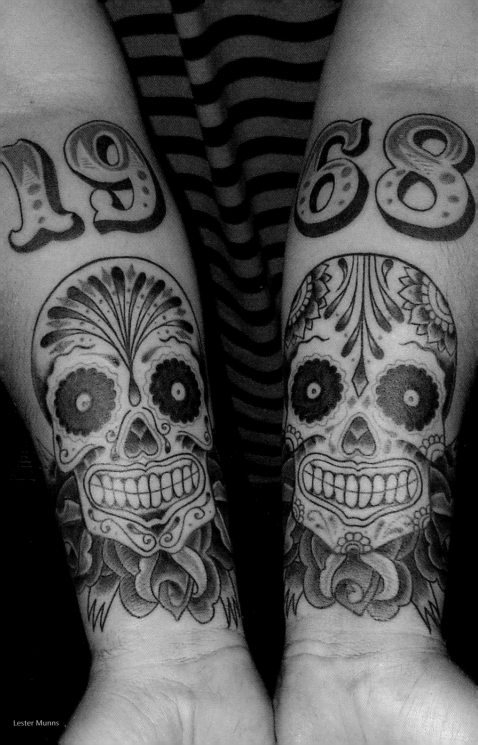

Lester Munns

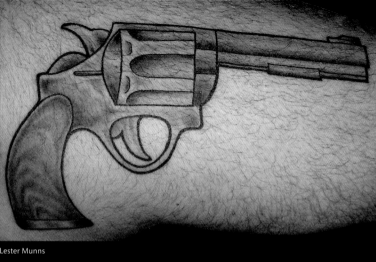

Lester Munns

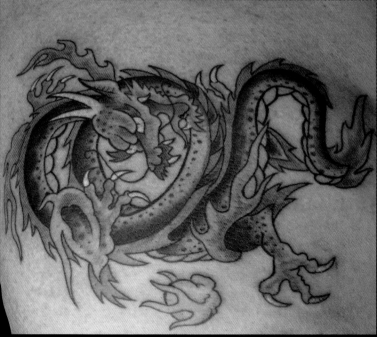

Lester Munns

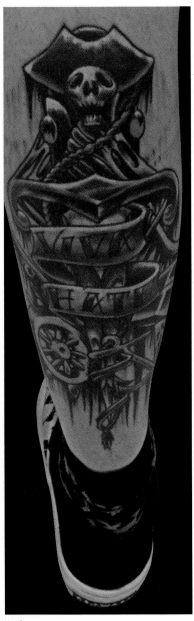

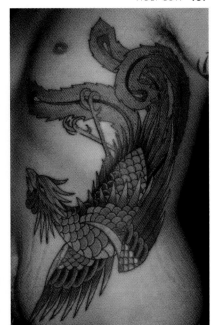

Yan Spencer

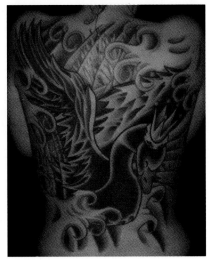

Yan Spencer

Yan Spencer

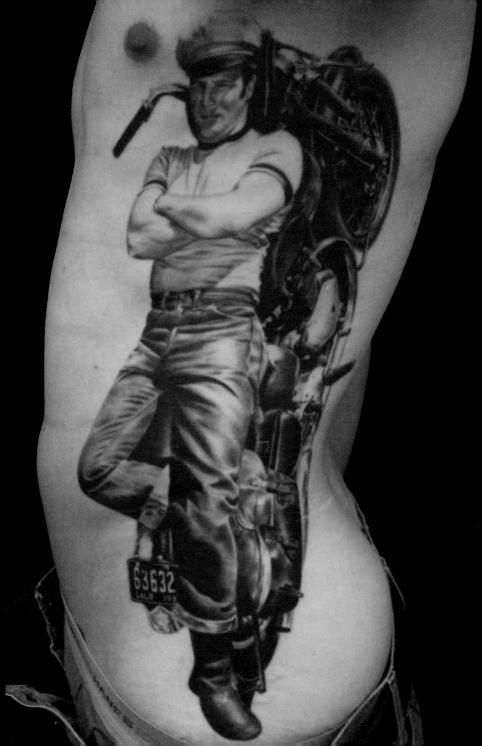

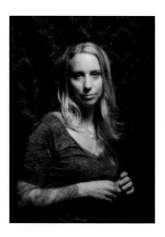

Megan Hoogland

With over fifteen years' experience, Megan Hoogland is one of the top female tattoo artists in the United States, working at countless conventions and being featured in numerous magazines worldwide. As a master in both colour and black-and-grey tattooing, she specializes in portrait and reproduction work, bringing her own style to each piece she works on.

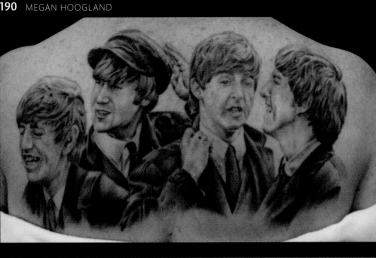

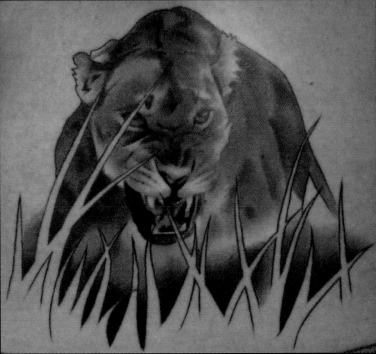

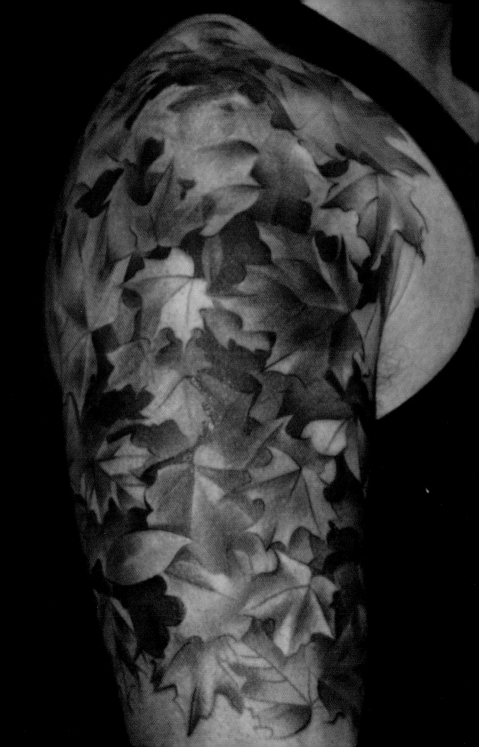

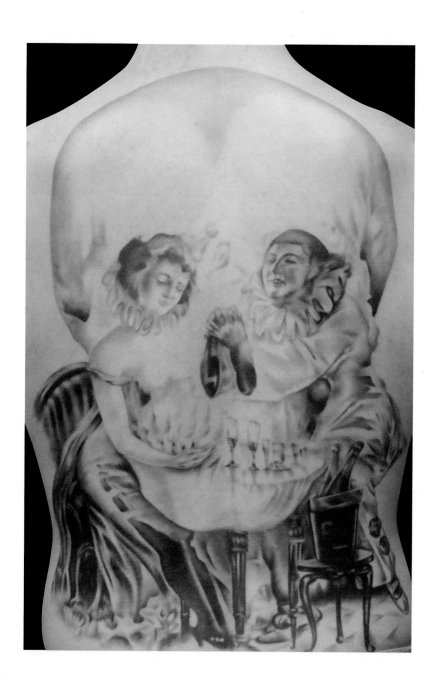

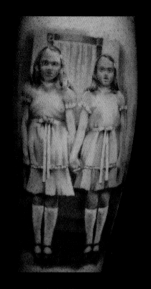

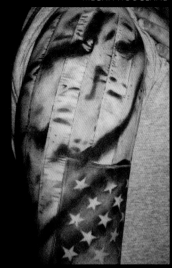

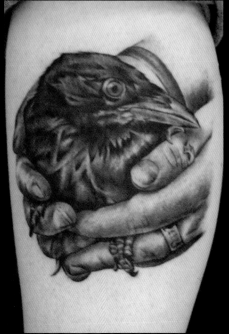

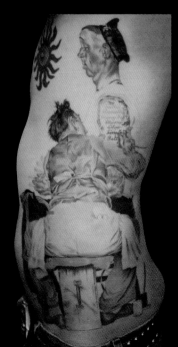

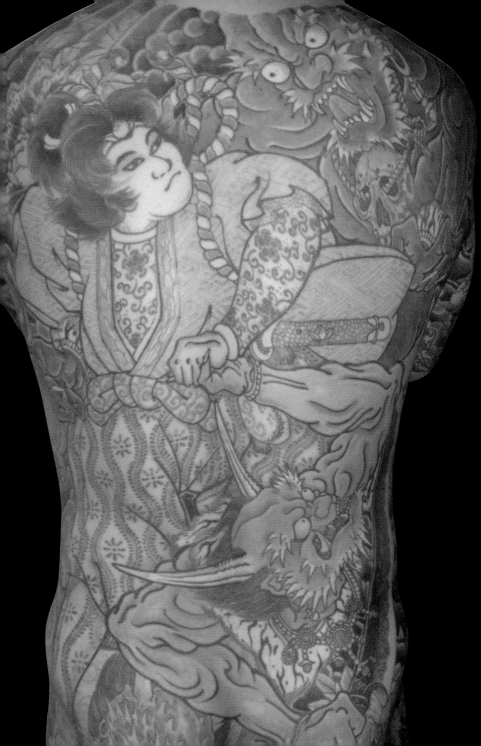

\mathcal{H}oriyoshi III

Born in 1946, Horiyoshi III of Yokohama City, Japan, began tattooing forty-three years ago. A legend in his trade of traditional Japanese Irezumi artists, he strongly believes in the continuation of the Japanese spirit or kokoro in all its facets and varieties. His son and heir Kazuyoshi-san will continue the family tradition. Lately Horiyoshi III has concentrated on Sumi ink calligraphy paintings which he combines with Irezumi images. He mostly draws his new ideas during the five-hour dialysis sessions he undergoes three times a week. Among many other diverse projects, he maintains the Horiyoshi III Tattoo Museum in Yokohama, which celebrated its tenth anniversary in 2009 and is run by his wife. His life motto is: "In this ever-changing, floating world one needs to be flexible in mind, and keeping it simple is absolutely best."

Artist photograph © Alex Reinke

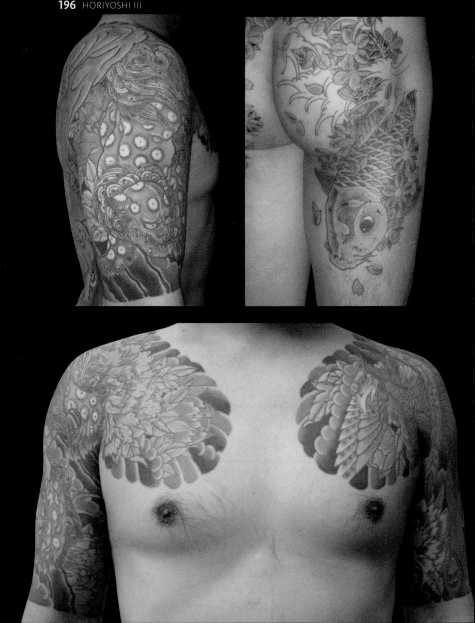

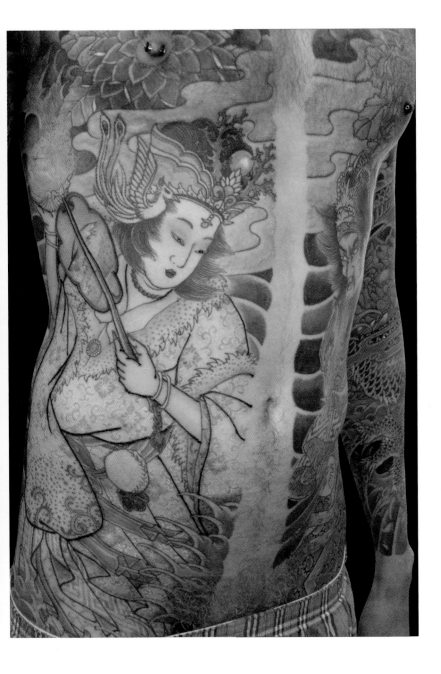

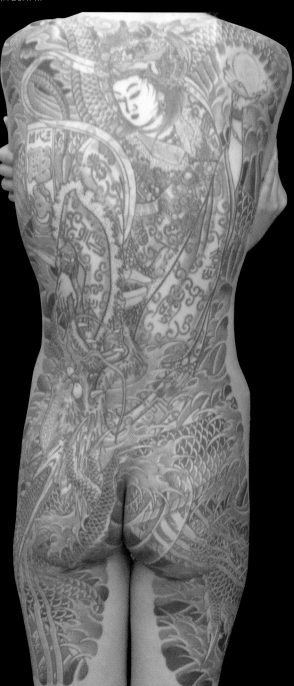

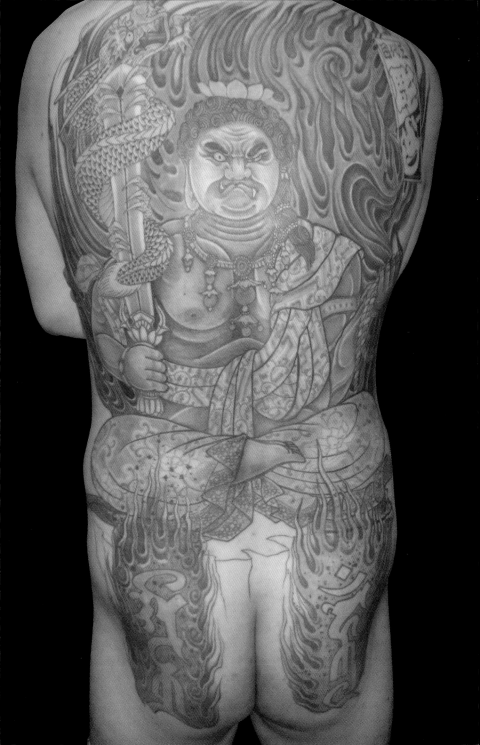

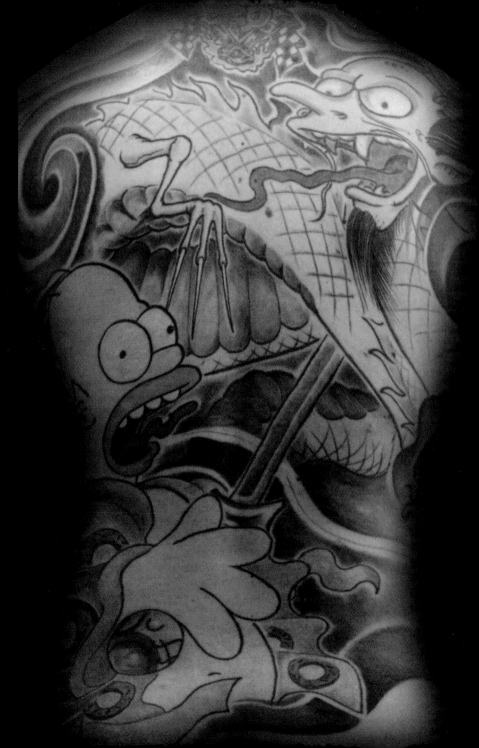

\mathscr{R}ob Hoskins

Basically a self-taught artist, Rob has been tattooing since January 2000. While based primarily in England, Rob has travelled the world, doing regular guest spots and conventions in every continent. He won his first award after ten months of tattooing and has continued to win many others worldwide since then. Now, however, Rob has established his own studio, Third Eye Dermagraphics, in Cheltenham, England, where he specializes in unique customized tattoos.

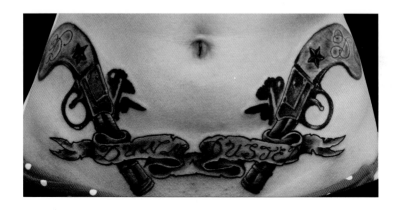

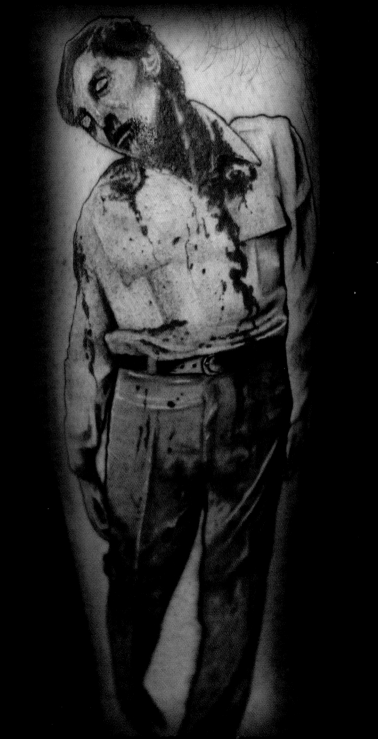

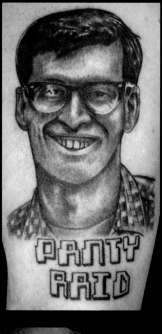

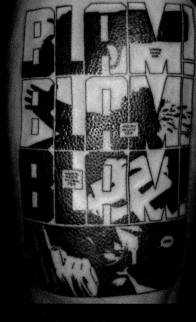

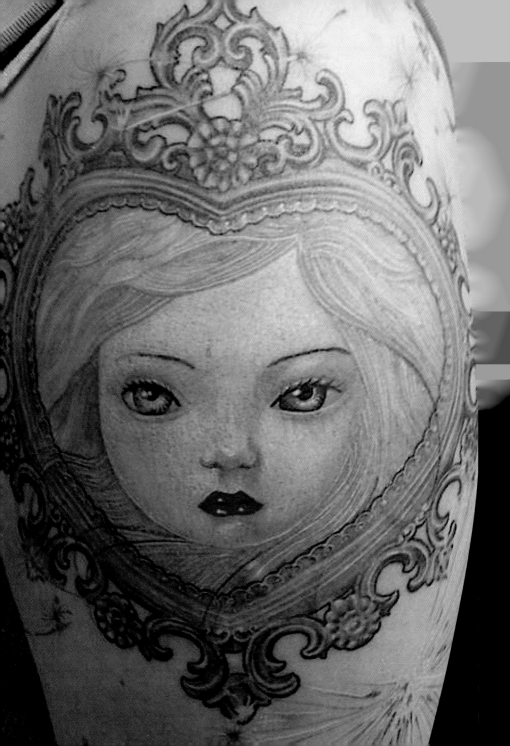

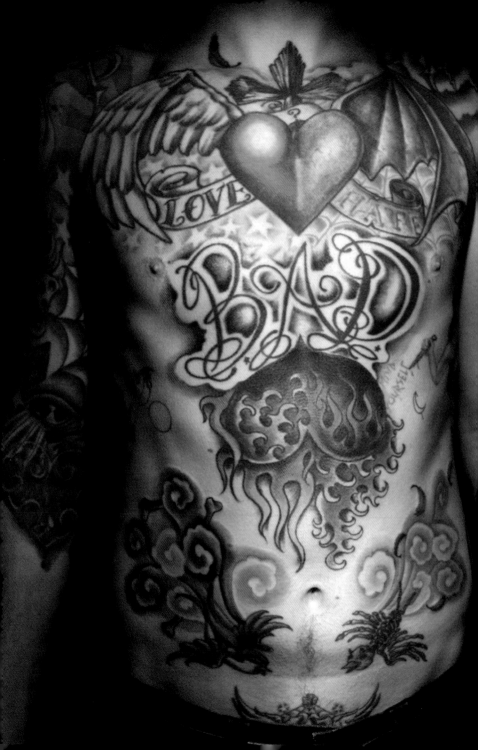

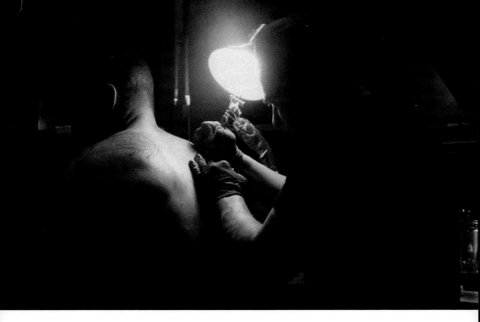

\mathcal{O}bie Hughes

At the age of six, Obie Hughes discovered his interest in art. Throughout his southern California schooldays he often defaced his folders or doodled the logos of his favourite bands on notebooks. Obie had his first tattoo at eighteen and thereafter his ideas for tattoo art began to consume his time. Fortunately for him, several friends and family members were willing to sacrifice their skin while he put some of his ideas into practice. His artistic ability was eventually brought to the attention of Corey Miller, and Obie began work at Corey's new studio, Six Feet Under, in Upland, California. For the next ten years Obie and Corey worked together, then Obie decided to venture out on his own and in July 2004 he established Speak Easy Tattoo Parlor. "Art and music . . . imagine life without them."

Studio photographs © Charlotte Hoffman

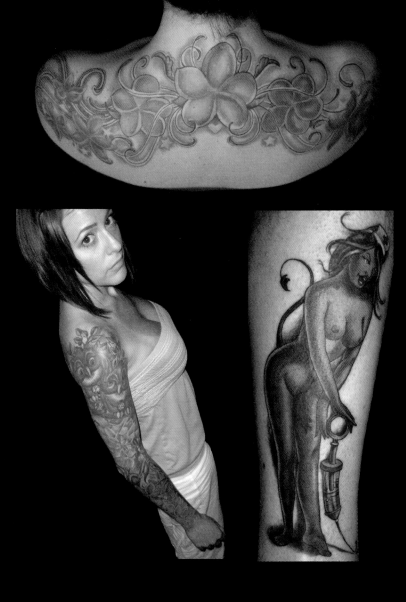

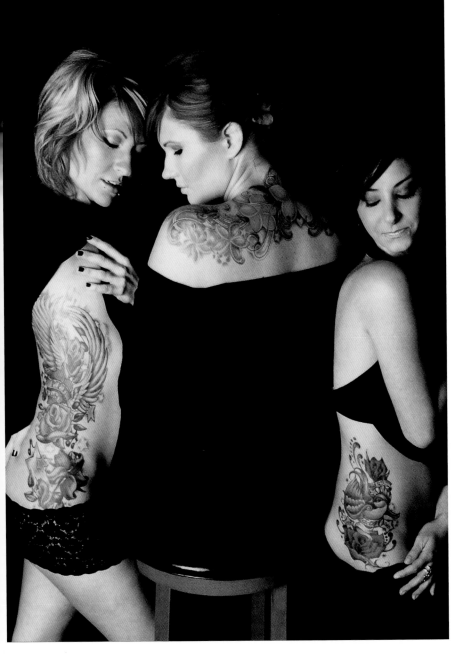

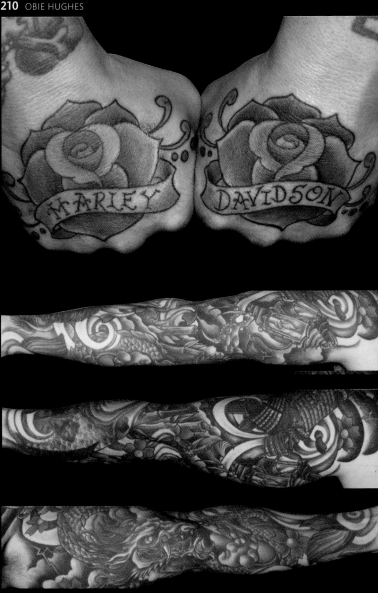

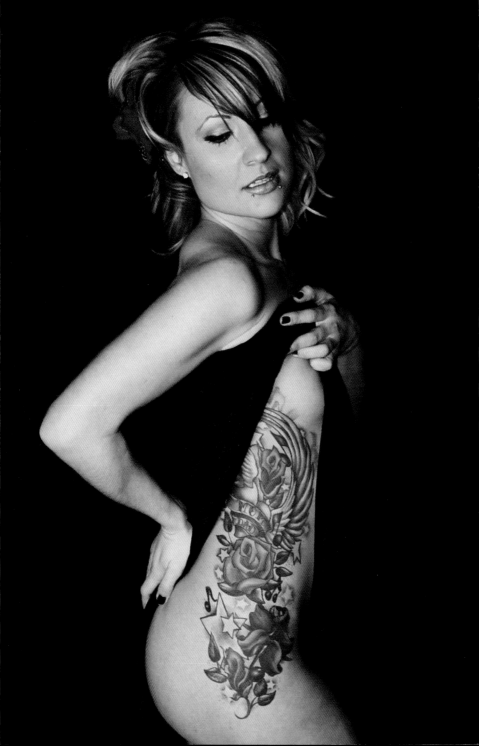

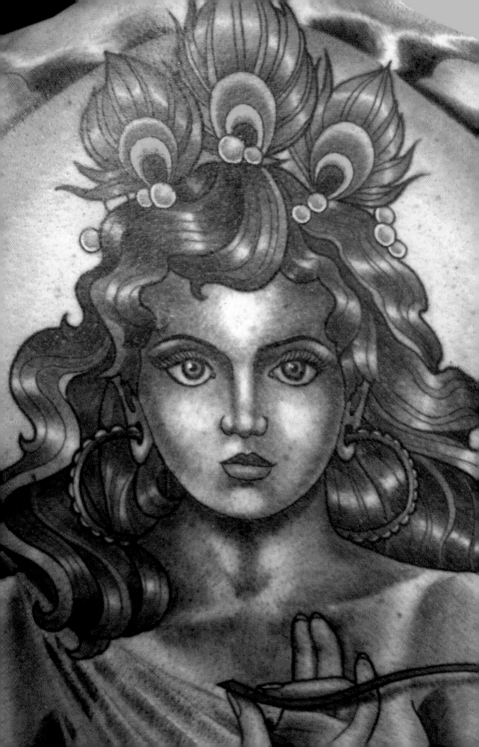

\mathscr{I}nma

Inma was first introduced to tattooing at the age of sixteen on a visit to London. She decided to stay in the city and has been learning and improving her craft ever since. She frequently travels the world, doing guest spots and conventions. She thanks all the artists she's had the opportunity to work and learn with as well as her trusting customers.

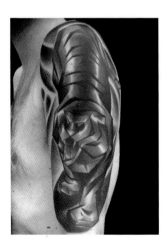

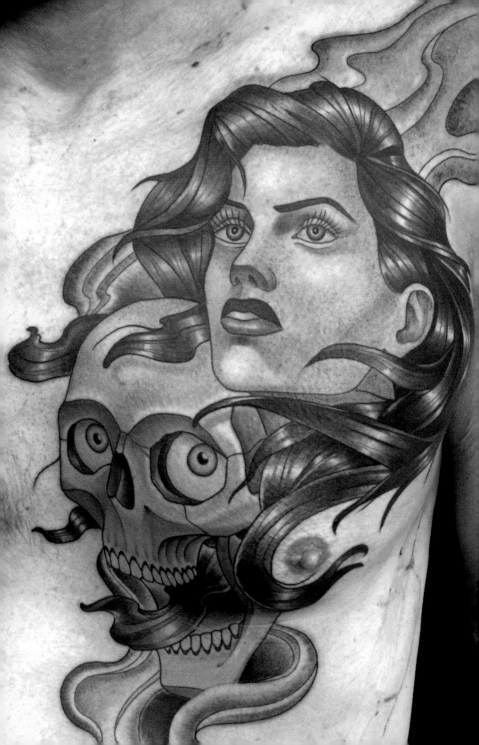

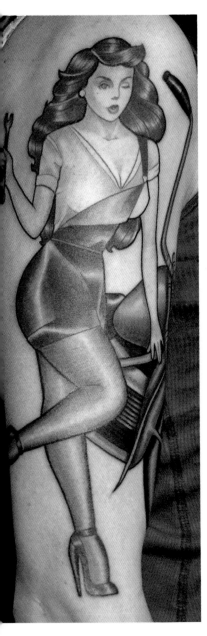
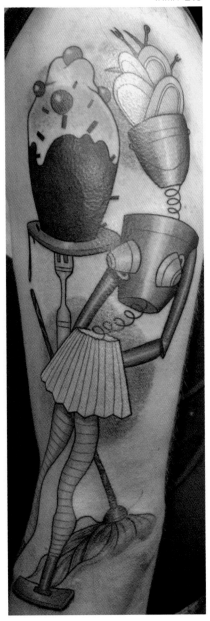

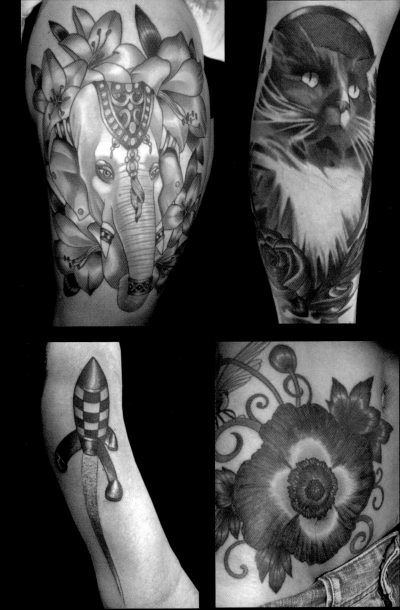

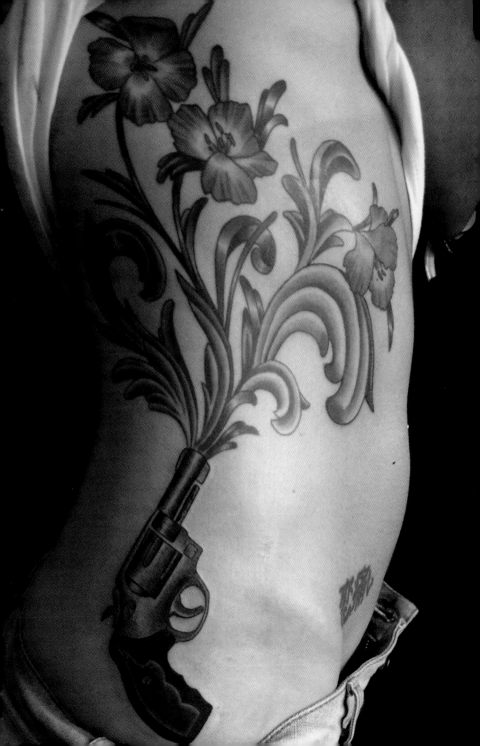

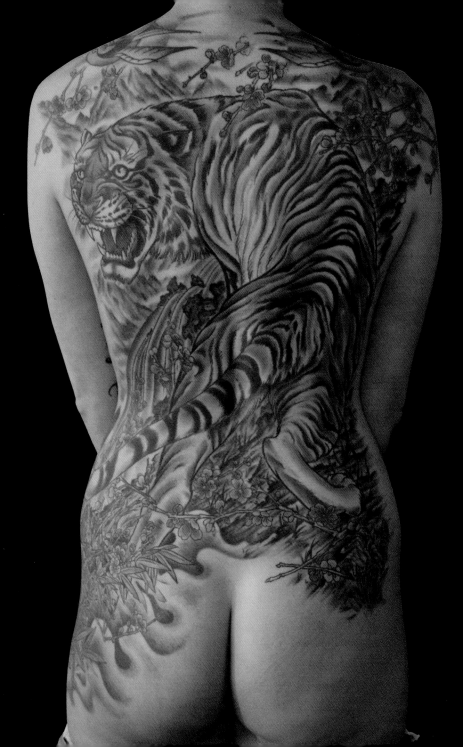

\mathcal{S}ean Jackson

Sean Jackson has been tattooing for around thirteen years now, spending the last six at Tattoo Magic. He says he's "got the usual story: always loved art and drawing, only went to school when it was art class, discovered tattoos, blah blah, you know the rest!" What Sean loves is taking his clients' vaguest ideas, making them into a tattoo and seeing their smile afterwards. He would like to thank everyone he's met over the years – especially the crew at Tattoo Magic – for all their help and advice. He adds "a huge thanks to all my fantastic clients for trusting me with their skin and sharing their time with me!"

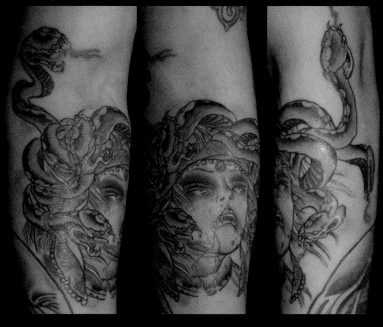

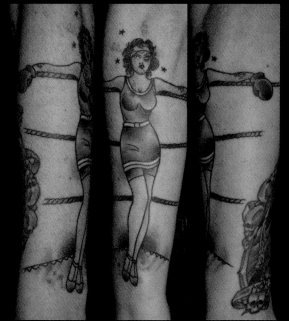

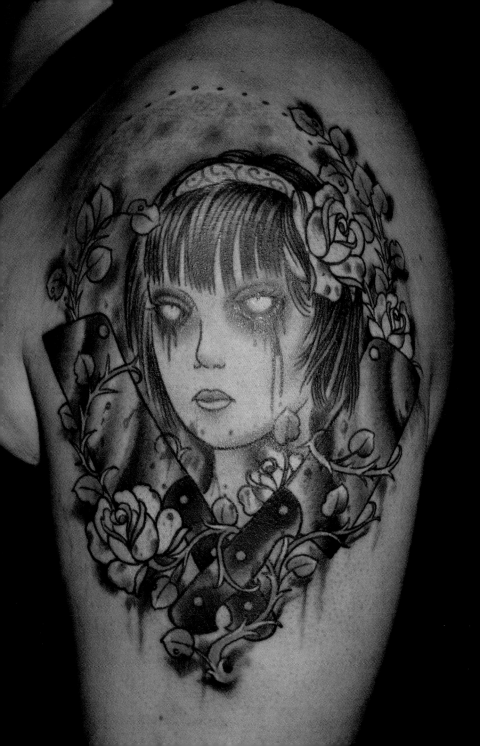

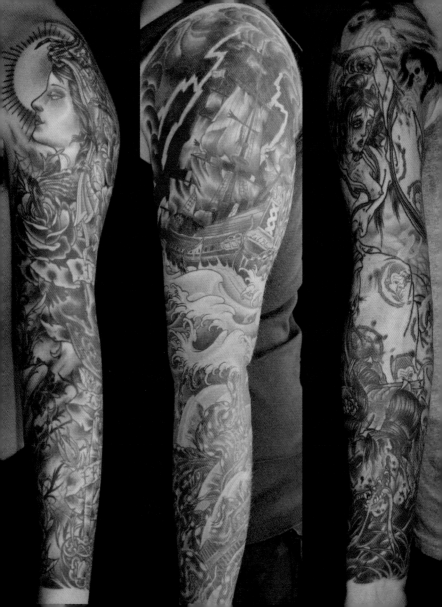

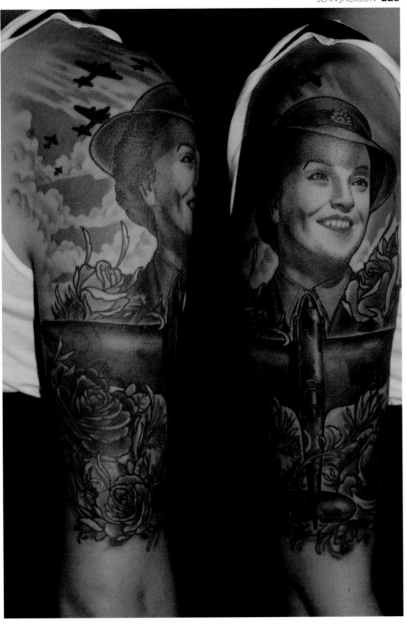

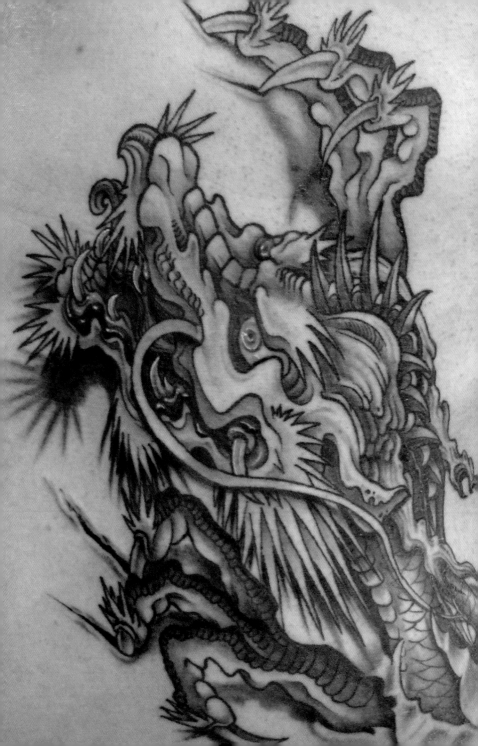

\mathcal{R}ay Johnson

Ray Johnson was born in Romford, Essex, in 1983. He first became interested in tattooing at the age of nine when his brother came home with his first few tattoos. One in particular, a Japanese dragon by Lal Hardy, captivated ray and it is a style that has interested him ever since. He has been tattooing for seven years and curently works in Immortal Ink with Jason Butcher, Lianne Moule and Mike Doodles.

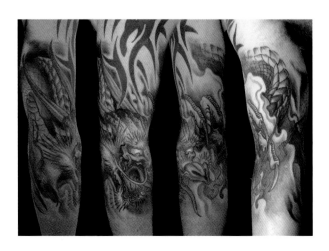

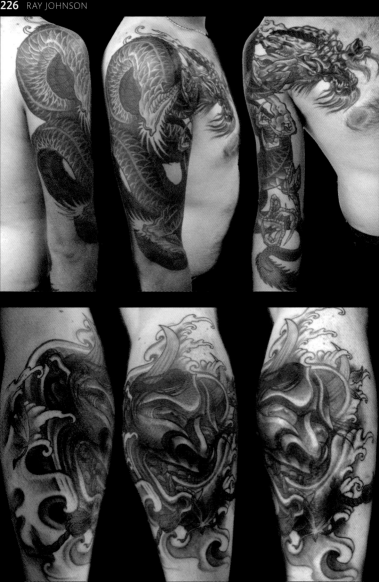

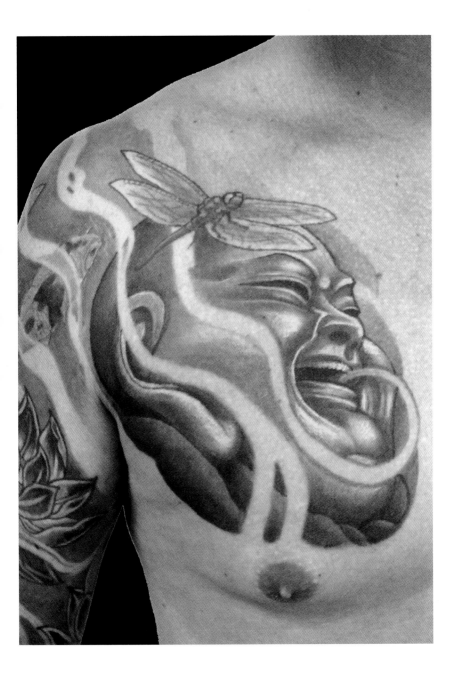

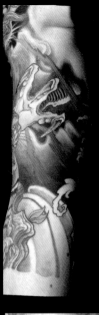
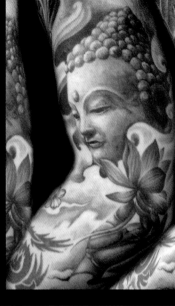
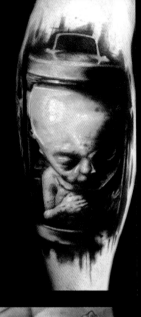
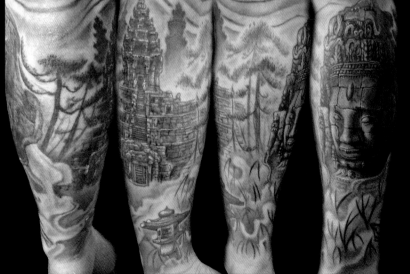

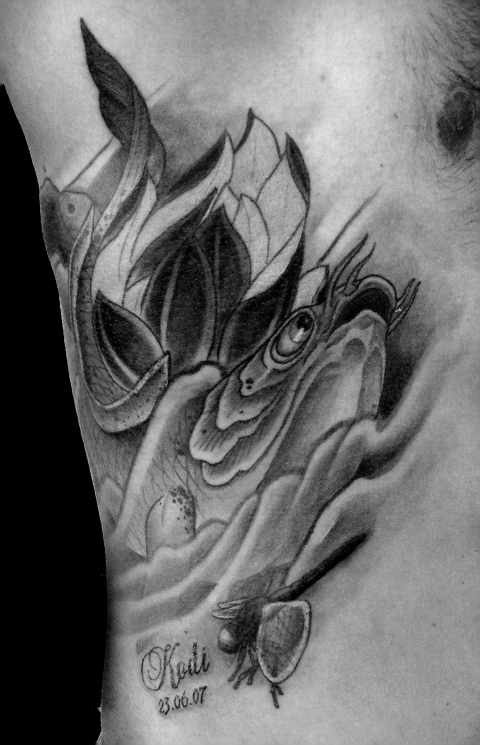

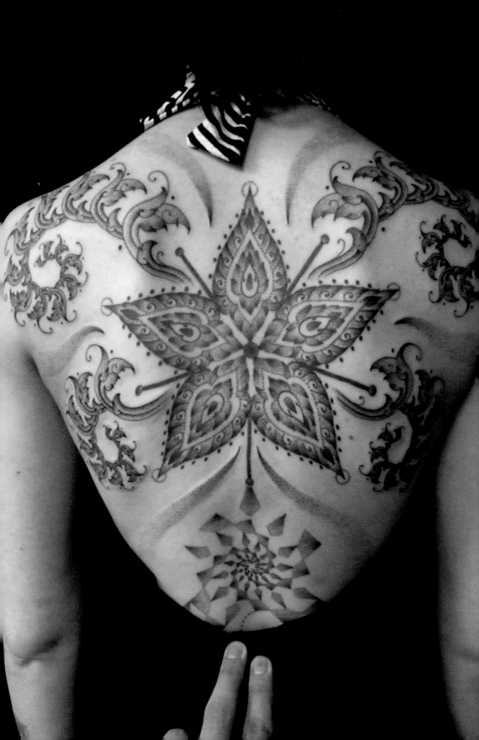

${\mathcal{J}}$ondix

Jondix was taught by Tas and later became an official apprentice of Mike the Athens. He still works at LTW in Barcelona, but guests at NY Adorned, Into You and Filip Leu's Family Iron shop. He believes that tattooing is a mirror that reflects the world we live in, and that all forms of art promote knowledge and encourage understanding of other realms. However, he also believes that everything is a total illusion.

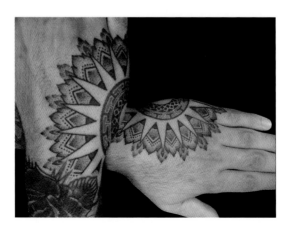

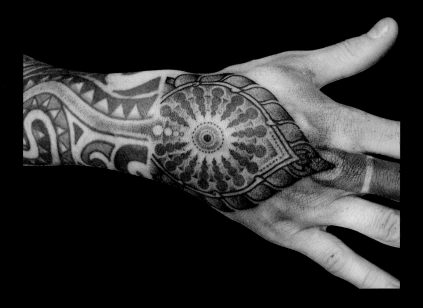

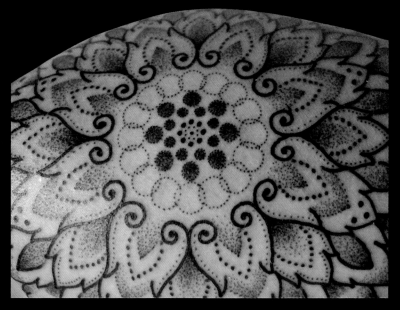

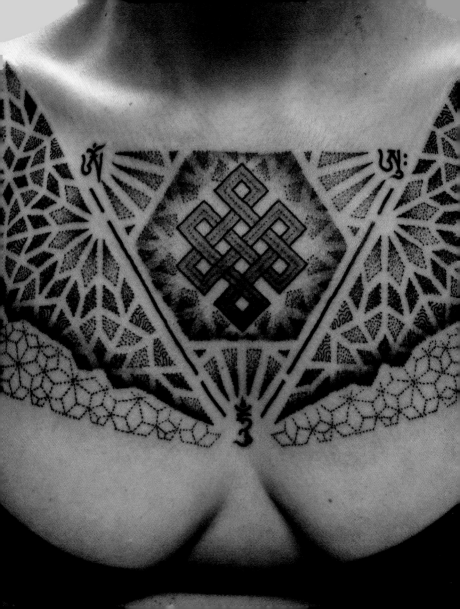

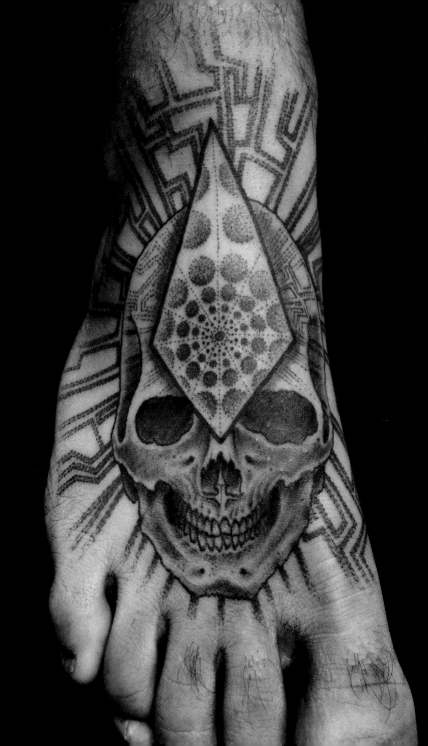

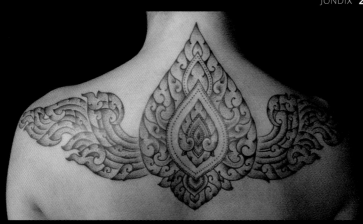

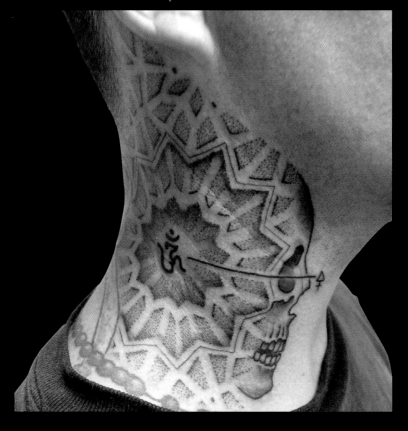

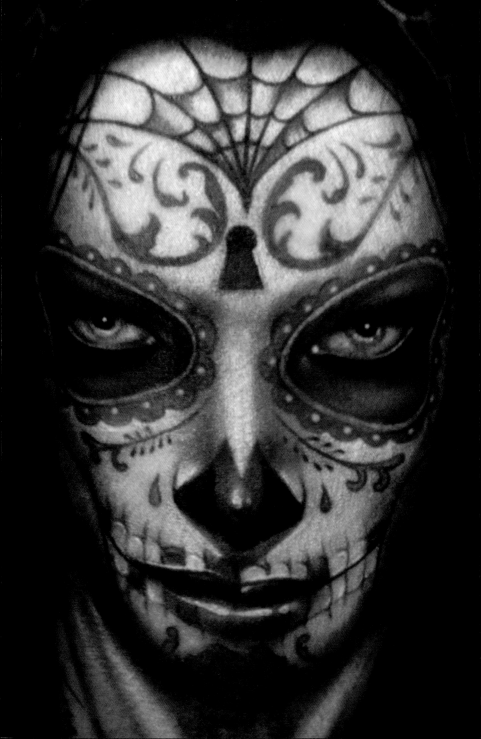

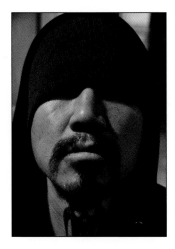

\mathscr{K}han

"I am a tattoo artist from South Korea. I've been tattooing since 2001 in Japan and other countries, drawing upon traditional Japanese tattooing for my main inspiration, but this has developed into my own neo-fantasy style. I'm part of the Kids Love Ink family and I enjoy working on realistic art, which is what my clients predominantly ask me for. Every day I try to stay humble and focused as, in this career, there is always more to learn."

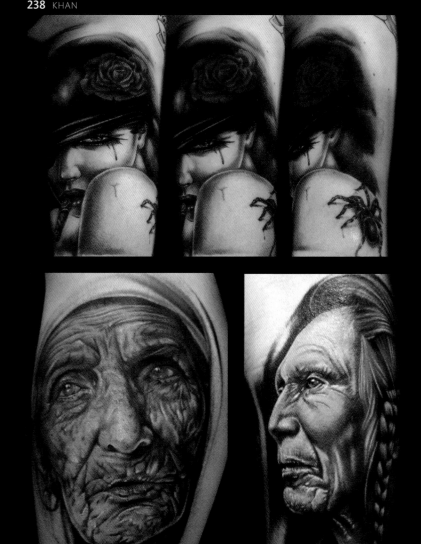

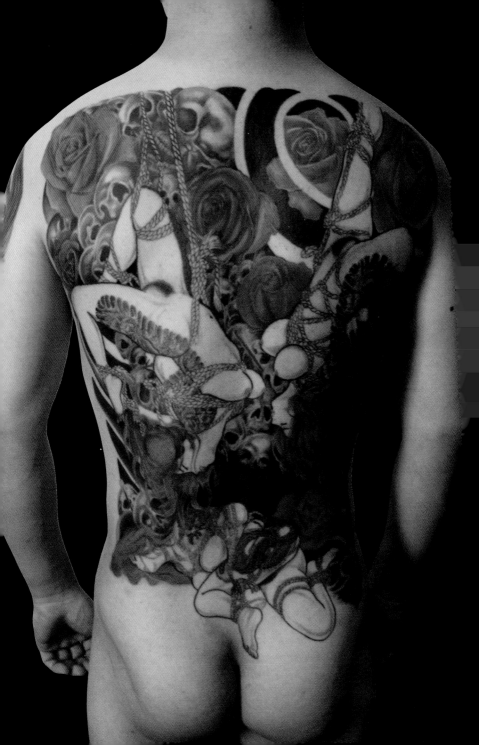

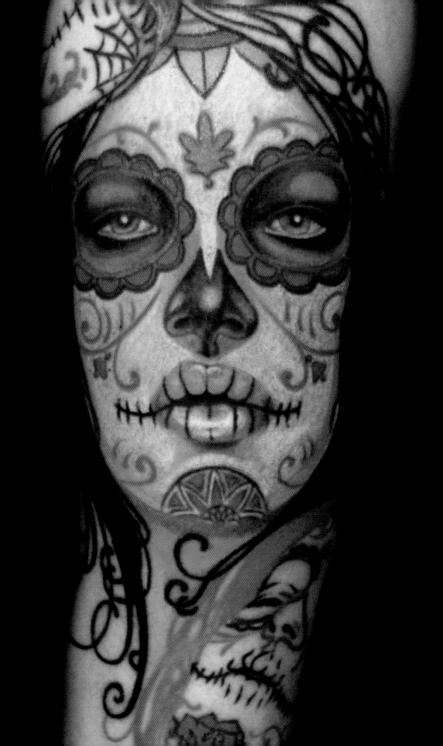

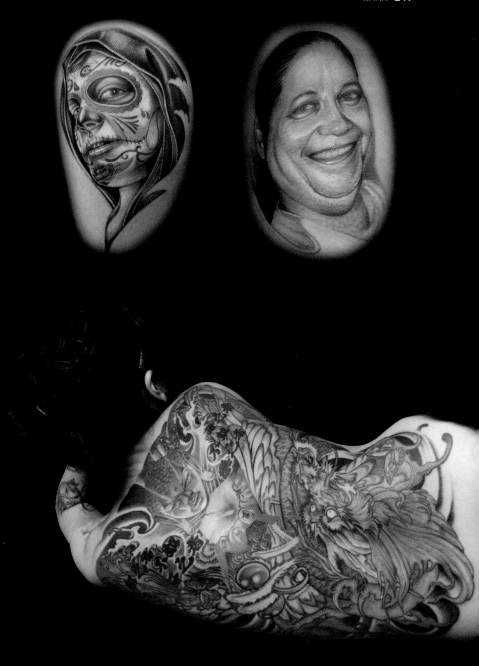

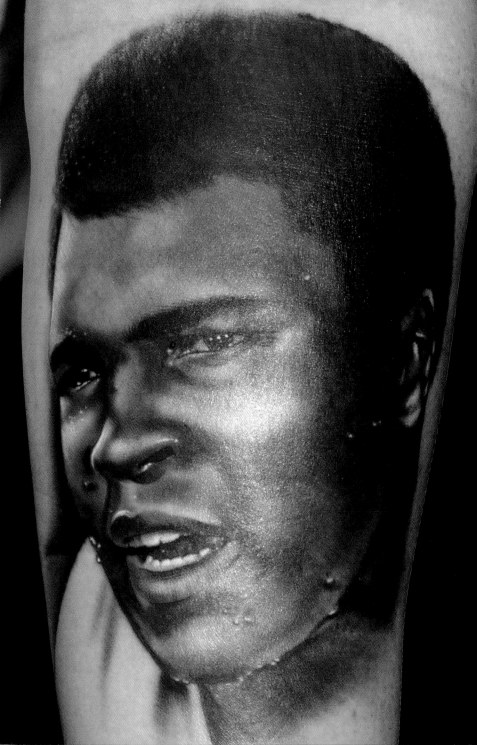

\mathscr{E}mma Kierzek

"Growing up in a creative family, art was always my passion. Landing in a job that complemented this was a dream come true. In the late 1990s I was lucky enough to get an apprenticeship on the north-west coast of England, and later I went on to set up Aurora Tattoo in Lancaster. Currently I divide my working time between Aurora and Royal Tattoo in Denmark. The standards and progression of the tattoo industry constantly inspire me and have introduced me to great people and places I would never have seen otherwise."

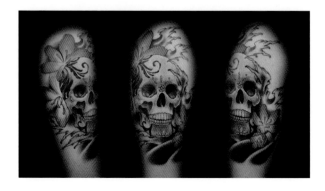

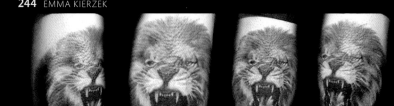

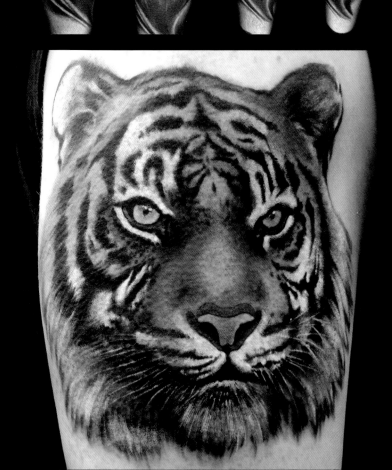

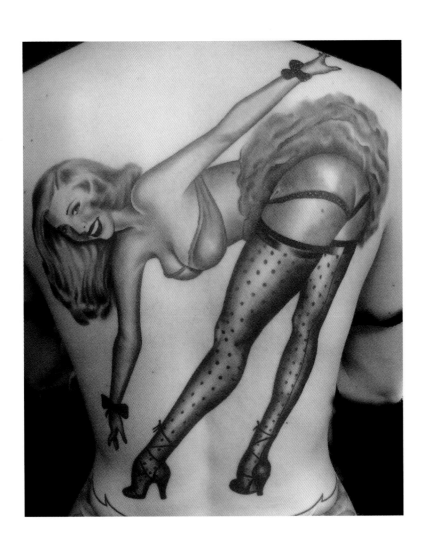

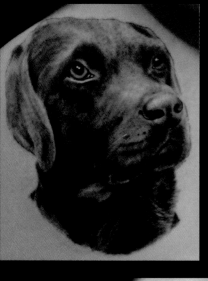

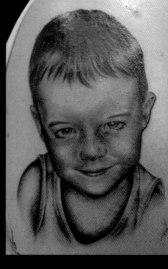

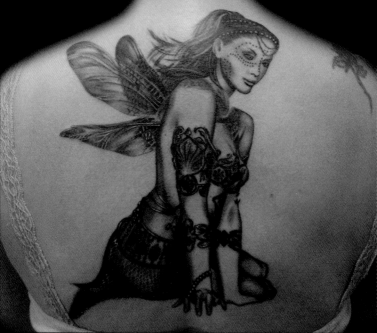

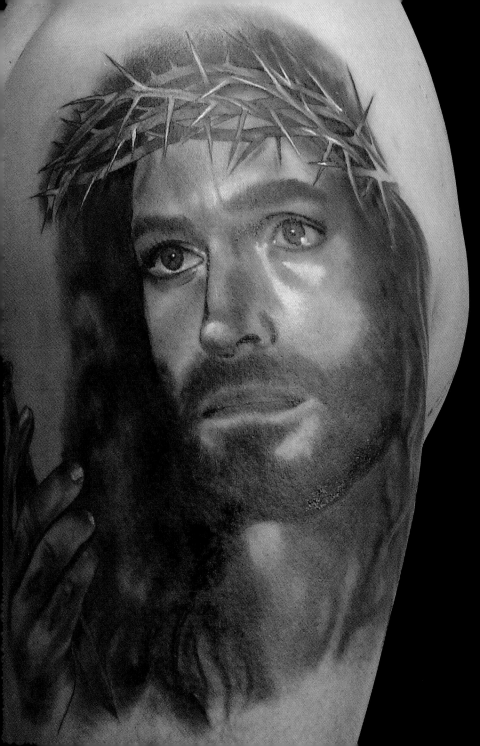

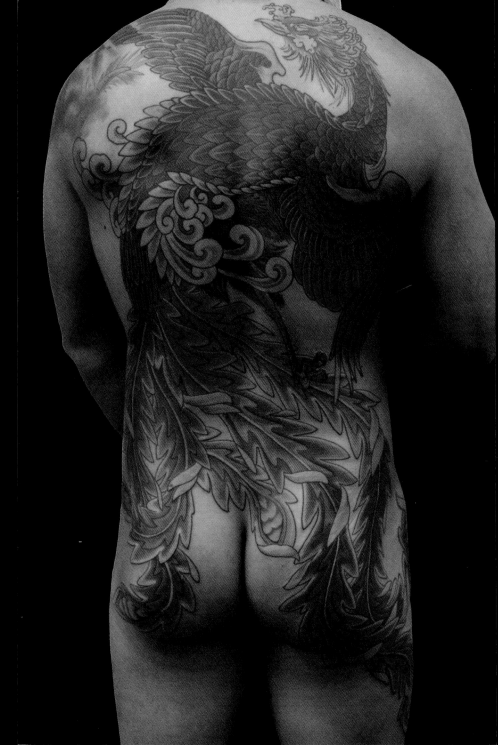

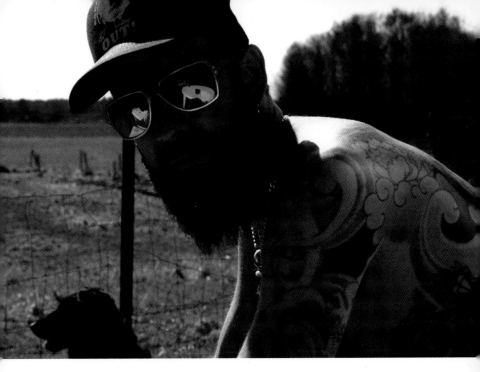

\mathcal{M}arcus Körling

Marcus Körling has been a tattooist for six years, having started out as
an apprentice in his hometown of Skövde, Sweden. After three years,
he began work with Jocke, who now runs the Temple of Art. Feeling that
he wanted to learn more, Marcus then moved to Herrljunga, a small
town not far from Skövde, to work with David at All Custom Tattoos.
He feels this is probably the best decision he's ever made as David
taught him almost everything he knows about machines, drawing
and everything about tattooing. After two years, having developed
diabetes, he moved back to Skövde where he worked for a while at
Magic Man Tattoos, before establishing his own studio in the town,
where he does what he loves to do – custom tattoos.

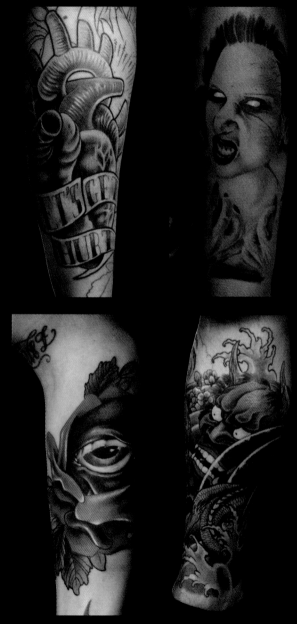

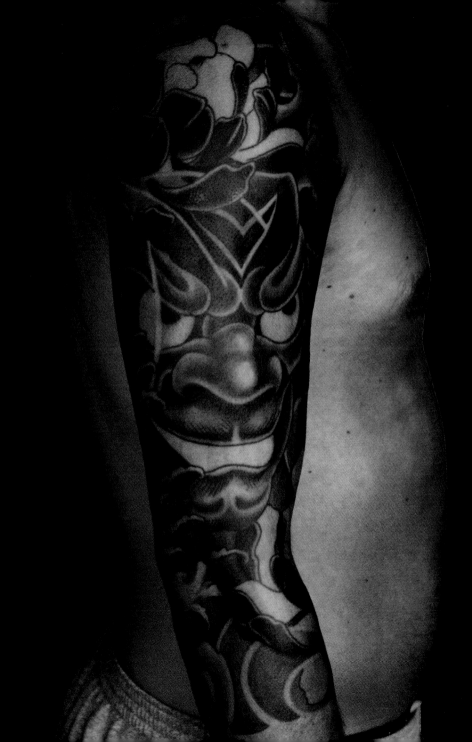

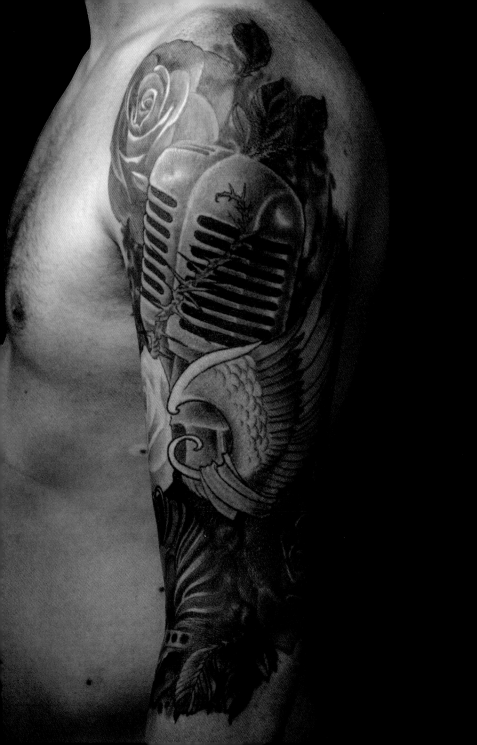

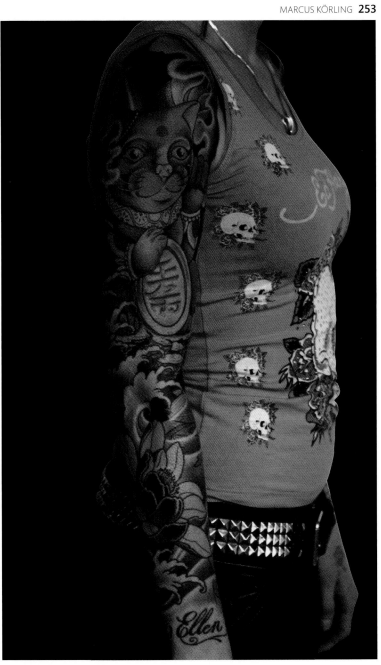

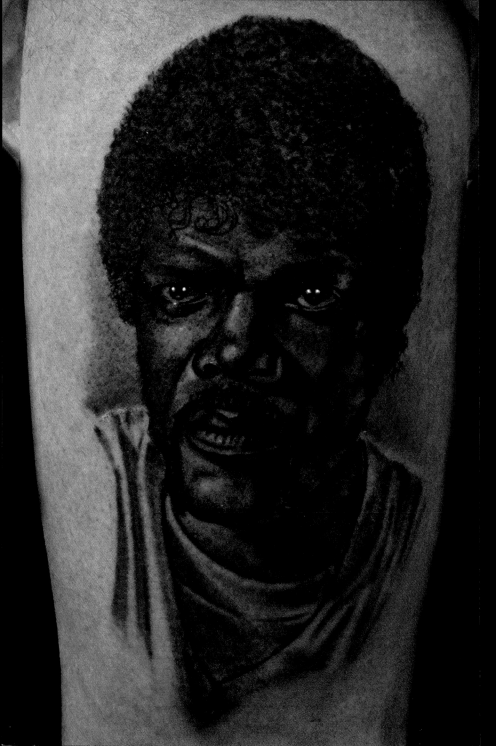

\mathcal{N}igel Kurt

Nigel Kurt started tattooing in Sheffield, England, around 1990. He opened his own studio, Fun House Tattoos, in Barnsley in 1993, which remains his base today. Nigel works primarily in black and grey and he has won numerous awards for his realistic style.

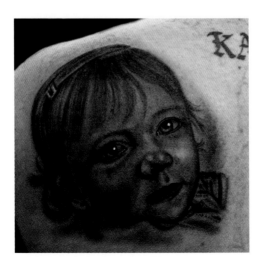

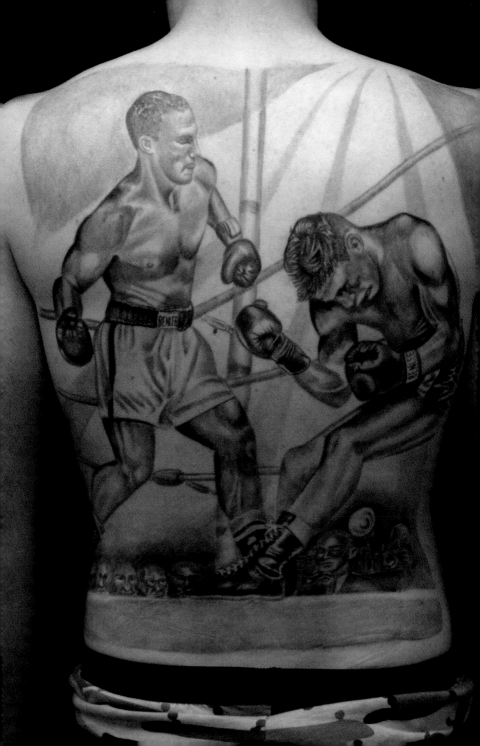

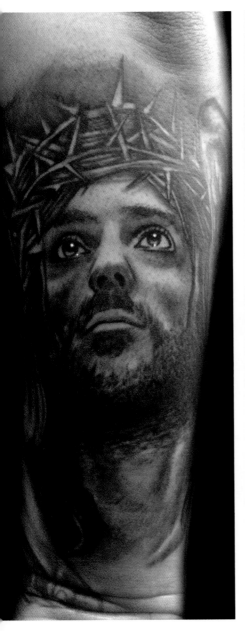

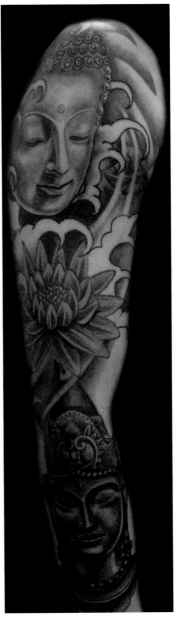

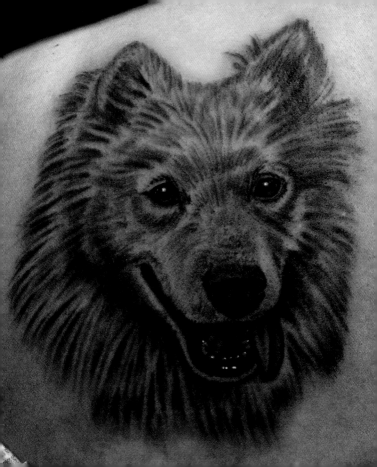

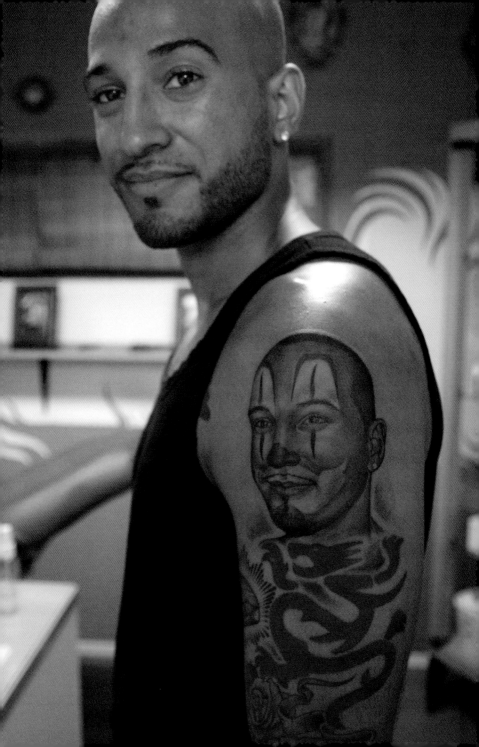

Born in Poland, in 1971, Kynst lives and works in the Netherlands, where he has been tattooing full time since 2002. From an early age his love of art was inspired and encouraged by his family: his aunt gave him the oil paint and his father provided – albeit involuntarily – his shaving brush. It was in this way that Kynst developed the basic skills and techniques for fadeout shadow work. The step from shaving brush to tattoo machine came years later, when a friend saw his artwork and offered him a tattoo machine and an arm! Kynst opened his studio in 2004 and strongly believes that "the art of drawing, the art of painting, the art of music and the art of travelling all melt together in the art of tattoo".

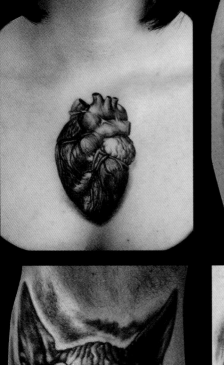

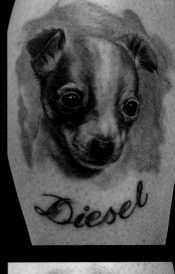

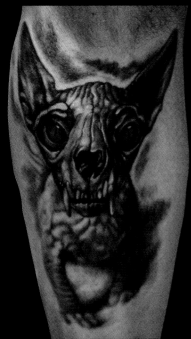

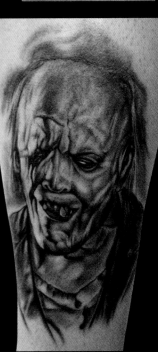

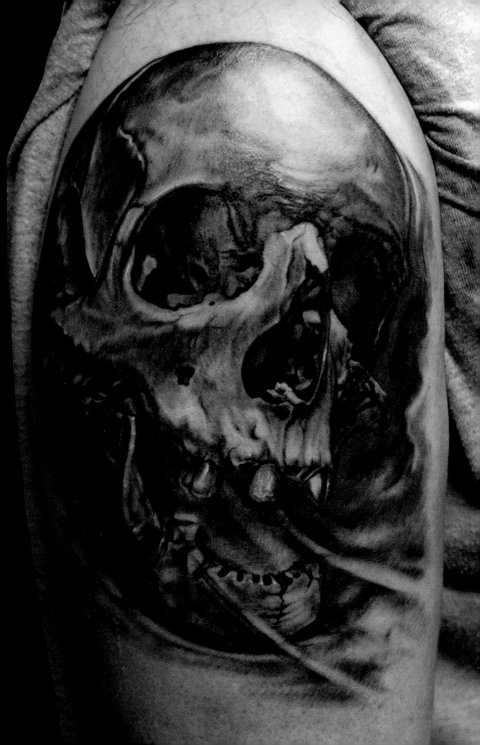

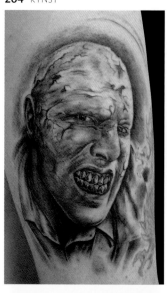

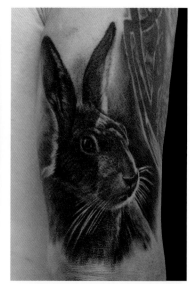

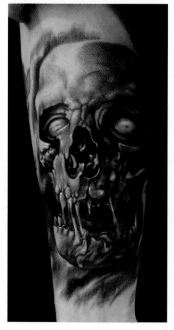

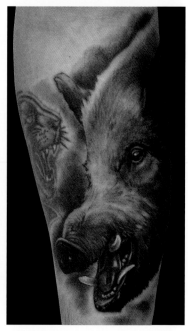

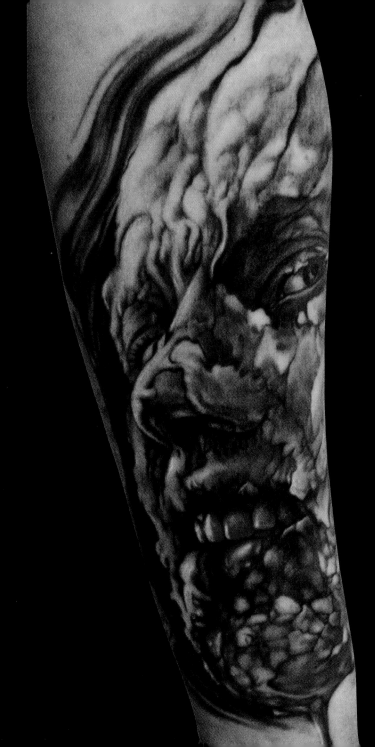

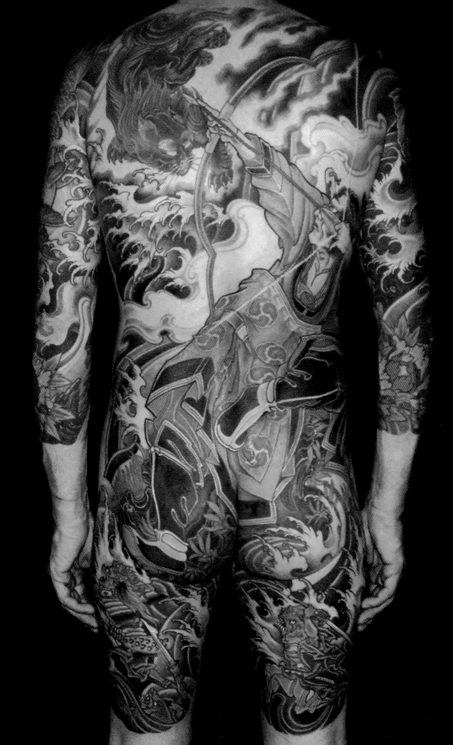

\mathcal{F}ilip Leu

"I grew up 'on the road' with my brother and two sisters. Our parents, Felix and Loretta Leu, were artists, travellers, hippies and free thinkers. Felix and Loretta started tattooing in 1978, when I was eleven, and I knew almost at once that this was what I wanted to do as well. In 1980, we settled in Lausanne, Switzerland, where we created The Leu Family's Family Iron. By the time I was fifteen, I was tattooing full-time in our studio. In 1988, I met Titine, the love of my life and a talented painter. After many travels and adventures together we now live in the Swiss mountains. We recently closed The Leu Family's Family Iron in Lausanne, and moved to a private studio in Ste-Croix, which is closer to home. I work there with my brother Ajja and my brother-in-law Matthieu. In the twenty-eight years since I started tattooing, I've been working on and specializing in large bodywork of my own version of Japanese, black and white, skulls, and anything else I like. Tattooing . . . it never gets boring. At forty-three I'm still passionate about it. Love and peace!"

Artist photograph © Jean-Paul Cattin

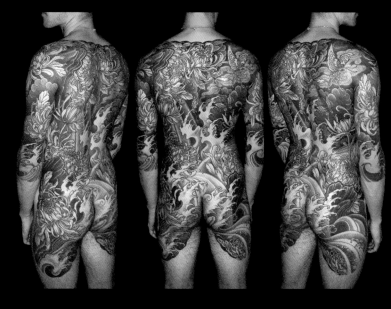

2004-5

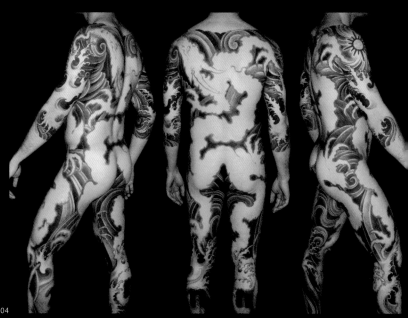

2004

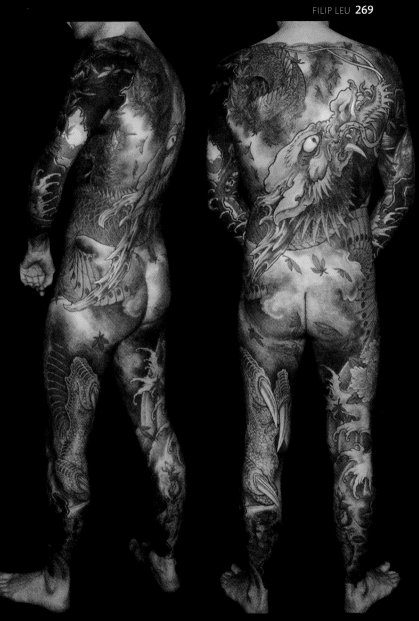

2006–7

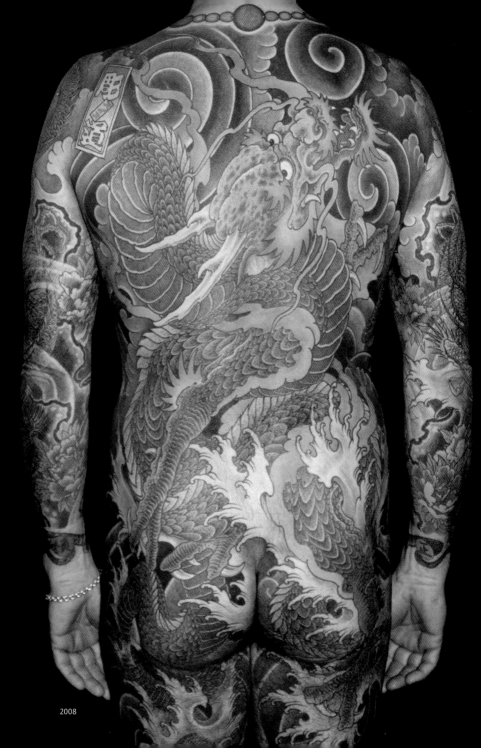

2008

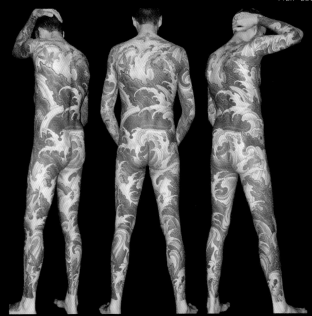

2009

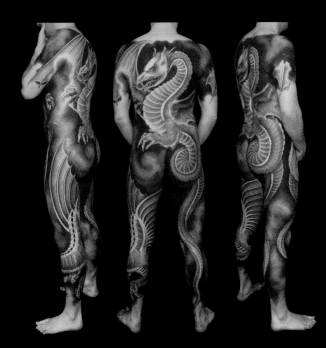

2009

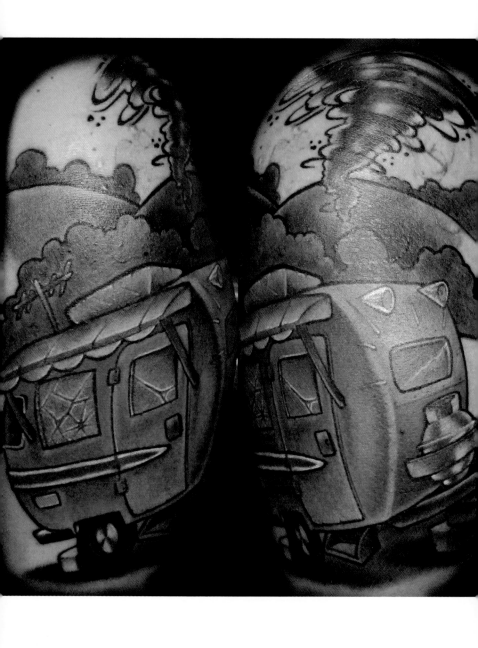

\mathcal{J}ime Litwalk

Originally from south-west Detroit, Jime Litwalk now works at Hart and
Huntington in Las Vegas. After initially hanging around tattoo shops
airbrushing and drawing, he considered a career as a tattooist after
seeing his designs inked onto people. After an eighteen-month
apprenticeship, Jime started tattooing at the age of twenty-one.
His instantly recognizable, colourful, animated style of tattooing has
earned him world renown.

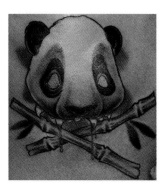

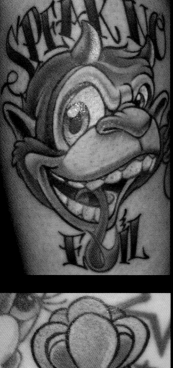

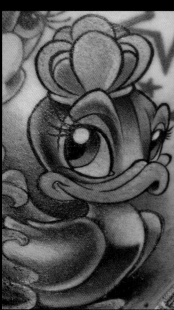

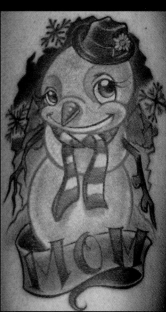

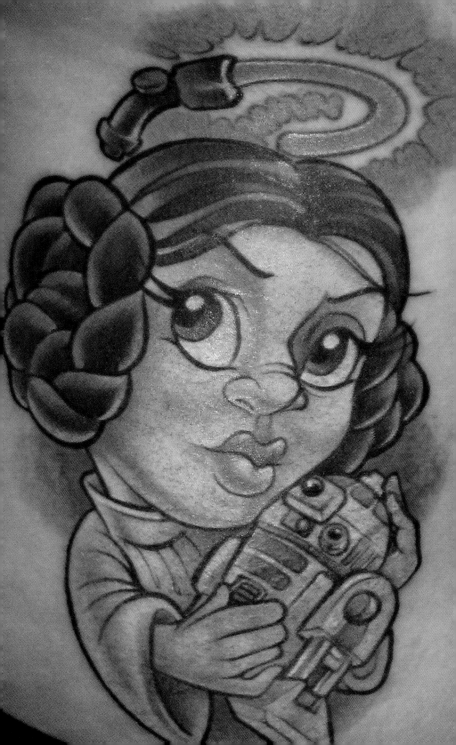

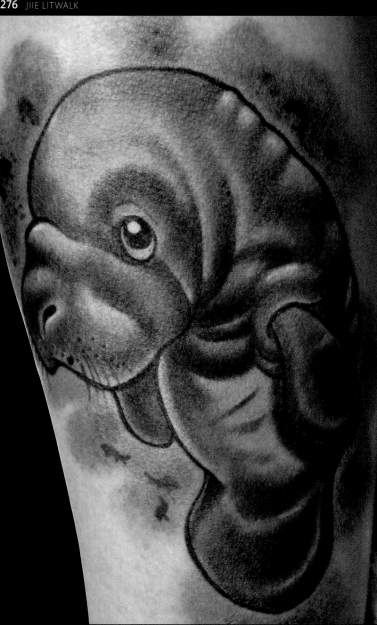

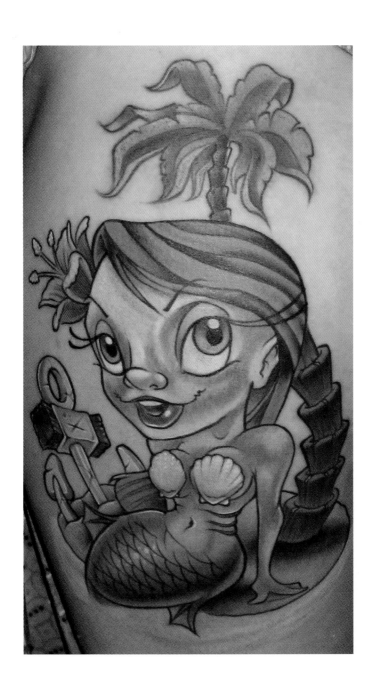

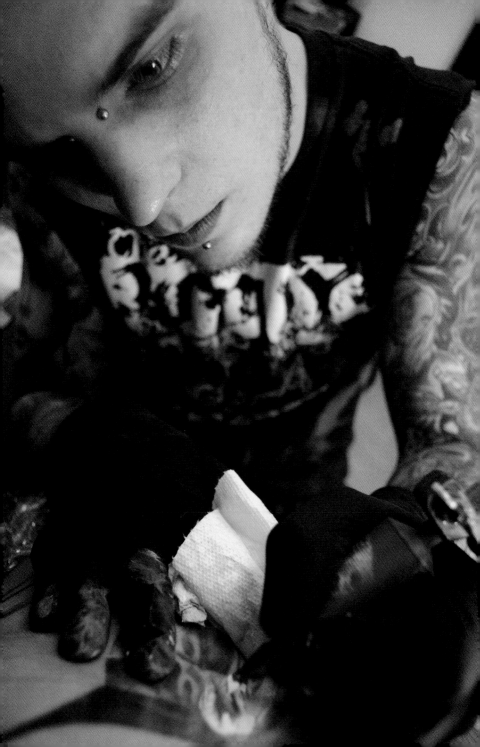

\mathcal{T}ony Mancia

"I grew up in Kingston, Pennsylvania. I was tattooed at a young age and since then I've been fascinated by tattoos. I started my apprenticeship when I was eighteen and have been doing everything I can to progress and keep pushing myself. I am obsessed with art, and love what I do. That being said, I will always try to further this industry and hope to keep moving forward with my career."

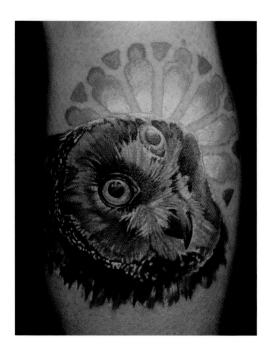

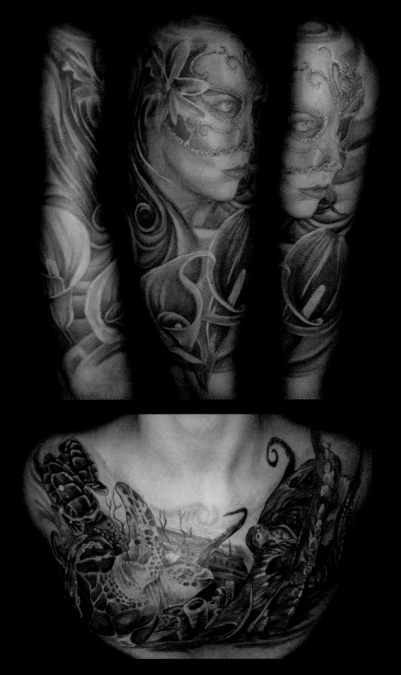

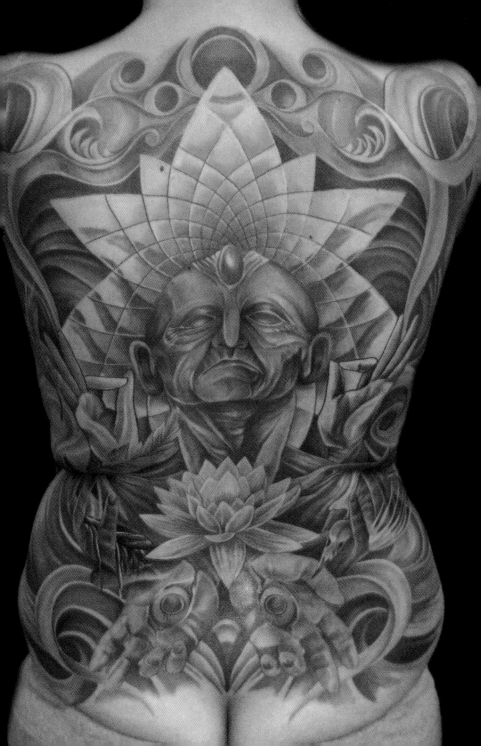

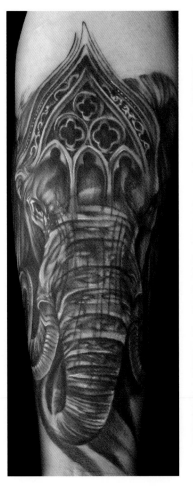
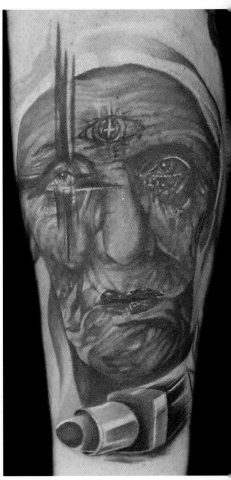

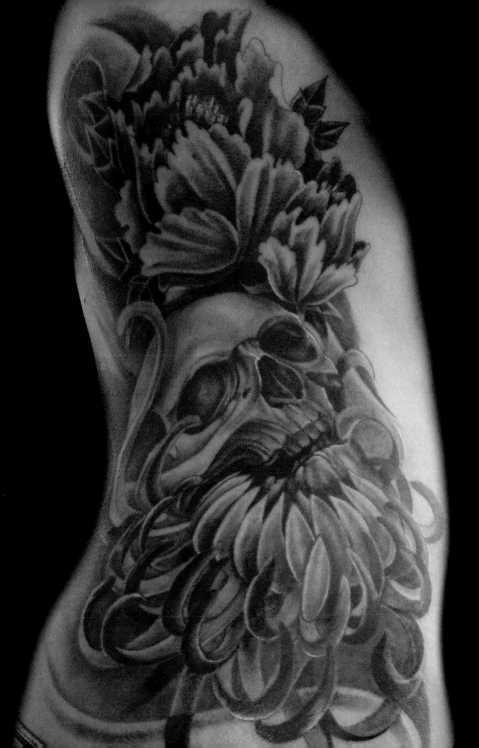

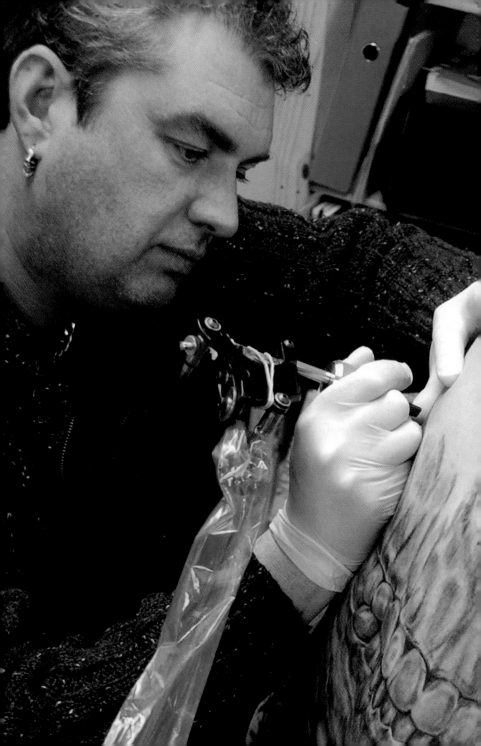

\mathcal{M}ick J

After being introduced to tattoos when Terry Oldham opened a studio in Walthamstow, east London, Mick J became fascinated with the world of tattooing. This eventually led to him becoming a resident tattooist in Blue Dragon Tattoo, Brighton, in 1998, working for Danny Fuller, where he developed his "painting" style of tattooing for which he has become well known. Now the owner of Blue Dragon Tattoo, he keeps the old-school values that were passed on to him by the likes of Terry and Danny, though he has a modern approach to his work.

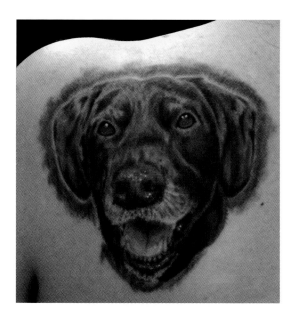

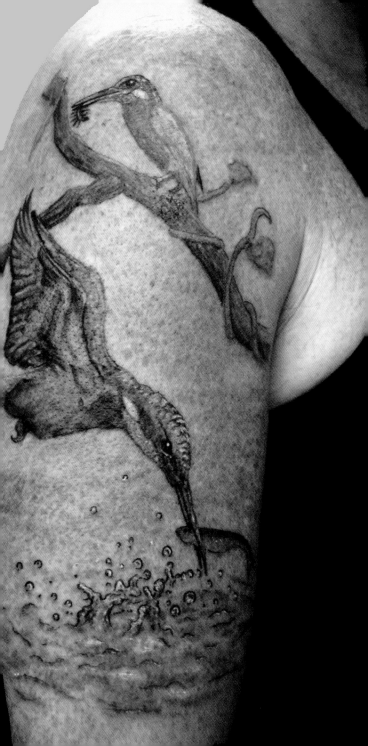

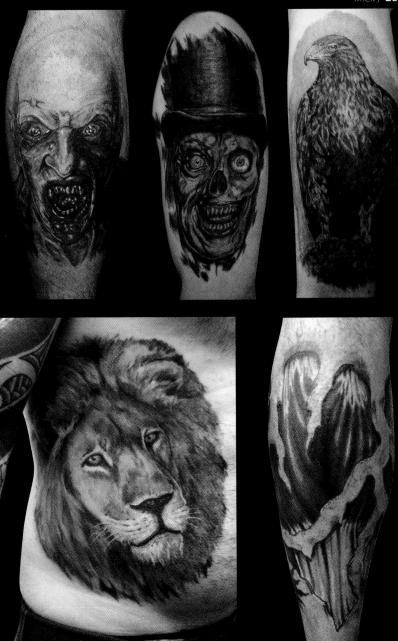

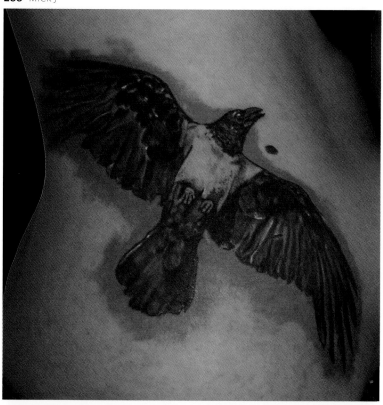

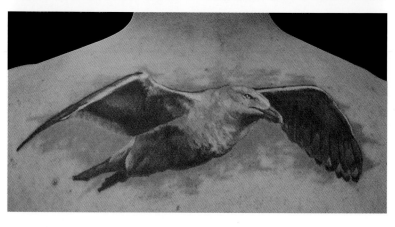

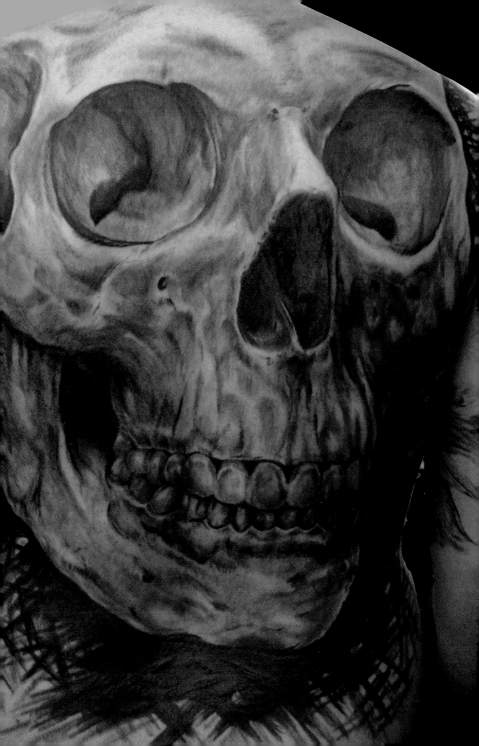

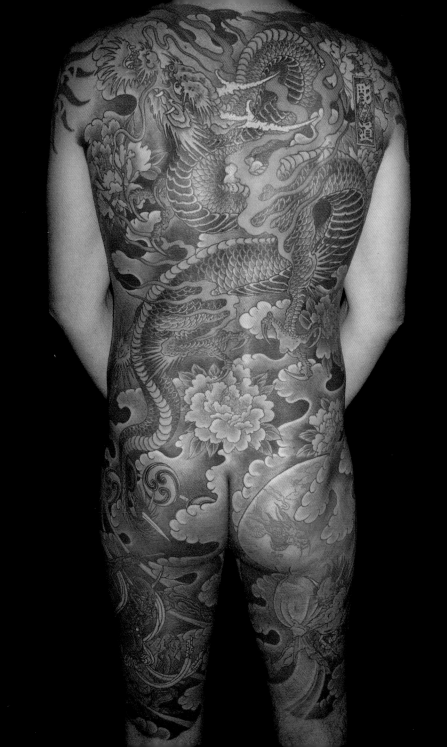

\mathcal{M}ick from Zurich

"I was born and raised in Zurich, Switzerland. When I was apprenticed as a scenographic painter at the Zurich Opera House I discovered an interest in tattooing and especially in the Japanese style. After attending the first Swiss Tattoo Convention in 1986 in Zurich I really wanted to be a tattoo artist. After I experimented on some brave friends, I got some serious support from Marco Leoni and his crew in Brazil. Getting tattooed by artists whose work I admired taught me a lot over the years and I was lucky to meet the Leu Family, Luke Atkinson, Horiyoshi III, Horitoshi and many other great tattoo artists whose work has encouraged me to do what I like doing today."

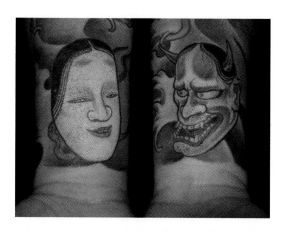

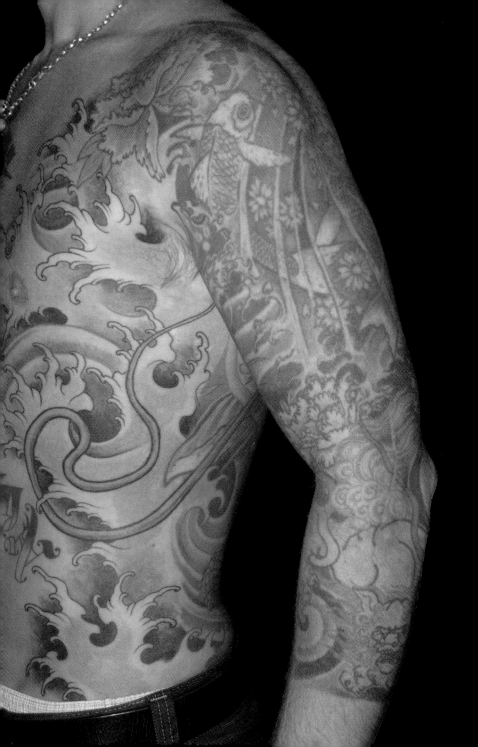

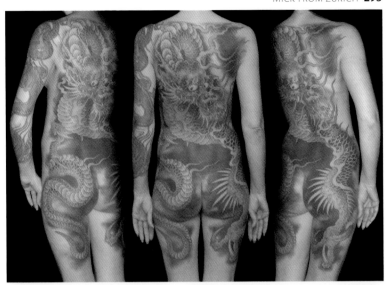

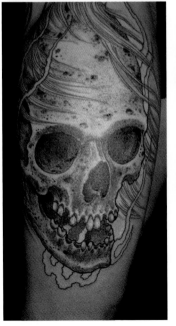

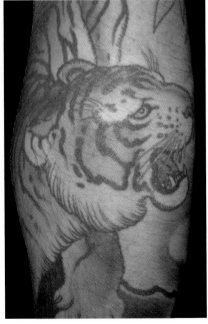

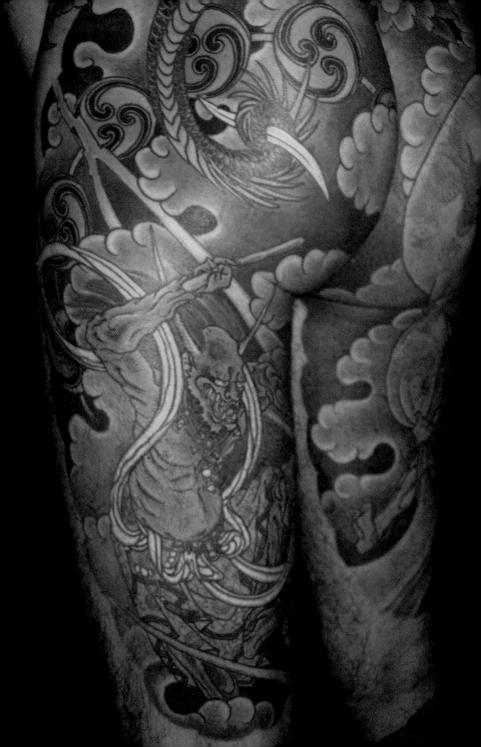

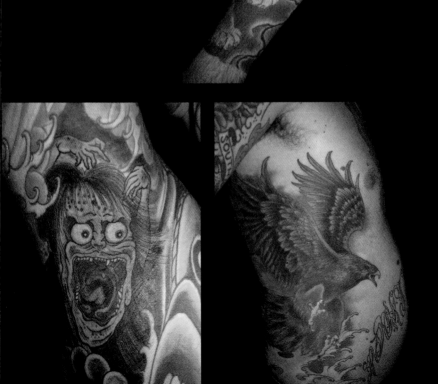

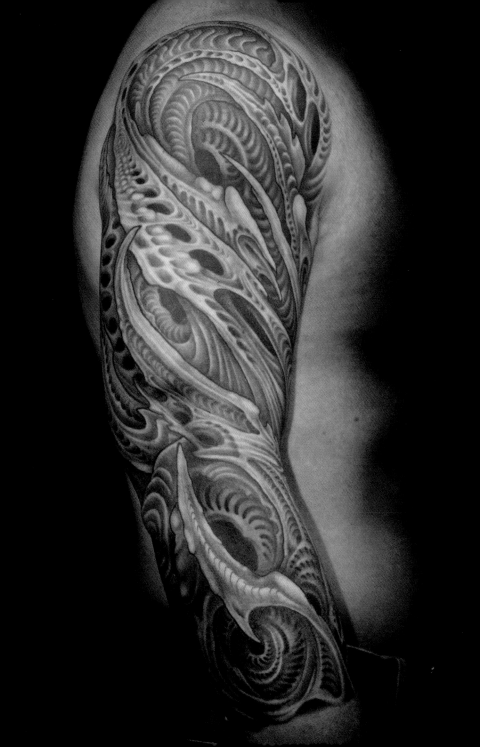

*L*ouis Molloy

Making his mark and pissing people off since 1981, Louis's general
mantra is that he is not out to try and impress anyone except the
client he is working with at that particular moment.
All other considerations are not relevant.

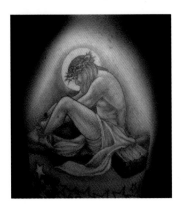

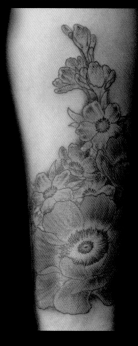

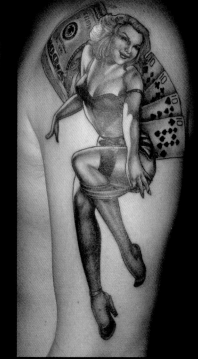

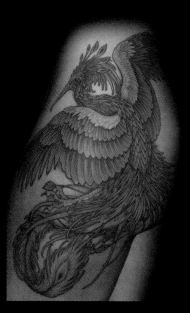

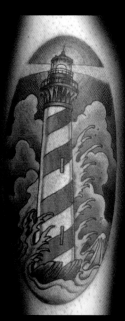

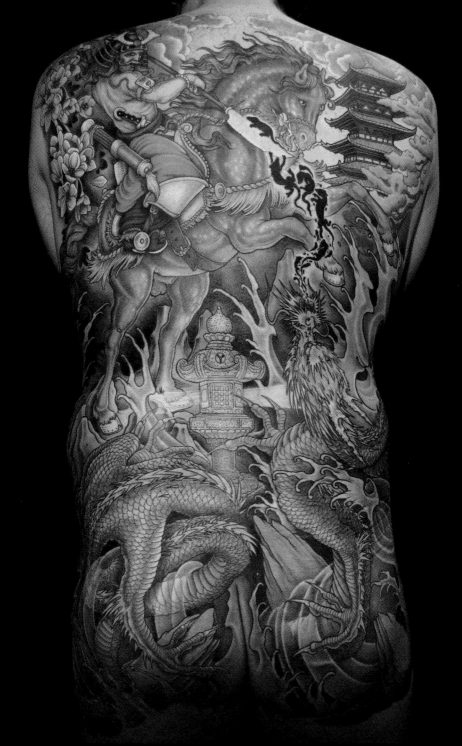

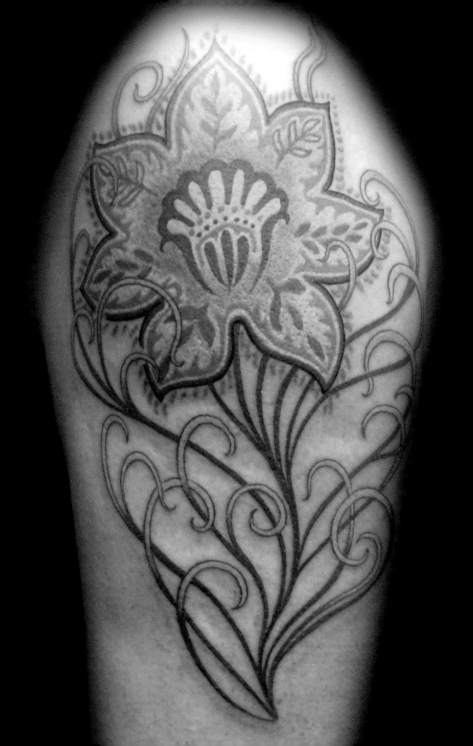

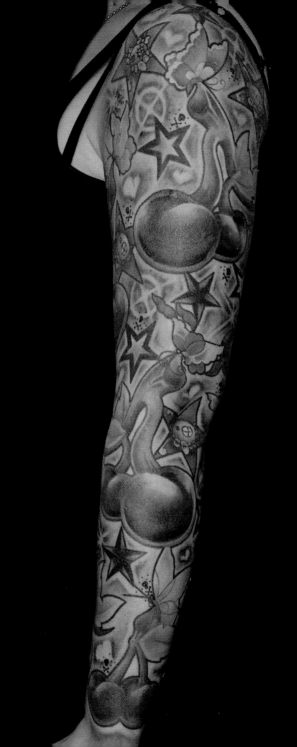

\mathcal{L}eah Moule

"I got into tattooing by gaining an apprenticeship at Immortal Ink in Essex, where I grew up. It was very unexpected as it was offered to me when I was visiting the studio with my sister. I spent my apprenticeship learning from Jason Butcher who owns the studio. At a convention I saw and fell in love with a truly wonderful man called Spud and then moved to Birmingham. There I got a job at Modern Body Art and that's where I stayed until I opened Spear Studio, in Birmingham, with Spud. I work here with two other artists and we try to cover as many styles as possible. Obviously, most people know me for my NewSkool and quirky style which is what I love to do. It is an all-female studio apart from Spud and we like to think we are a friendly and cheerful studio, somewhere that's fun to get tattooed in."

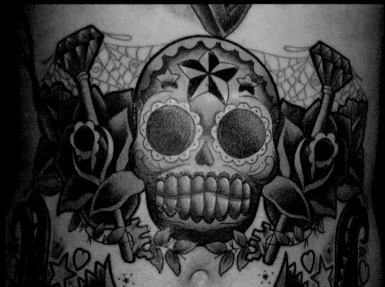

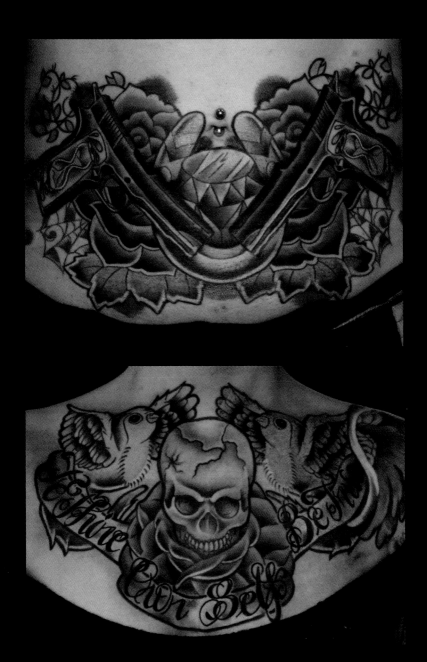

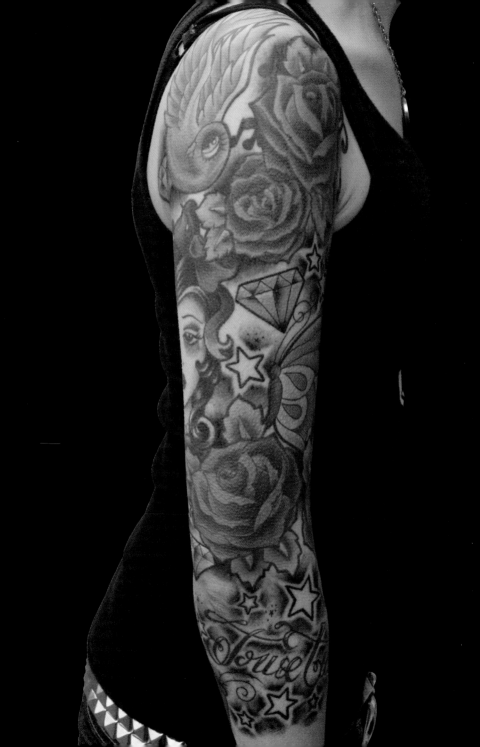

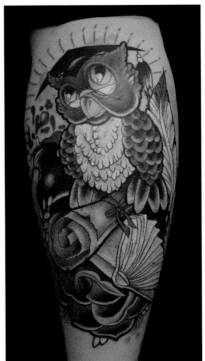

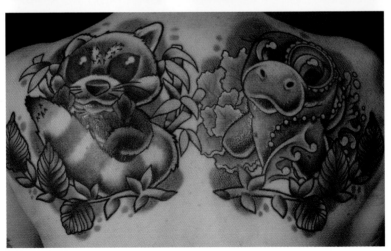

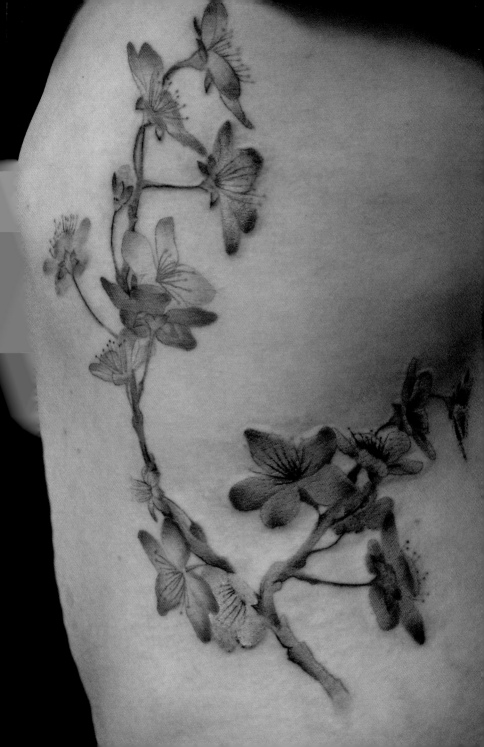

\mathcal{L}ianne Moule

"My love of tattoos first started when I met my boyfriend Jason Butcher nine years ago. He had just started to teach my sister, Leah Moule, who now has her own studio called Spear. I started my tattooing apprenticeship in 2007 after working as a Saturday receptionist in a tattoo shop for seven years. From an early age I always loved making art and studied fine art at both college and university. My art background really helped my tattooing. I prefer to tattoo in colour, and love to recreate colour realism but also give a feminine touch to my tattoos."

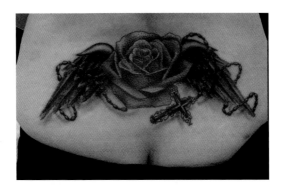

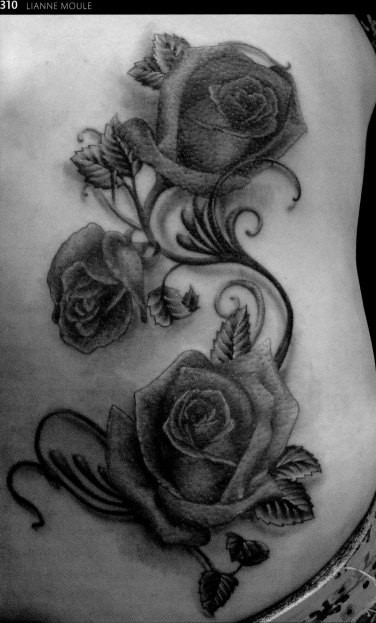

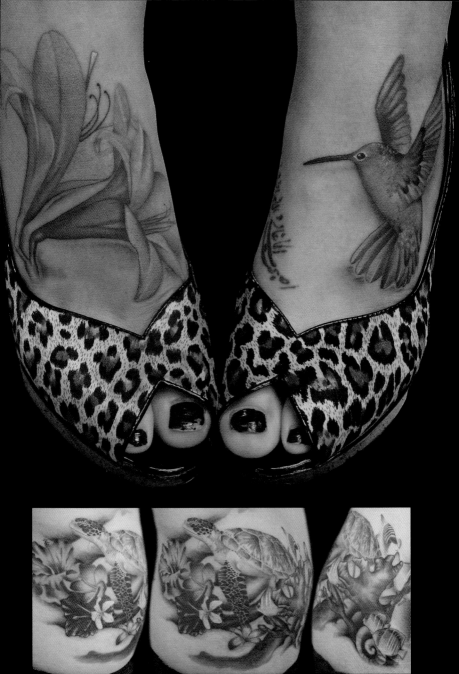

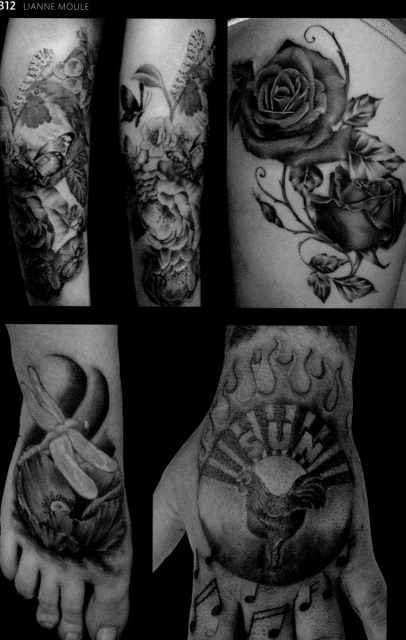

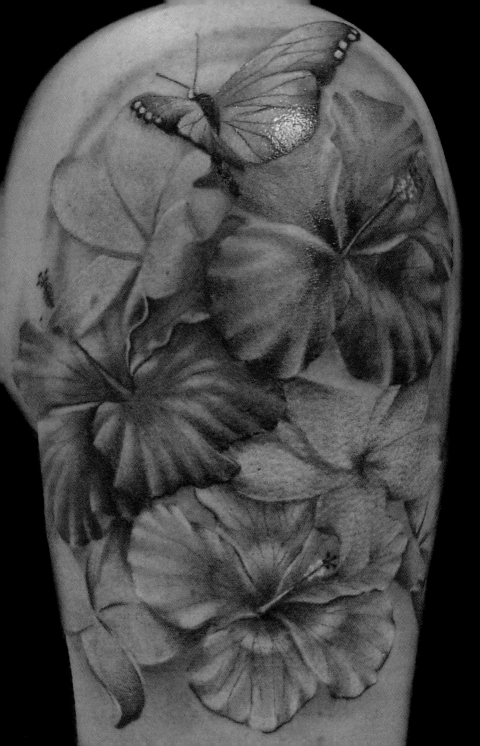

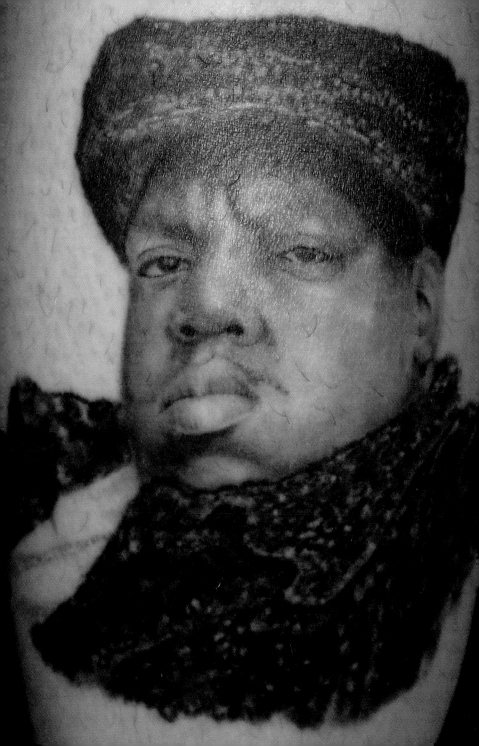

\mathcal{N}8 Dogg aka Nate Drew

N8 Dogg was born in Alexandria, Virginia, in 1972 and he started tattooing in 1992 in Richmond, Virginia. He feels he has been fortunate to have known people such as Tony Olivas and Billy Eason, who have helped him get his foot in the door and point him in the right direction. In 1988 he moved to Salt Lake City, Utah, where he established Lost Art Tattoo. In 2003 Lost Art Tattoo and Flaco Productions began the Salt Lake City tattoo conventions. Nate Drew can be found at Lost Art Tattoo in Salt Lake City and Ogden, Utah, and at Jack Brown's Tattoo Revival in Fredericksburg, Virginia.

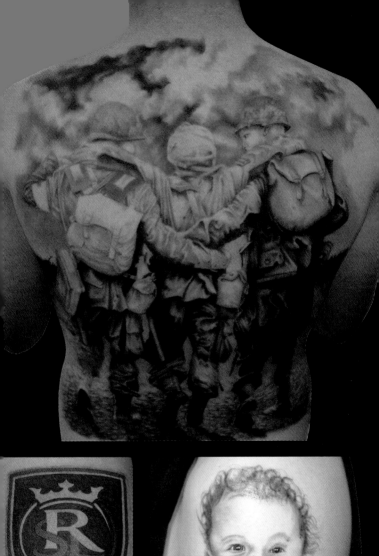

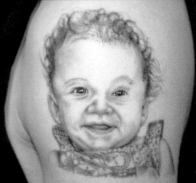

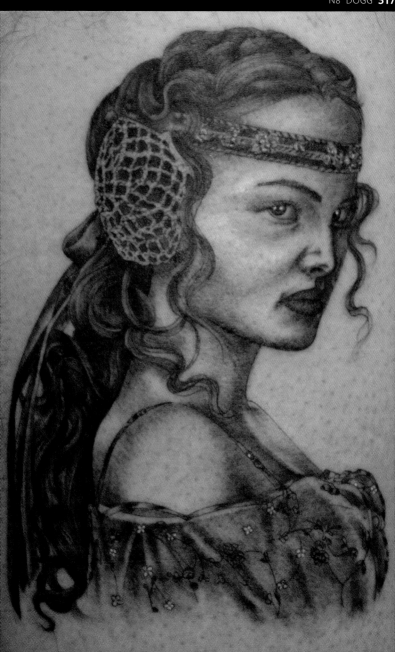

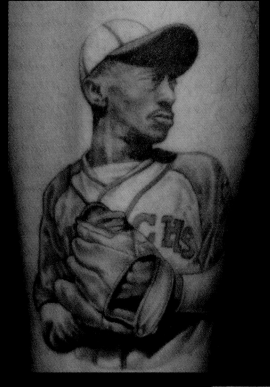

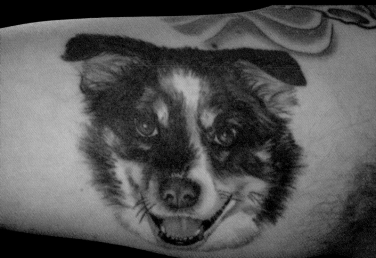

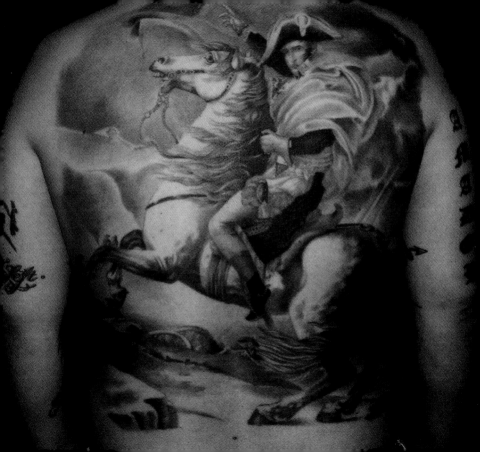

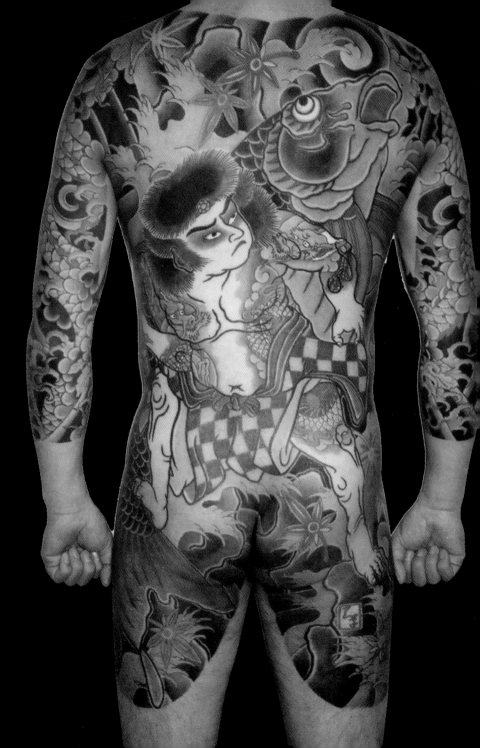

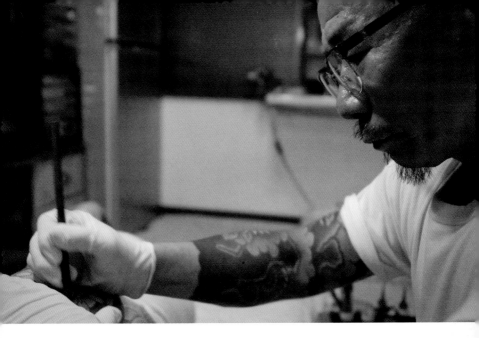

\mathscr{N}akamura

Fifty-five-year-old Nakamura-san lives and works in Oumuta-shi close to Fukuoka City in southern Japan. He is one of the last traditional Japanese Irezumi artists in Japan to work entirely with hand tools. Lines, shading and colour are put into the skin with the rare technique of Shamisenbori, whereby the Irezumi artist uses the hand tool in a way that it resembles a musician playing the Shamisen (the Japanese guitar). The soft touch and speed of Nakamura's technique, as well as his thirty-five years' experience, enable him to finish a sleeve in a week and a back piece in a month. His life motto is closely related to the ideology of his good friend Horiyoshi III: "In order to preserve the Japanese spirit of kokoro we need to bring it to the people who are truly interested in it, even outside Japan."

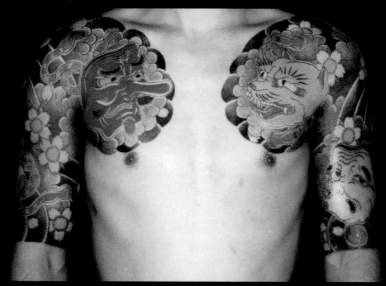

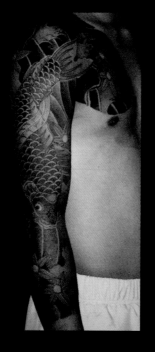

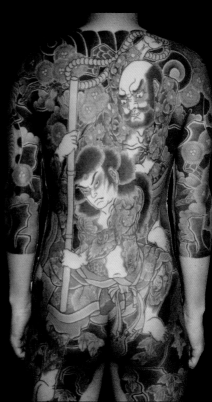

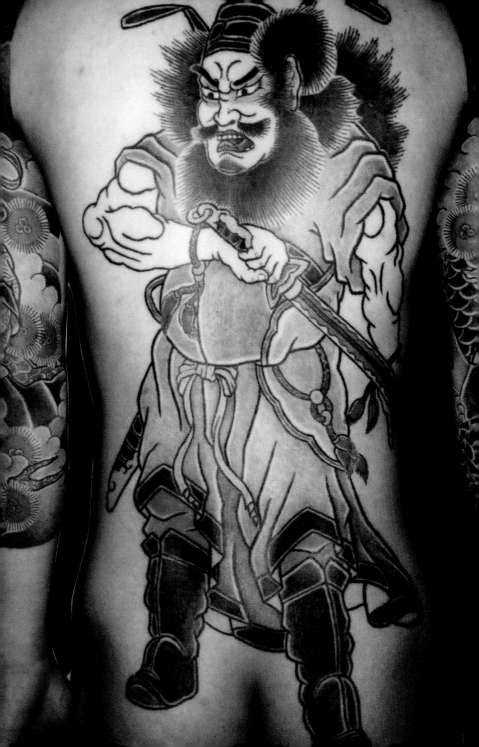

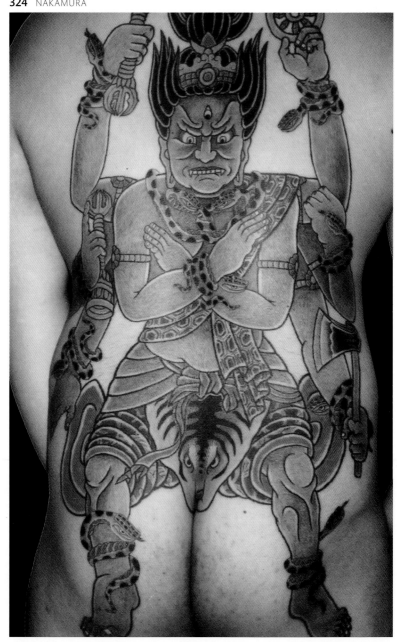

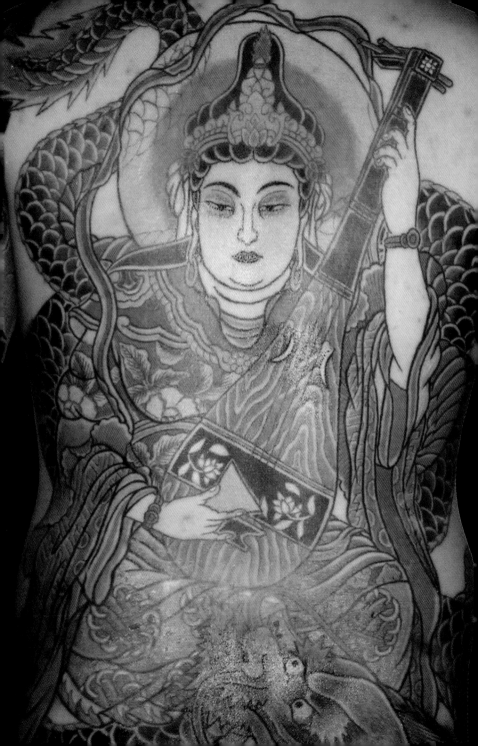

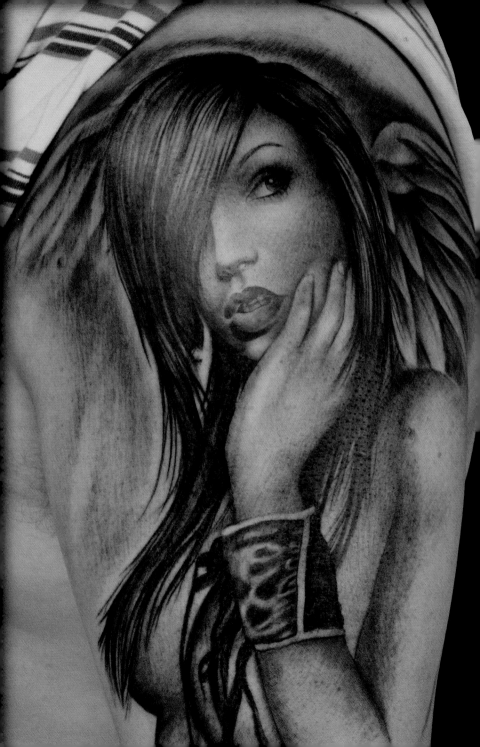

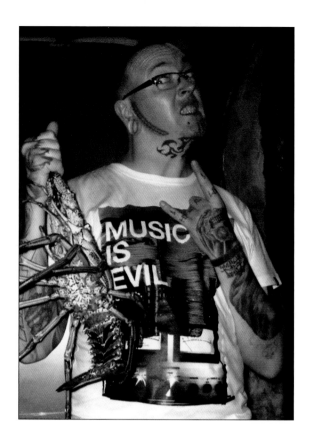

 Paul Naylor

"Go hard or go home."

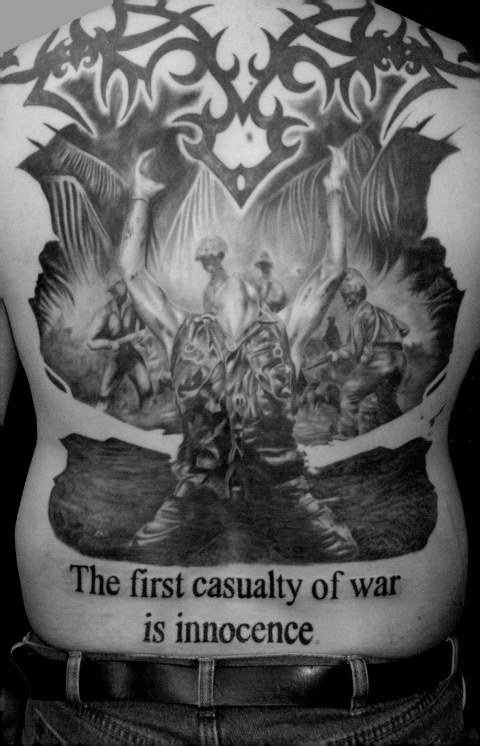

The first casualty of war
is innocence.

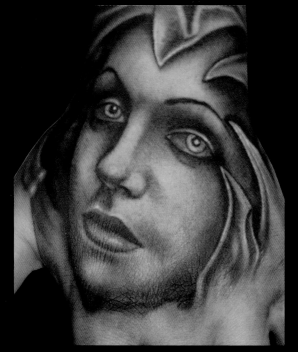

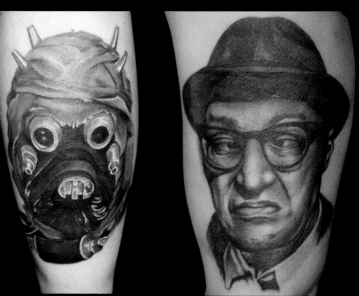

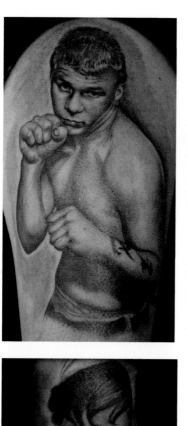
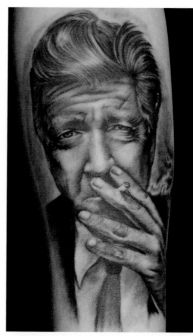
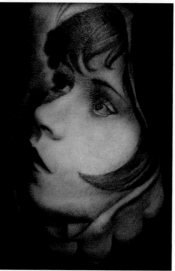
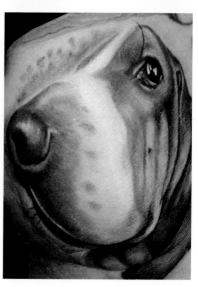

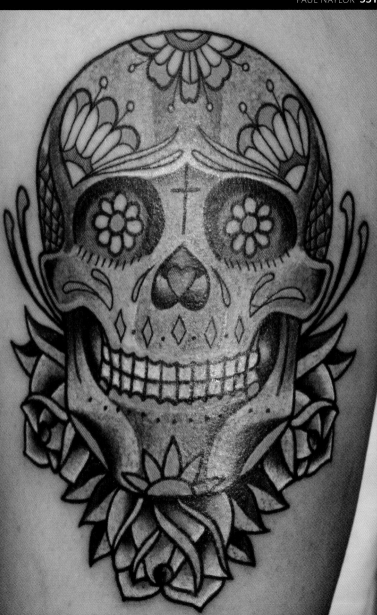

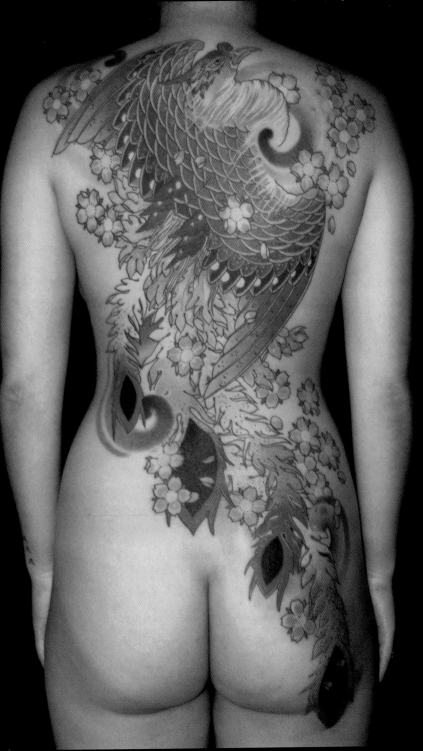

\mathcal{L}uca Ortis

Luca Ortis was born in Luxembourg, of Italian parents, in 1977 and says he "started playing around with a tattoo machine" in 2002. It was when he settled in London at New Wave that he was given the opportunity to really explore the Japanese style that initially sparked his interest in this great trade.

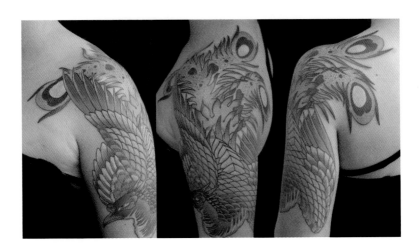

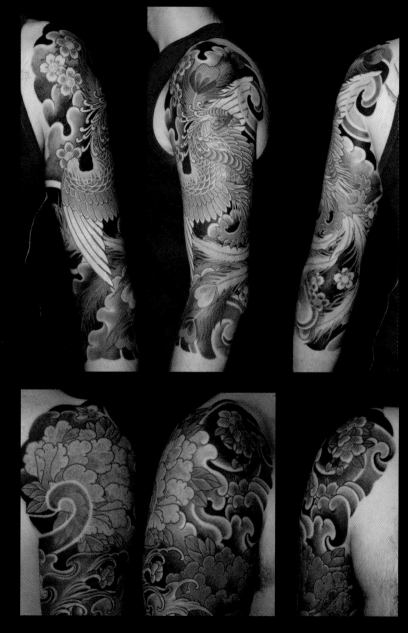

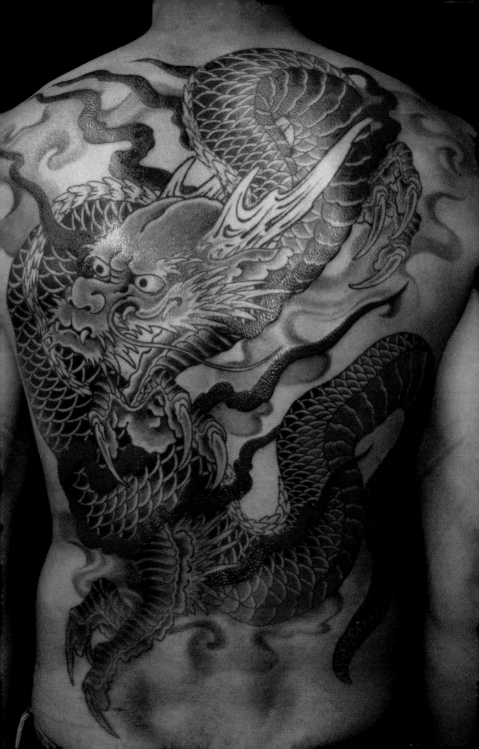

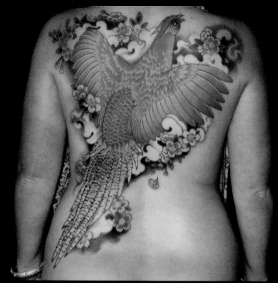

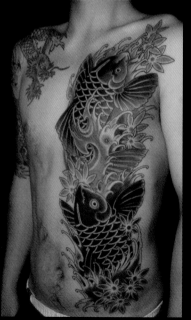

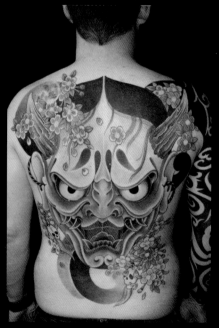

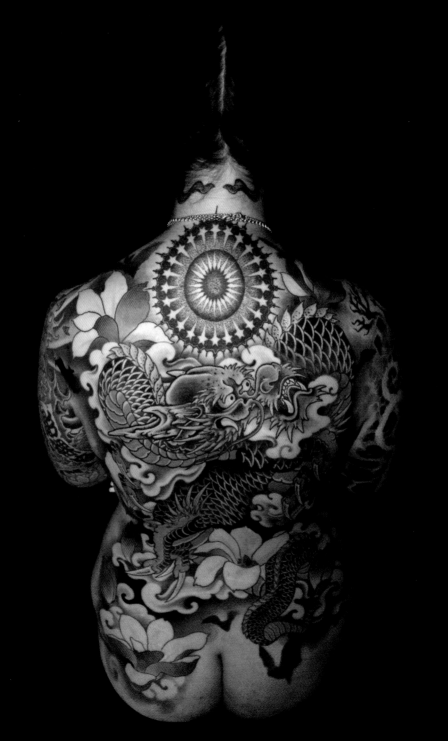

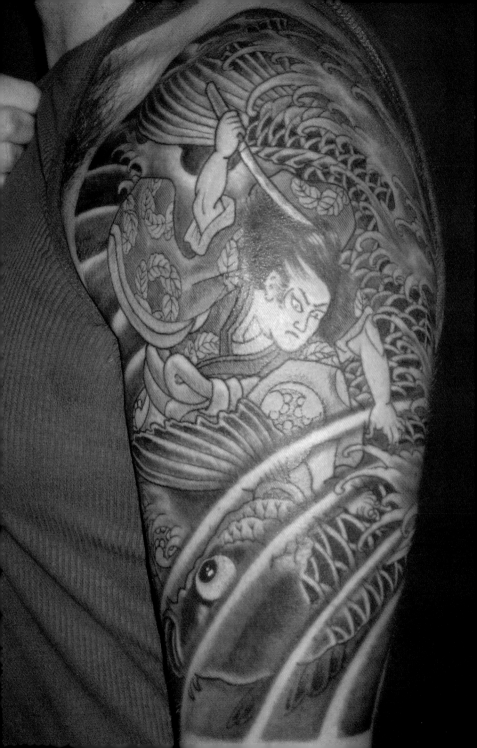

\mathcal{R}ich Pearson

Rich Pearson has been tattooing since around 1993 and still finds tattooing as exciting as ever. He served his apprenticeship under Micky Sharpz, "master tattooist and machine builder", from whom he learned to apply a solid clean tattoo. Rich opened his own studio, Gung Ho! in Moseley, Birmingham, in December 2007, where he and other passionate artists create beautiful tattoo work. Rich's main focus is Japanese-influenced, and he finds more and more clients daring to start their collection with larger work.

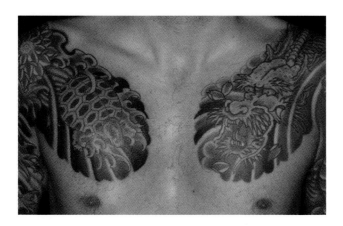

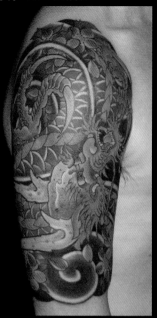

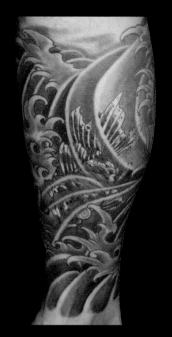

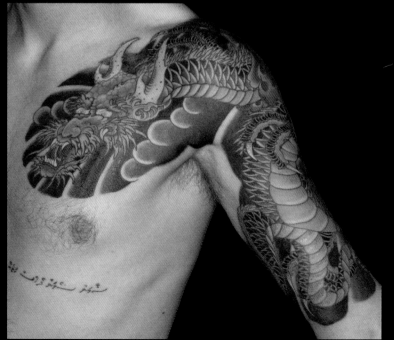

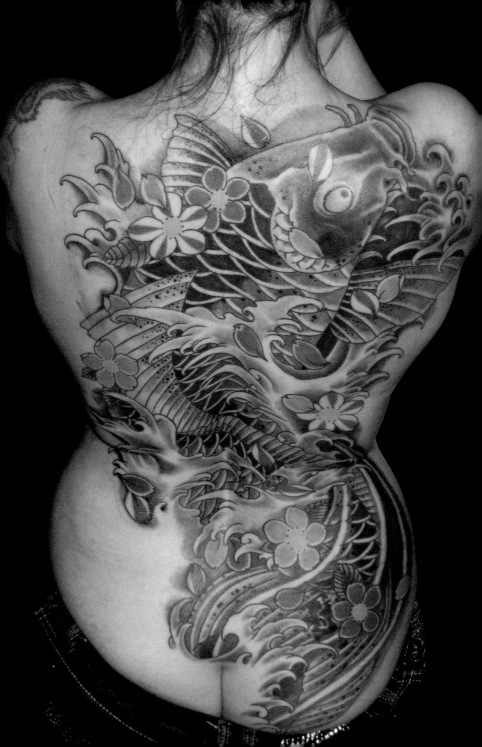

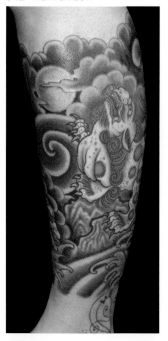

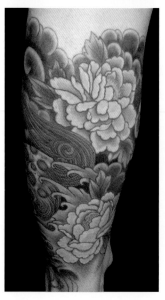

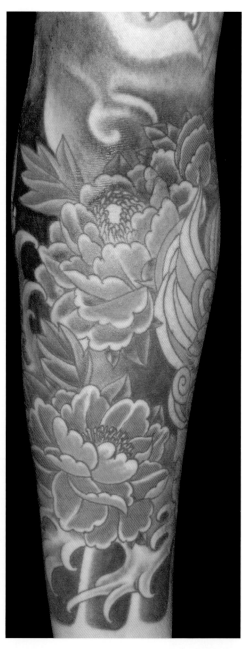

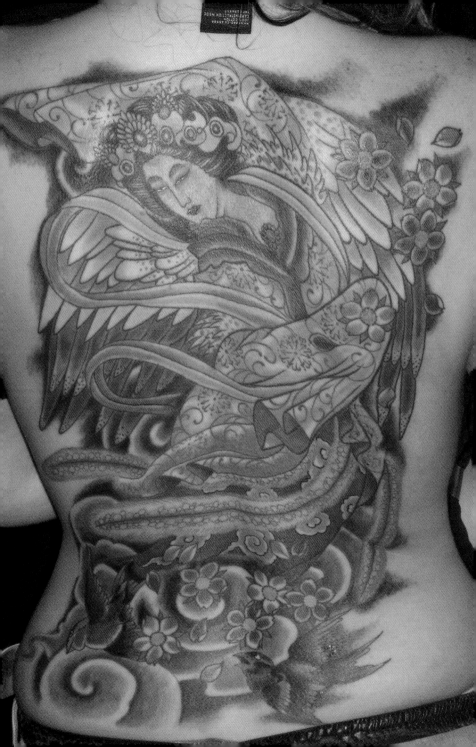

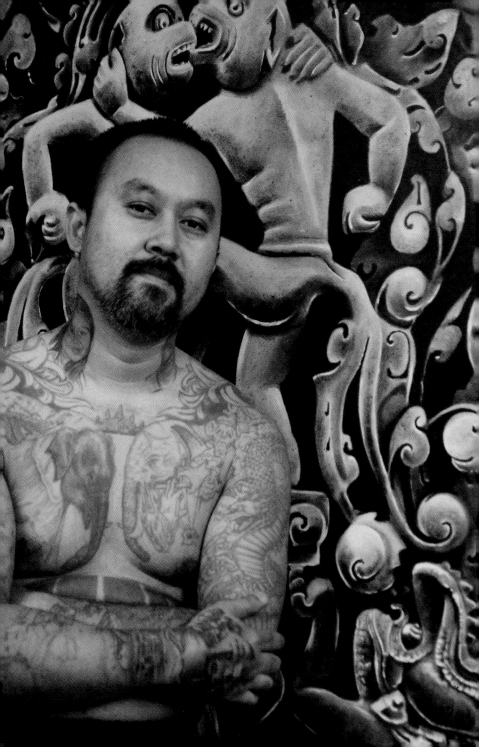

\mathscr{R}obert Pho

Robert Pho is a completely self-made artist and taught himself the art of tattooing in 1989, even practising techniques on his own skin. Once he'd become proficient, he opened Skin Design Tattoo in High Point, North Carolina, in 1998, where he worked alongside several other artists for the next six years. In 2004 he moved closer to his West Coast roots and relocated the shop to Las Vegas where he continues to create his art to this day. A fan of black-and-grey tattooing, Robert's smooth shades and detailed gradients are sought after by collectors worldwide, and he is especially adept at replicating lifelike portraits on skin. His tattoos have won awards and been featured in various magazines and publications around the world.

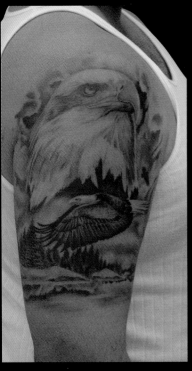

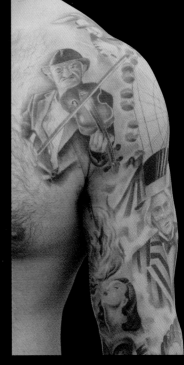

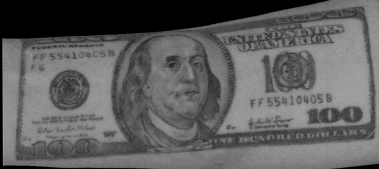

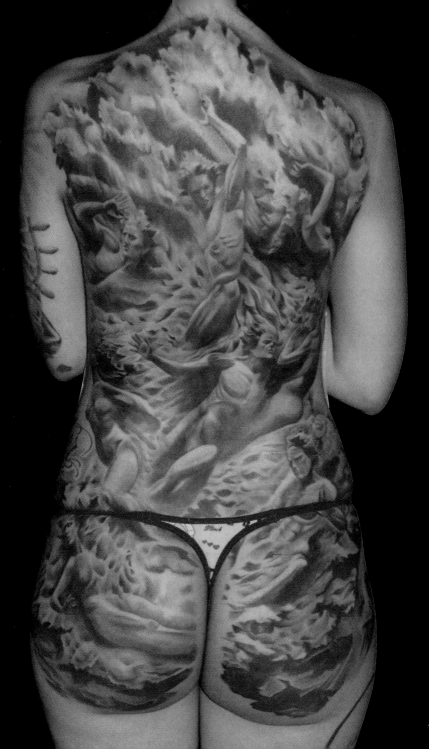

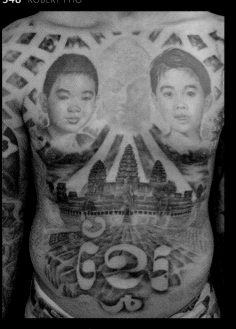

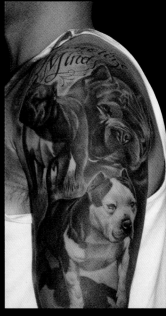

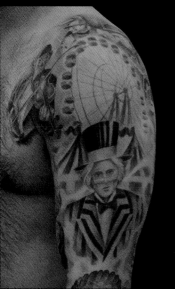

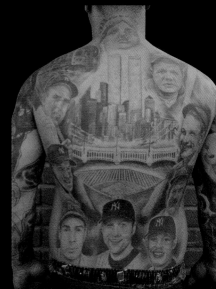

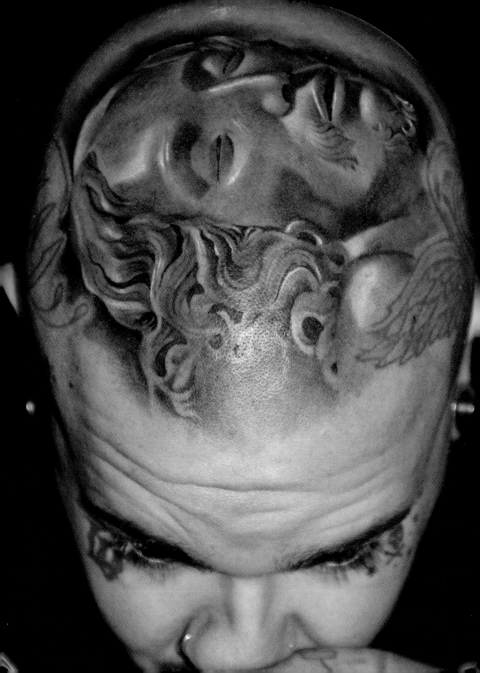

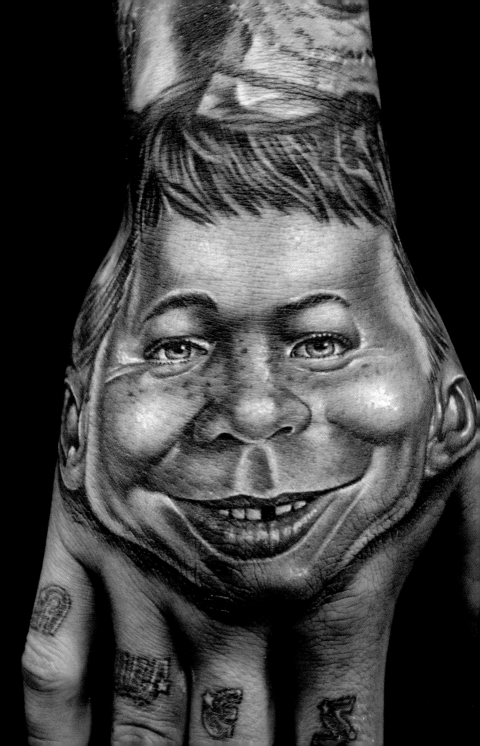

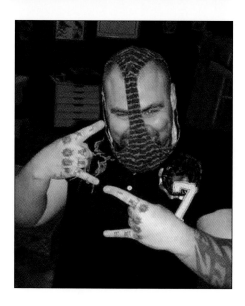

Cecil Porter

Cecil Porter has been tattooing professionally for about five years.
"My goal is to give every customer a great tattoo, but more than that,
for them to leave thinking that they got their money's worth and had
a great time. I try to make customers feel as though they are old friends,
and to realize that it should be a fun experience. I strive to stay hungry
and get better all the time. As long as I continue to love what I do and
the people I tattoo I'll keep doing it." Cecil thanks Lal Hardy and all the
tattooists who came before. "Without them building the foundation
we wouldn't have the industry we have today."

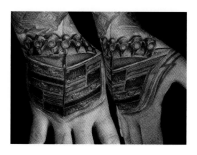

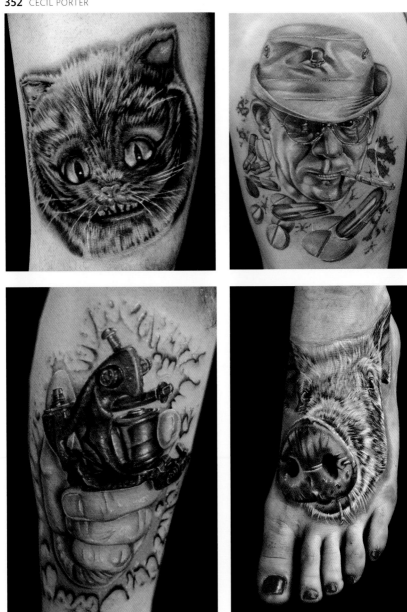

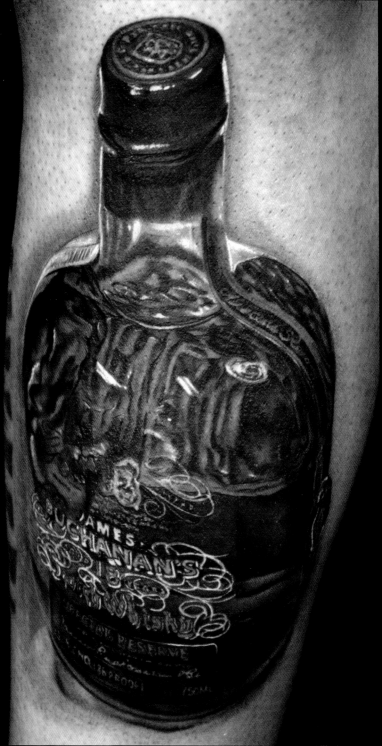

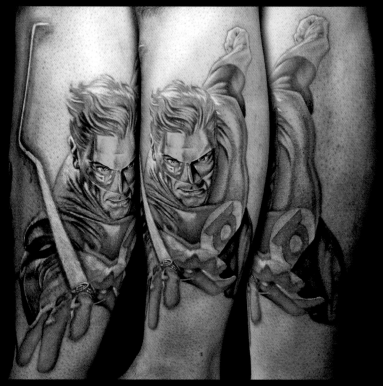

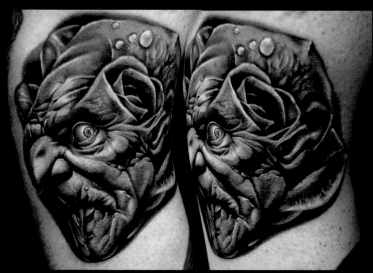

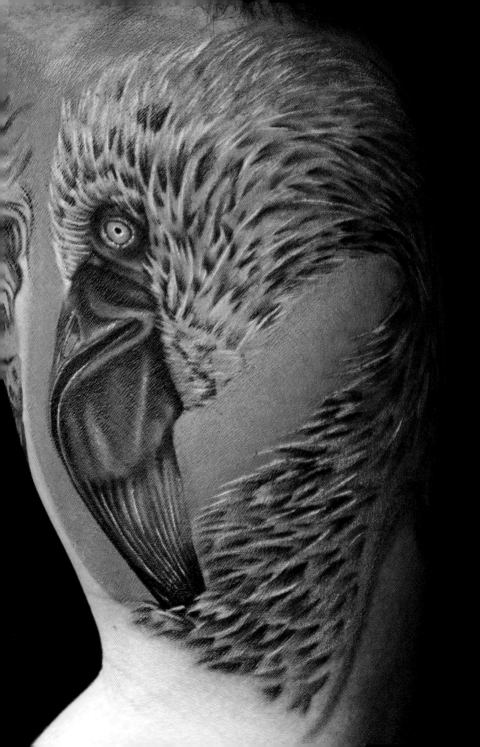

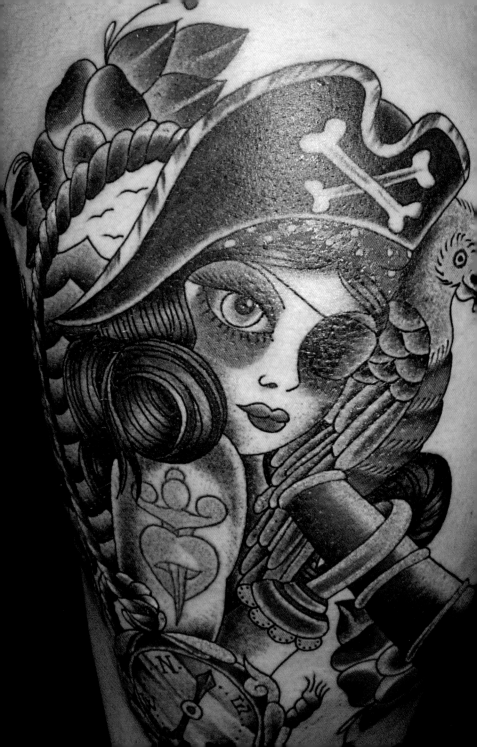

*L*ucy Pryor

Lucy has been tattooing for eleven years and has spent the last six years at Into You Tattoo, London. She travels as much as she can: "It's motivating and inspiring to work in other studios. I've seen some amazing places and met some truly wonderful people."

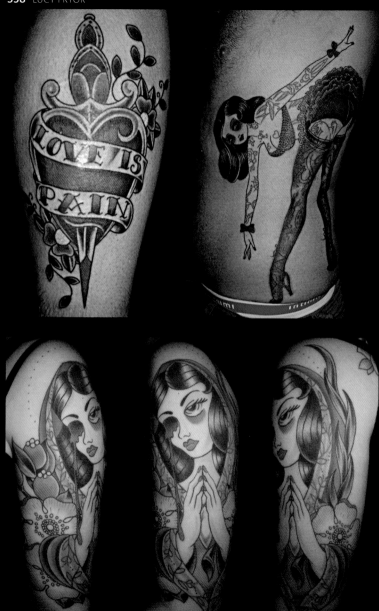

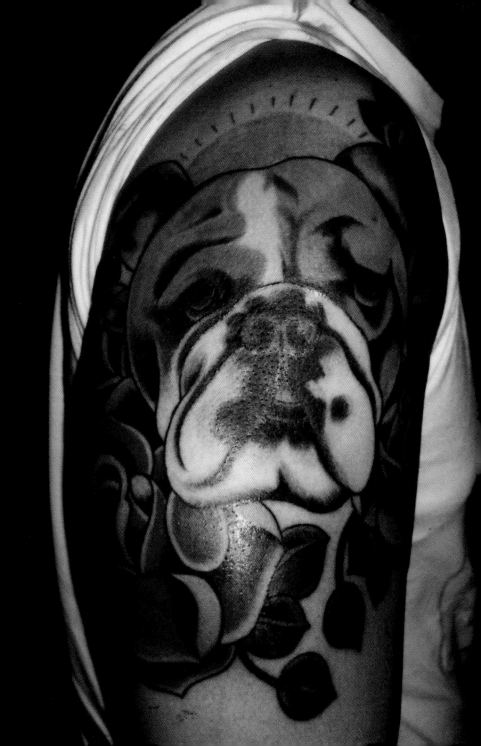

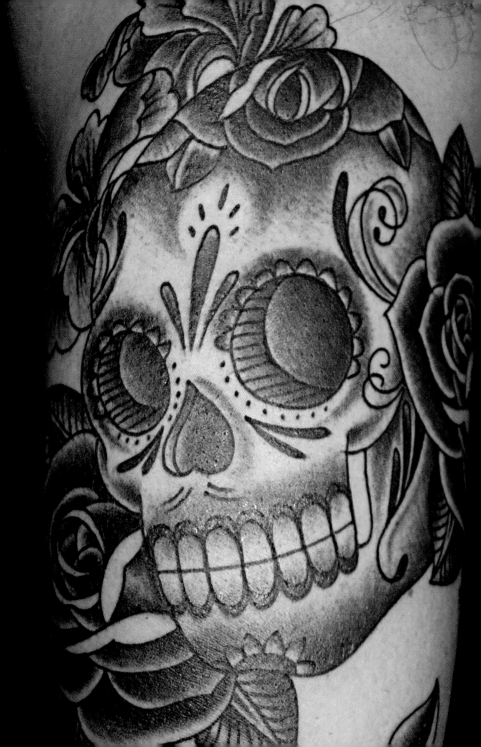

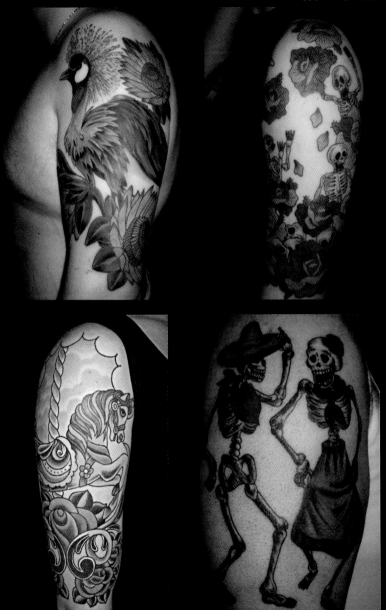

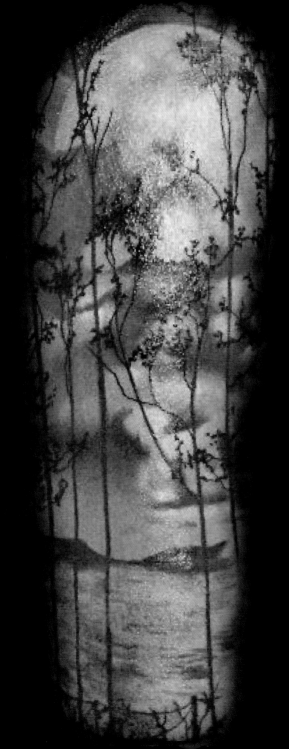

an Rooke

"I have always been creative and loved to draw and paint from a young age. After studying art and design at college for three years I rejected a university place in order to continue a career in tattooing. I am a completely self-taught tattoo artist and have now been tattooing for around three years, opening my own studio in July 2009. Although it's been hard work to get where I am now, it's been worth every minute and I can honestly say I love tattooing! I like to try all styles and enjoy seeing how my work evolves. I am excited to see how my work will continue to develop and how much I can push my imagination with regard to design."

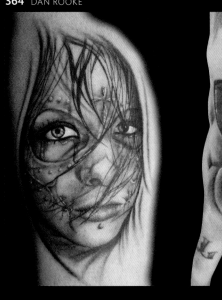

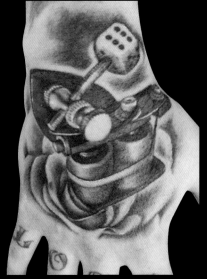

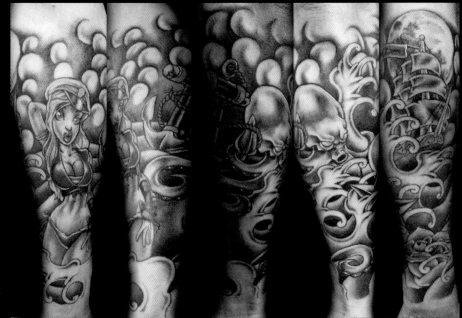

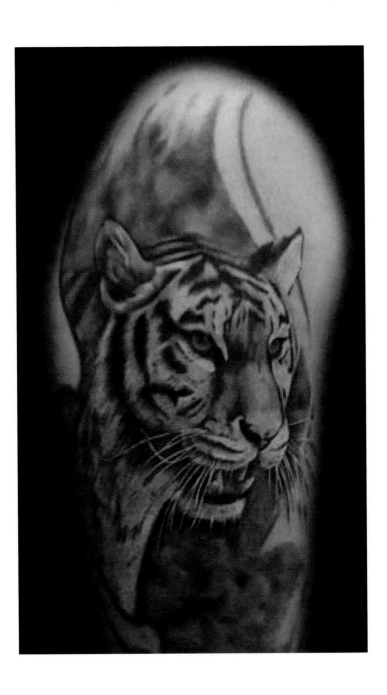

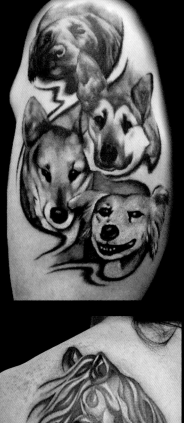

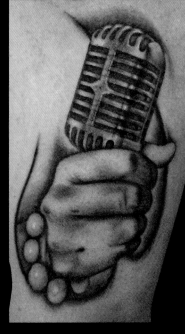

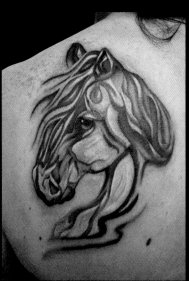

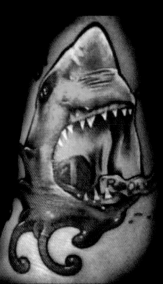

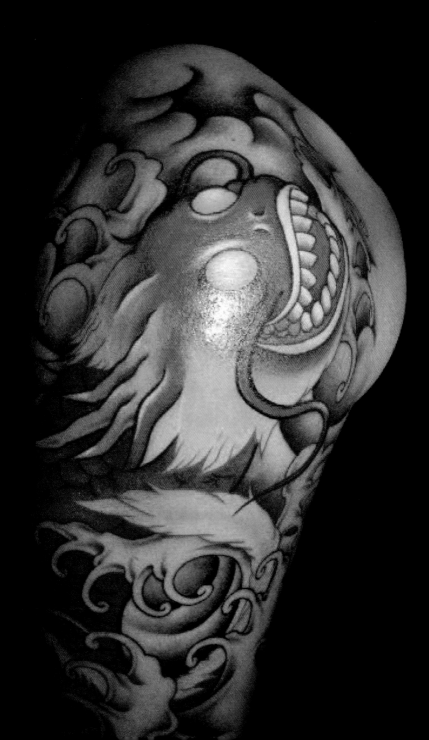

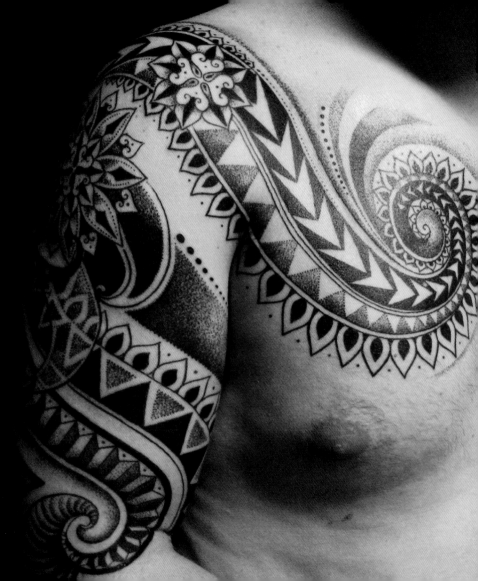

\mathscr{A}manda Ruby

Amanda Ruby was born and raised in Zimbabwe where she spent three years at art college. Her fascination with tattoos began when she arrived in England at the age of twenty-one, but it wasn't until the beginning of 2008 that Amanda started tattooing at Squidink Tattoo in Folkestone, Kent. "From the start the passion I had for tattooing told me it was what I should be doing!" Amanda loves to combine realism and pattern work wherever possible. "I love both styles, so why not?" She has worked at four conventions in the last year and plans to do many more.

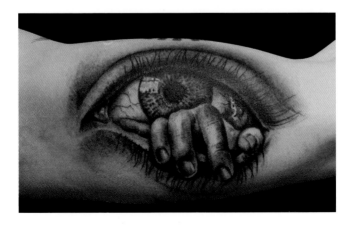

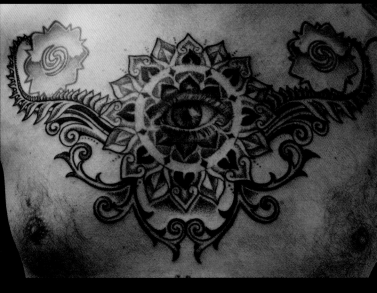

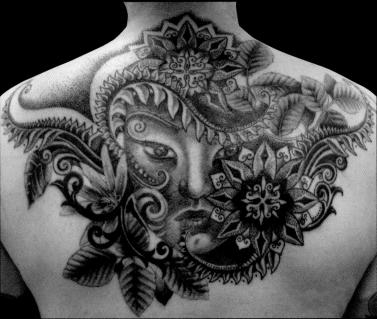

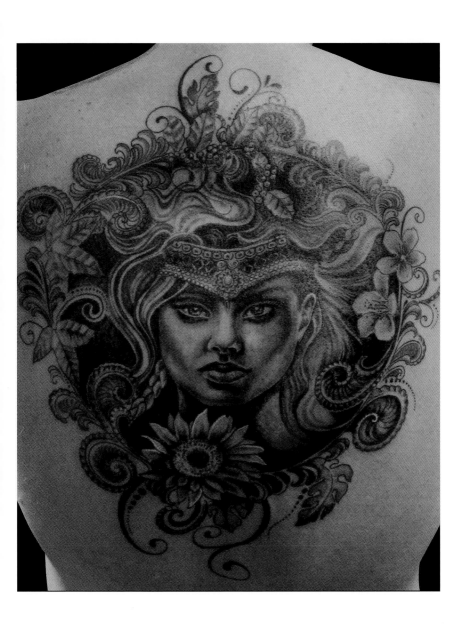

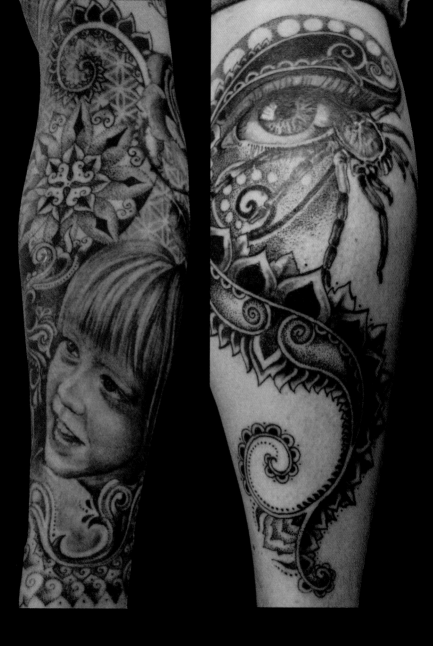

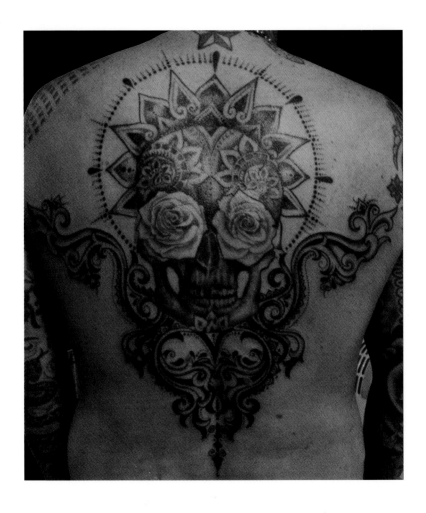

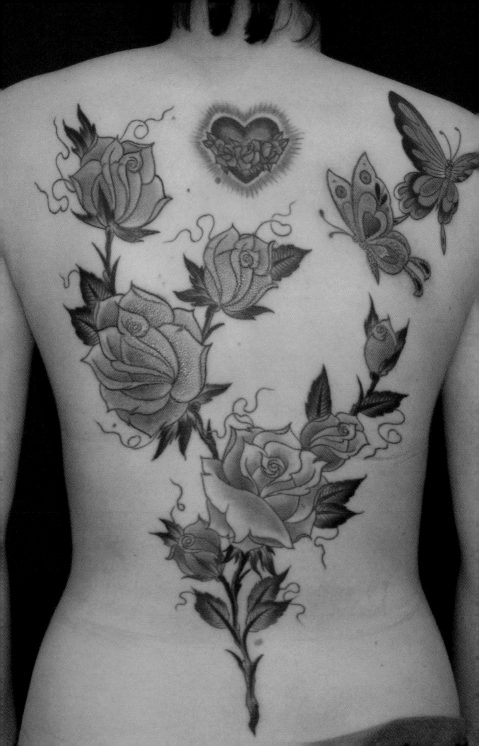

\mathcal{J}amie Ruth

Jamie Ruth started tattooing in New Orleans, Louisiana, in 1995. After a three-year apprenticeship she "went off to see the world". Over the next ten years she tattooed in California, Holland, Germany, Borneo, Australia, New Zealand, Paris, Denmark, New York, Spain, Italy and Sweden. She now works at Good Times Tattoo in London. "I love making bold, classic, fun tattoos that will be lifetime keepsakes!"

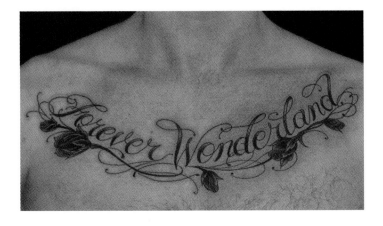

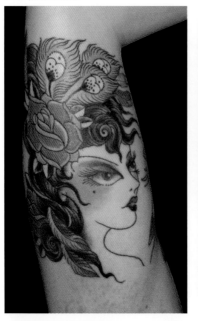

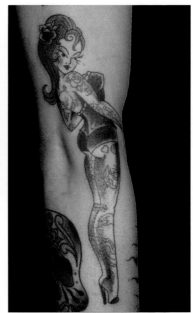

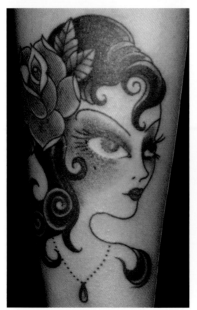

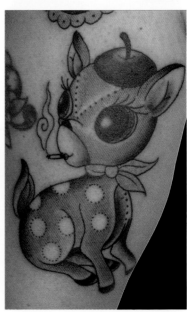

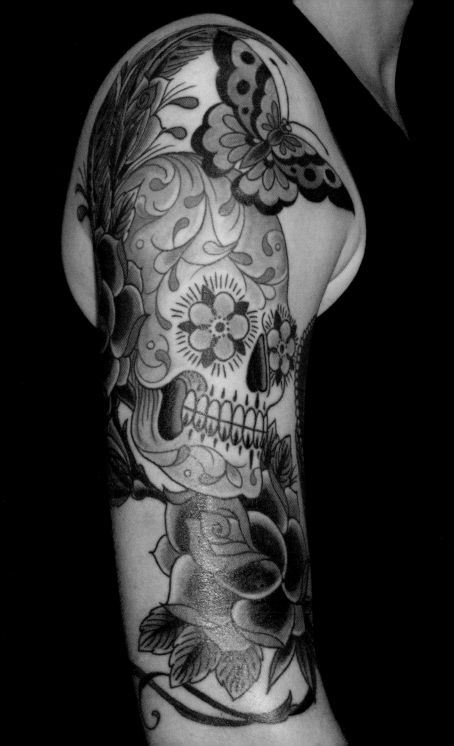

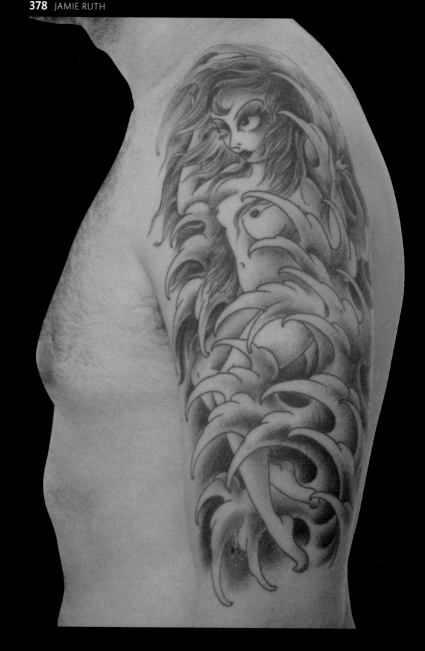

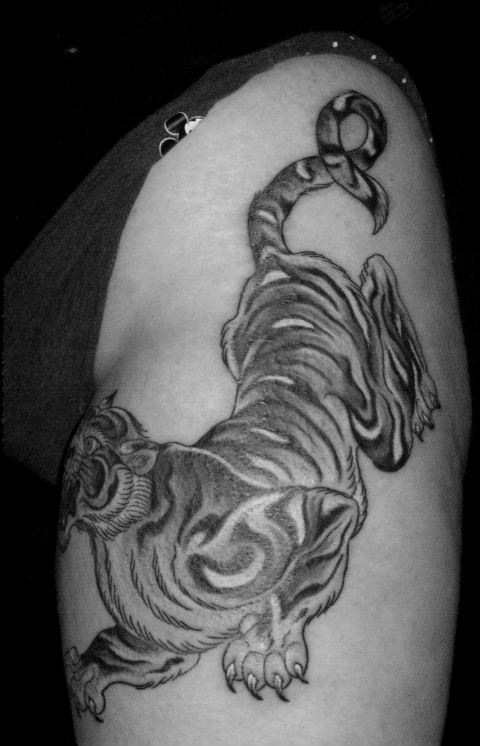

\mathcal{P}aul Scarrott

Paul Scarrott was born and raised in Cheltenham, and has been tattooing professionally since 1998. He got his break at Mantra Tattoo Studio, Cheltenham, where he has remained ever since, earning a great reputation and loyal client base. Paul enjoys working at tattoo conventions and has worked all over the world including Canada, America and Europe. He specializes in Japanese and black-and-grey work and gets his inspiration from many great artists, including Shige, Bob Tyrrell and Filip Leu. Paul feels very lucky to do something that he loves for a living. When not working he spends time with his family, paints, watches movies and listens to music.

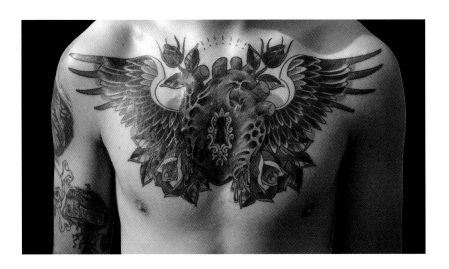

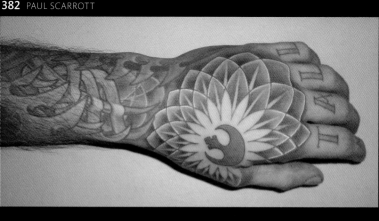

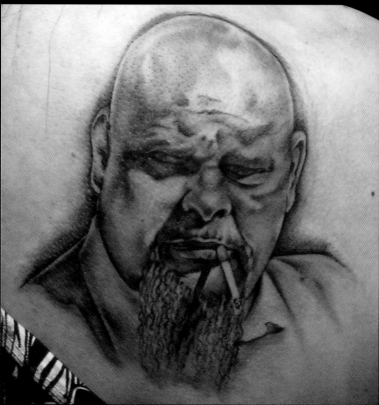

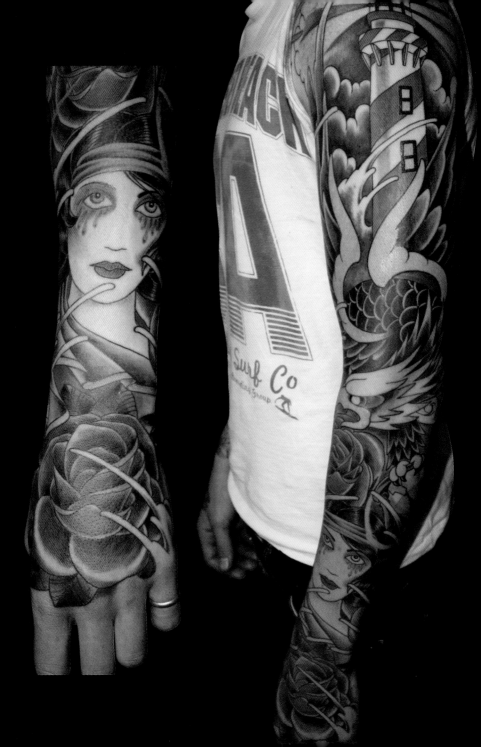

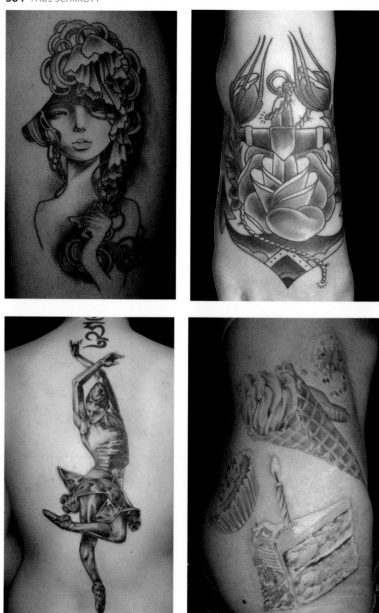

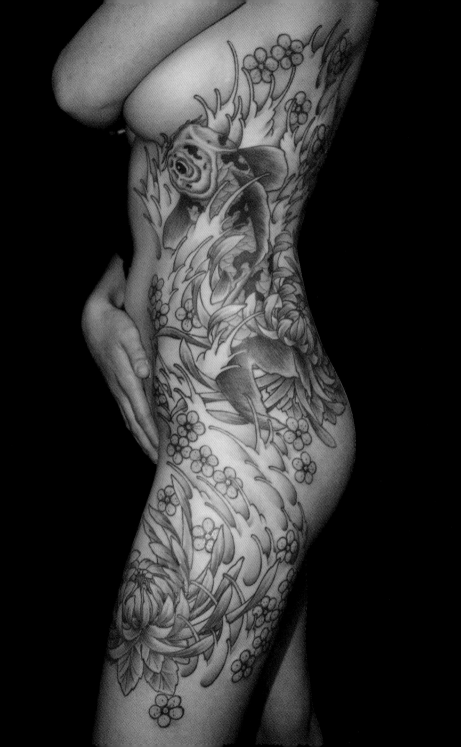

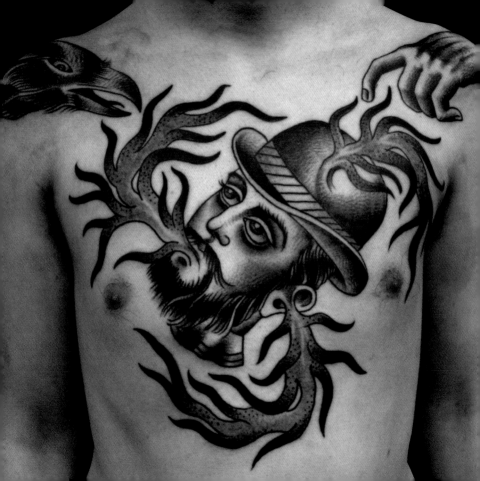

\mathcal{S}arah Schor

Sarah Schor started tattooing professionally in the summer of 2008 after serving a nine-month apprenticeship at Red Hot and Blue Tattoo in Edinburgh. Since then she's done guest work at In Name and Blood, MVL, Cult Classic and New York Adorned. She says, "I'm extremely grateful to Paul Slifer who gave me my apprenticeship. He's shown me unending support and will always be a huge inspiration to me."

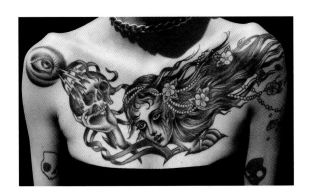

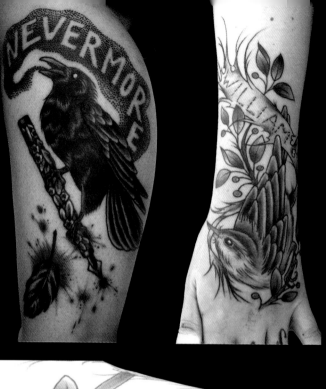

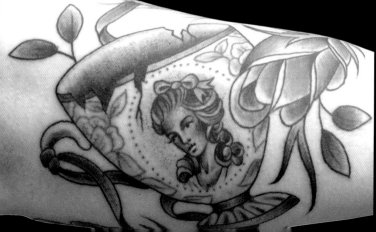

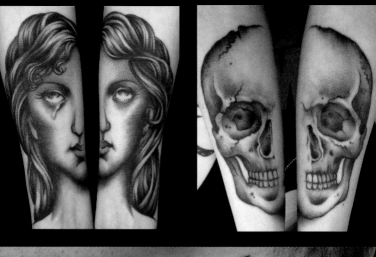

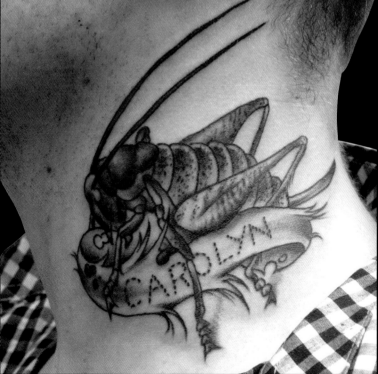

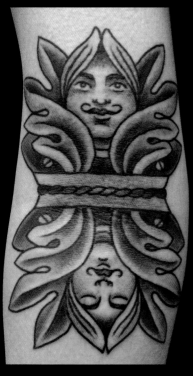

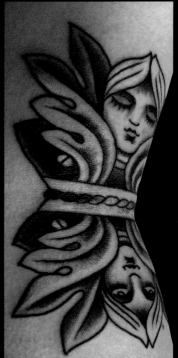

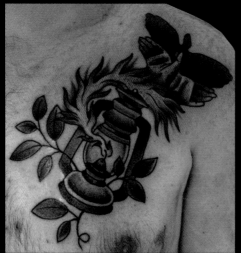

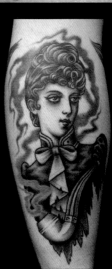

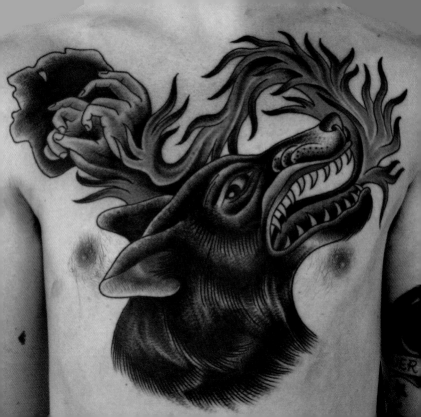

*M*ick Squires

In 2005 Mick was working as a server engineer for a small company. "I was bored, I had no creative outlet and I was looking for a change in my life." Later that year he decided to get tattooed and was so fascinated that he knew he wanted to become a tattooist and "kept annoying Chris Reid in Geelong, Victoria, for an apprenticeship". A few months later he was working on the counter and cleaning the studio on his days off. By January 2006 he was able to leave his nine-to-five job, becoming an apprentice five days a week. In 2009 he attended a convention where he gained recognition doing black-and-grey realistic tattoos. Later, he got hold of a pneumatic tattoo machine and within two weeks was doing colour realism.

Artist photograph © Nicole Reed

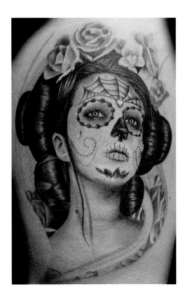

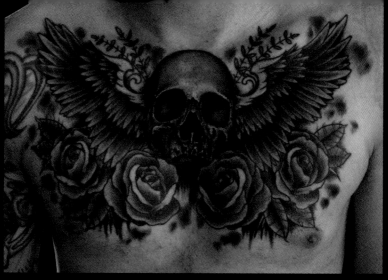

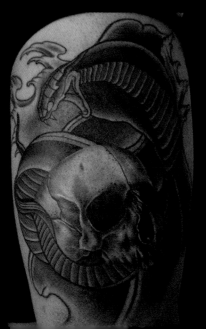

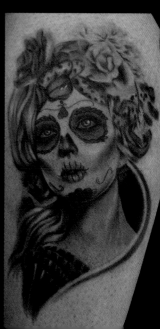

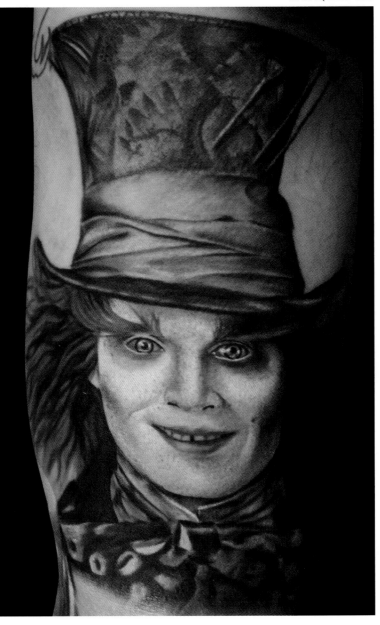

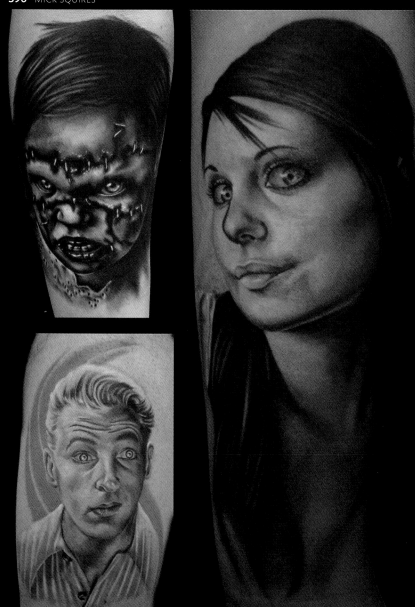

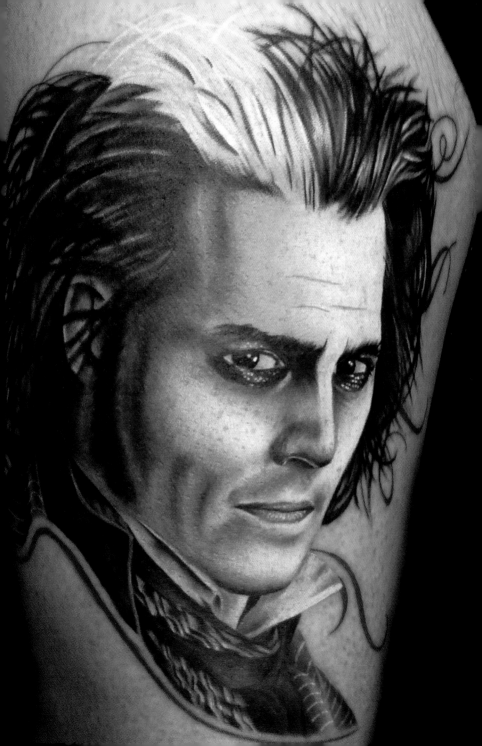

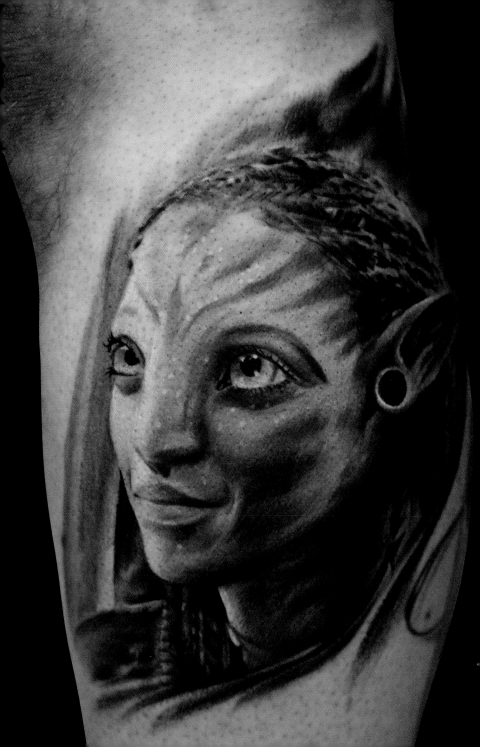

\mathcal{T}om Sugar

Tom Sugar has been tattooing for eleven years. He came from the small city of Sroda Wielkopolska in central Poland just over five years ago to work at Alan's Tattoo Studio in Moreton, Wirral. Tom never went to college to do any art courses, saying that "it all comes naturally". Tom works at many conventions in the UK which he enjoys because he can "meet many people and talk about tattoos and machines". His speciality is portraits and he says that "there's nothing better than to see customers leave with a happy smile on their face".

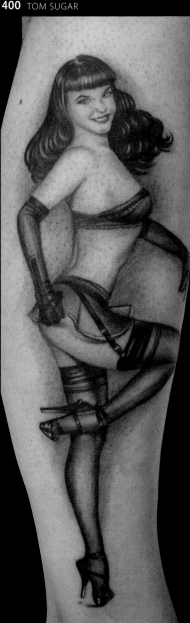

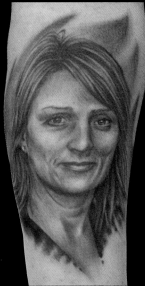

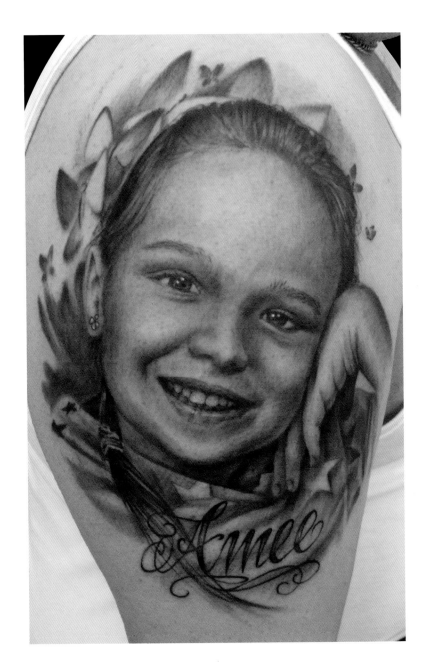

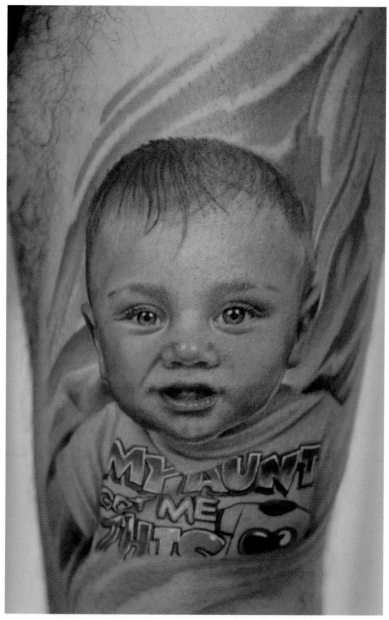

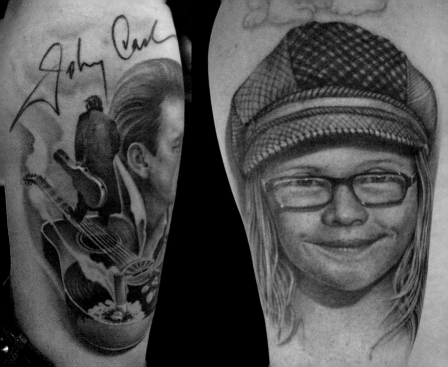

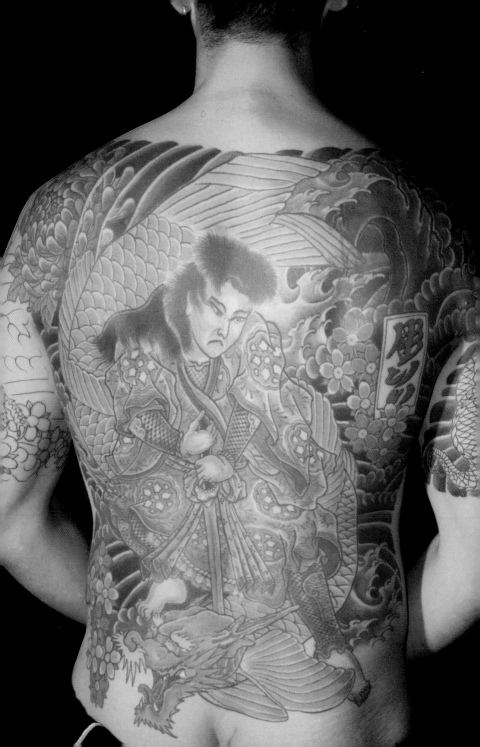

\mathcal{L}ee Symonds

"My first tattoo experience was walking past Davey Ross's studio in Colchester, Essex, and looking at all the photos of the large tattoos in the window. I would spend hours looking at them, absolutely spellbound. On my fifteenth birthday, with my birthday money, I plucked up the courage to go in and have my first tattoo. From that moment I was hooked. I became the shop runner, unpaid, simply to be in the studio. In 1985, when I saw an ad for Ultra Tattoo Supplies in a biker magazine (this was before the days of the internet and tattoo magazines, when supply companies were thin on the ground) I bought the kit and started scaring my friends. Twenty-five years later I'm still doing it – and everyone thought it was just a phase I was going through!"

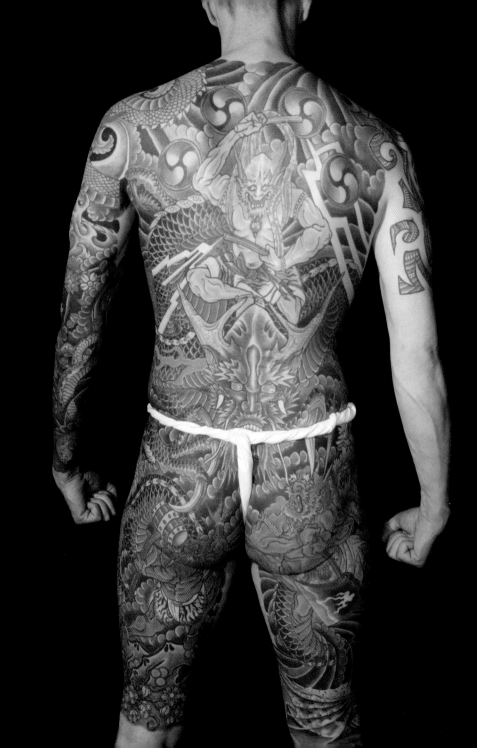

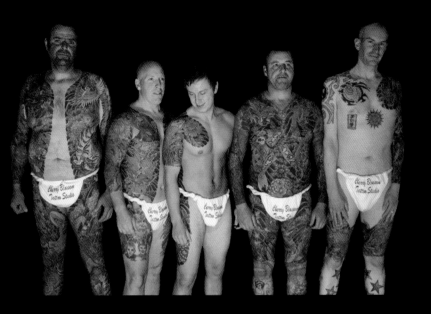

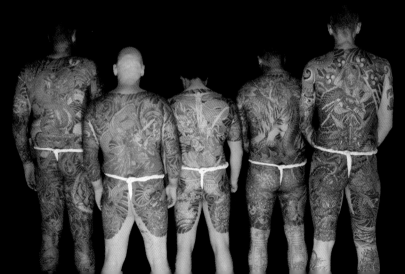

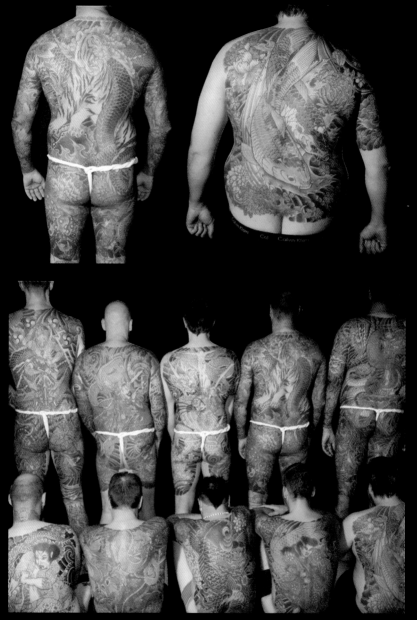

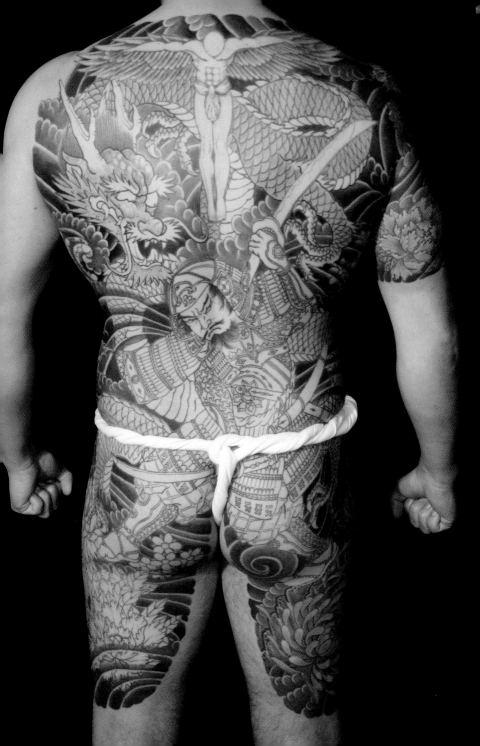

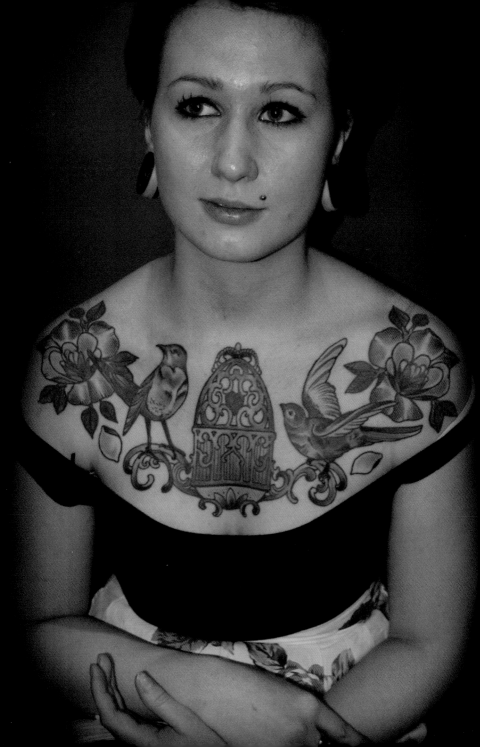

*T*iny Miss Becca

"I have been tattooing for around seven years now. Before then I was a hapless sculpture student who naively fell into tattooing. I opened Jayne Doe, my own little studio in the heart of Essex, in April 2009. I guess my style would be described as neo-traditional accompanied by a muted palette and an appreciation of Victoriana and taxidermy. I love Berlin and bad pop music, and survive life being fuelled by vast amounts of tea. I'm a simple creature who is easily flustered and highly pitched, but who means well at all times."

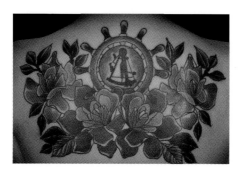

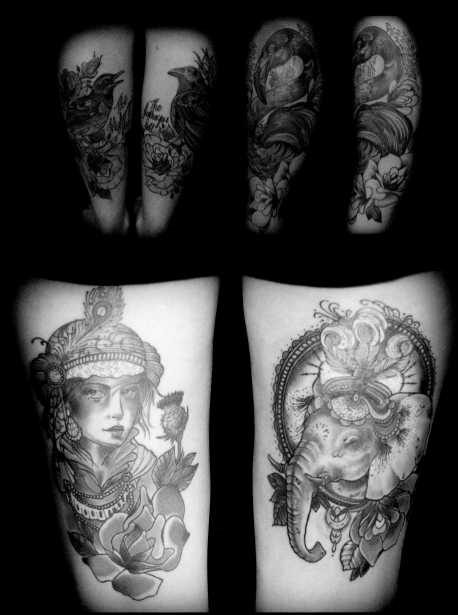

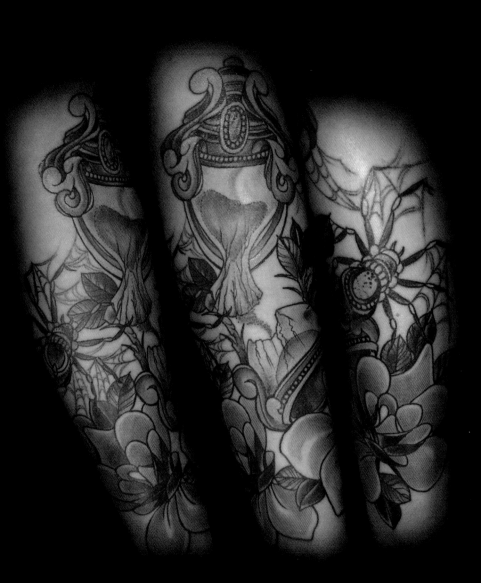

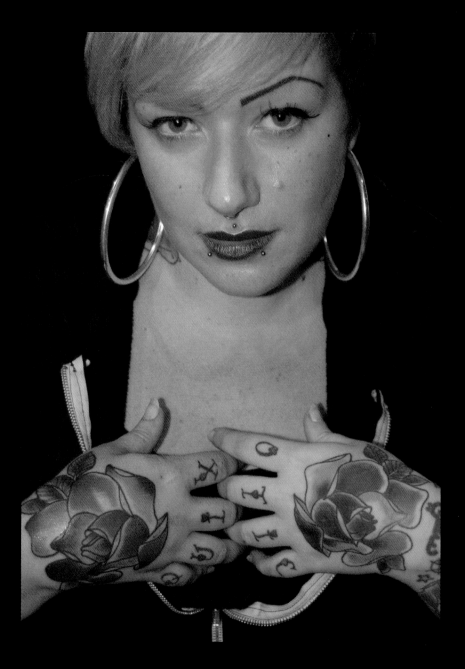

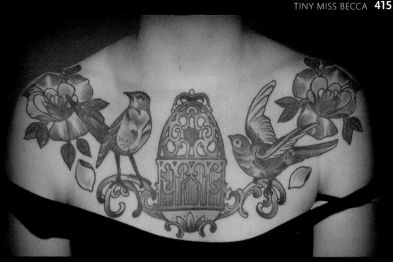

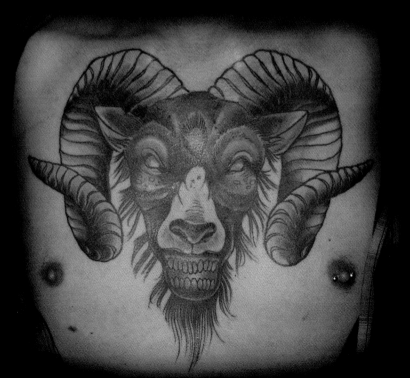

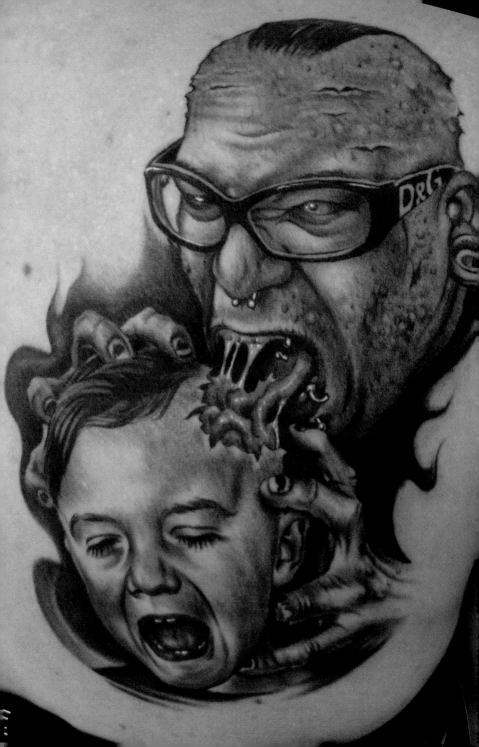

ℬob Tyrrell

Bob lives in Detroit, Michigan, and when he's home he spends his time
tattooing, drawing and playing guitar in a band. He spends most of his life
on the road though, working at tattoo conventions around the world,
doing guest spots at various tattoo shops and partying with his friends.
He's "livin' the dream".

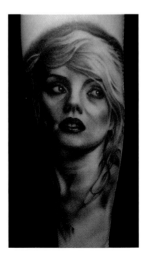

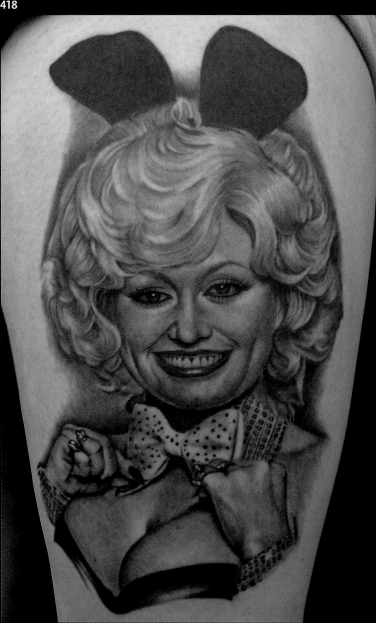

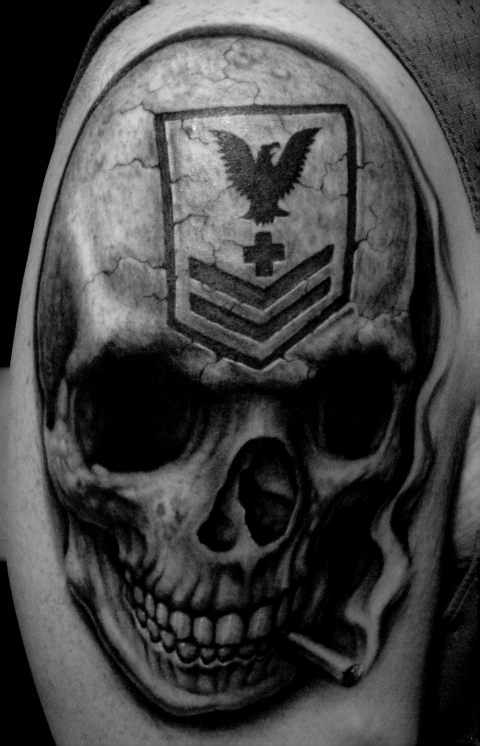

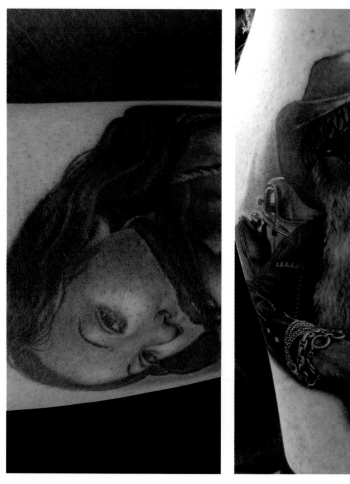

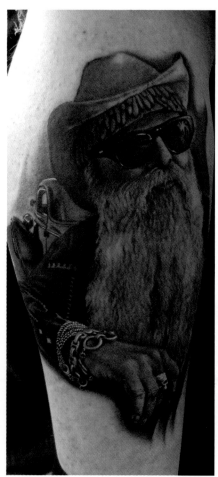

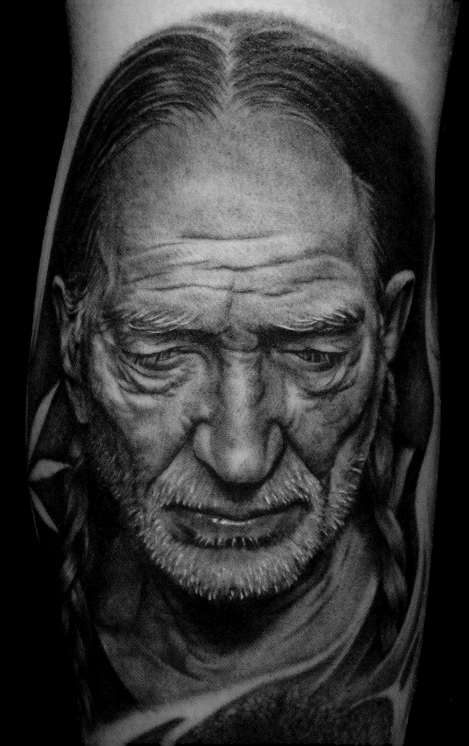

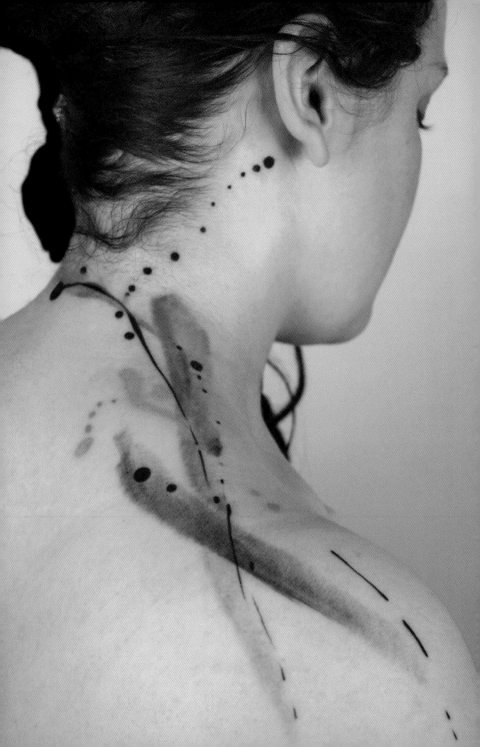

\mathcal{A}manda Wachob

Amanda has been tattooing since 1998 and is currently taking bookings at Dare Devil Tattoo in New York City. She has been pushing the boundaries of the tattoo medium in order to blur the line between fine art and body art. A trained artist, she has exhibited her work in galleries and museums worldwide.

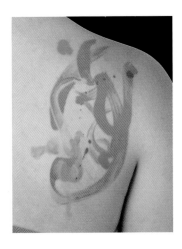

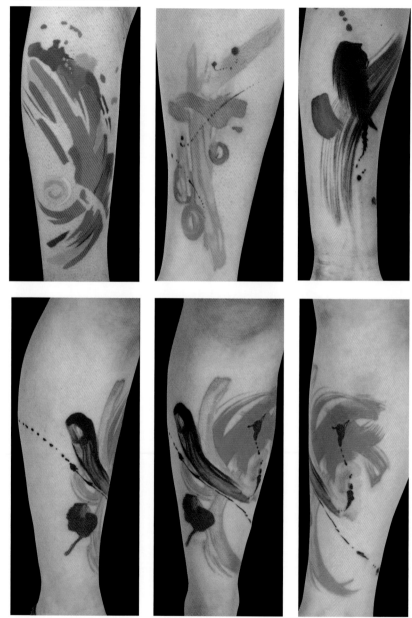

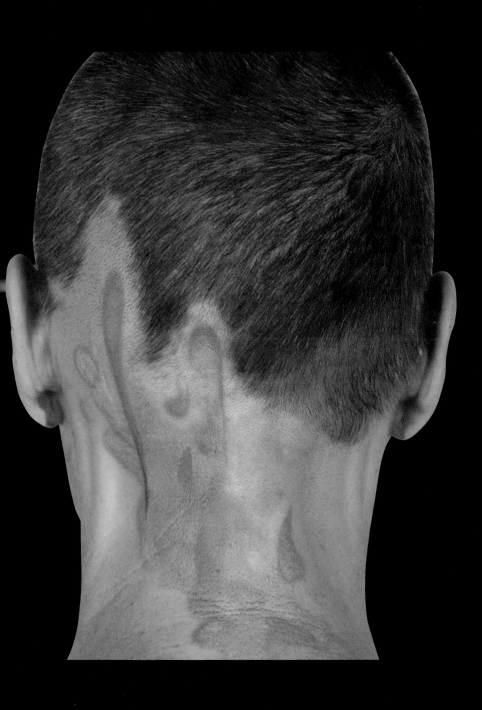

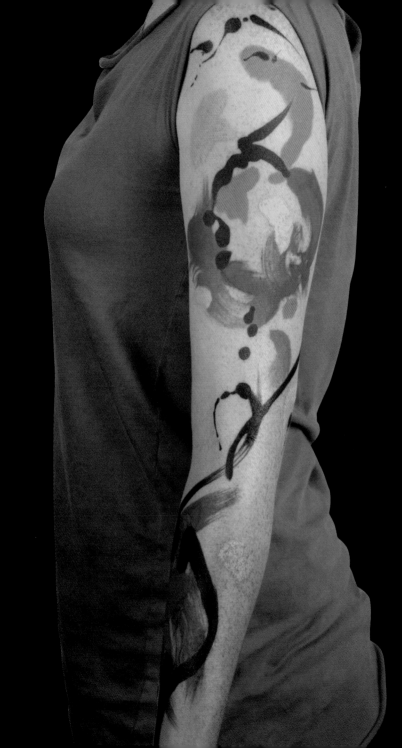

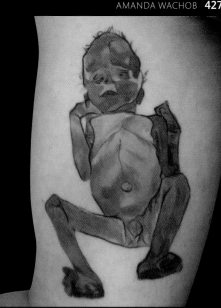

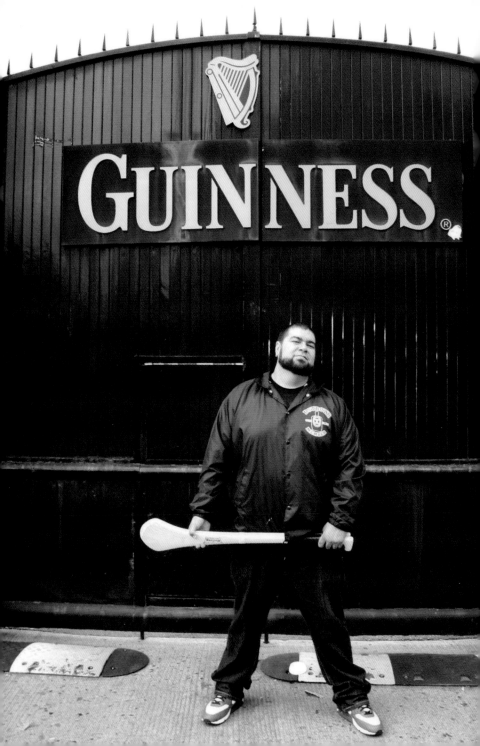

orm

Worm picked up the trade sixteen years ago and still loves tattooing in southern California. Currently he works at SpeakEasy Tattoo in the Inland Empire (southern California), but he says that his heart also lives at SwineLine Tattoo with his Waterford Well Bois, Ireland.

"I love what I do because I get to travel to new places, work at conventions, and meet some cool people. Here's everything else you need to know about me – Mac 'n' cheese, Guinness, butt-rock metal and the word 'boobies'."

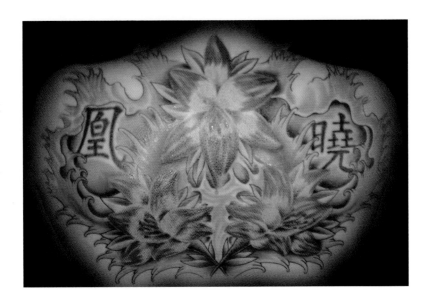

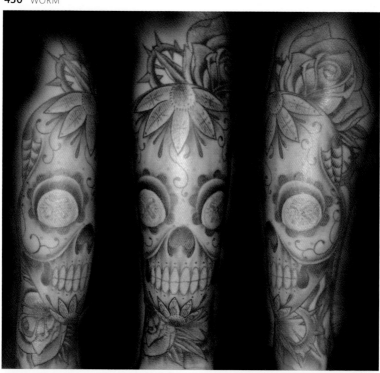

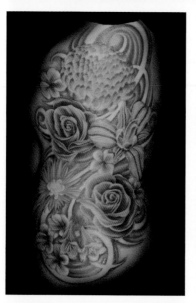

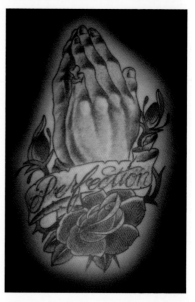

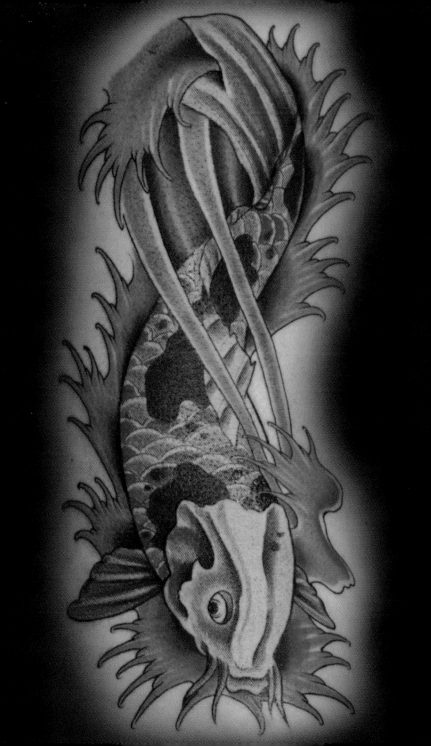

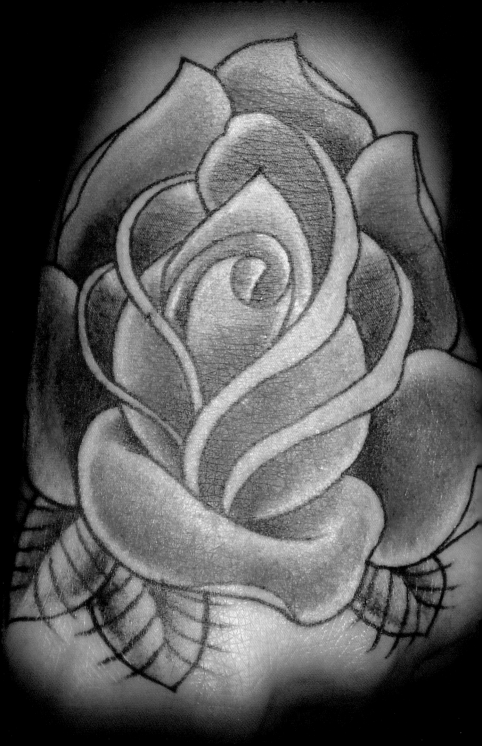

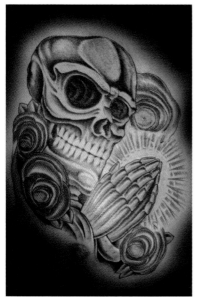
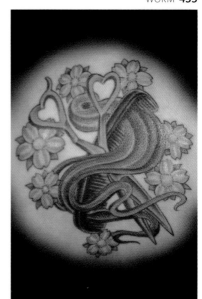
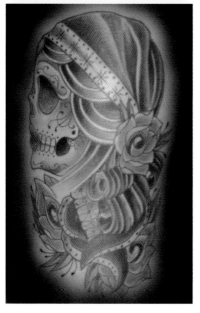
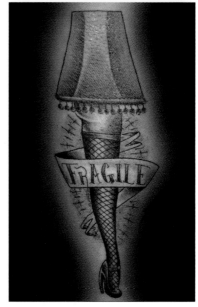

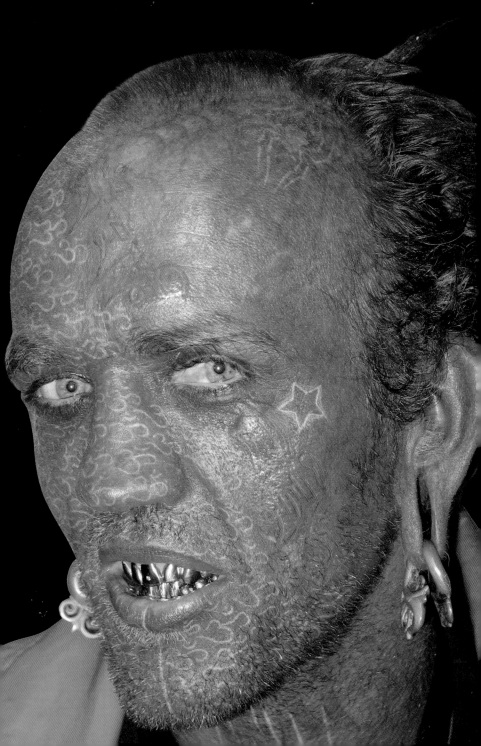

Xed LeHead

"Greetings Earth dwellers . . .
I am Xed LeHead of the Clan LeHead from the Planet LeHead on the
outer reaches of the Galaxy Freakout and I am immortal . . . I have been
tattooing for 2157 years and my work is still as rubbish as ever . . . After
all these centuries of tattooing, I still have the passion flowing through
my veins stronger than ever and begin now to embark on a whole new
phase of my work . . . some may say an evolution, some may say a
devolution, but you will have to wait a while to see where it's going . . .
Deepest thanks to every being who has been inspirational and
instrumental in the path I have been on and where it is leading me."

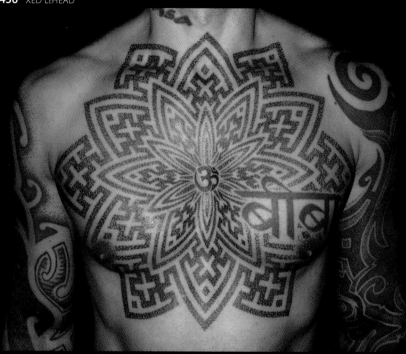

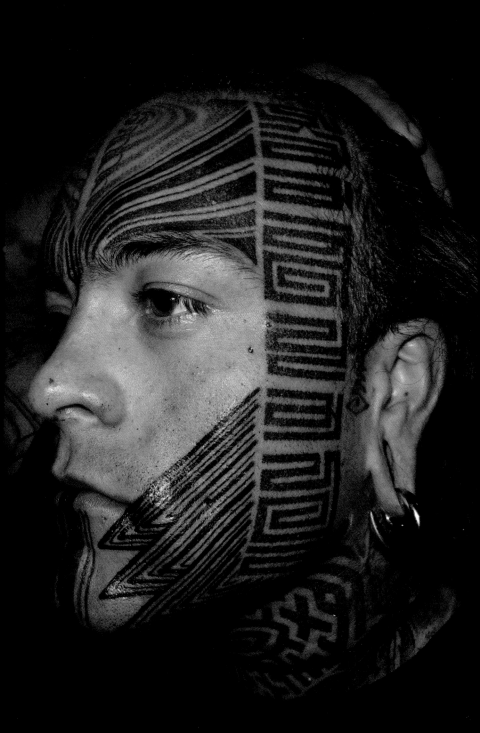

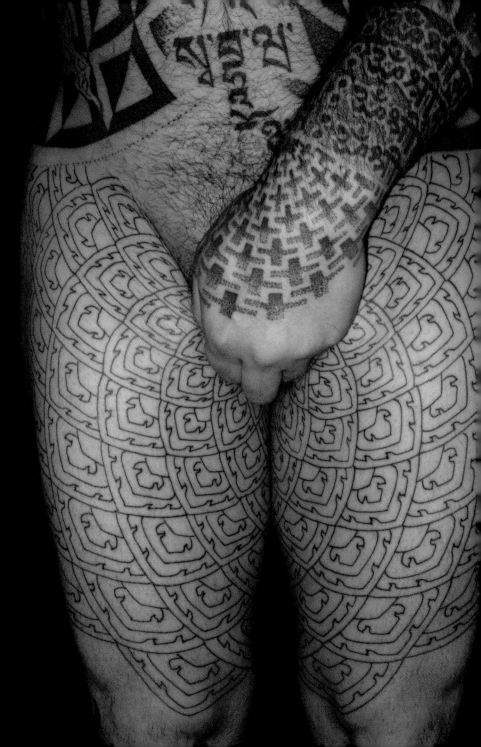

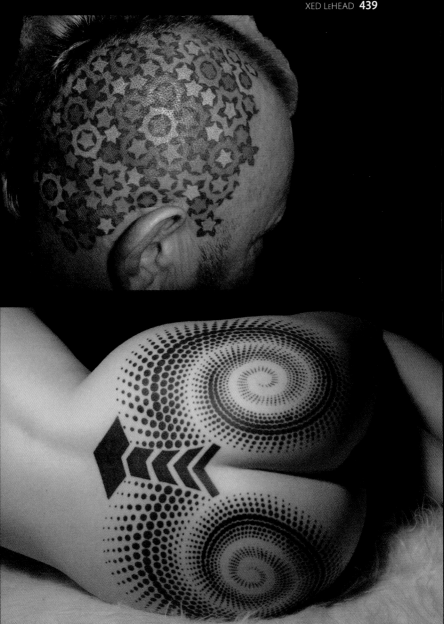

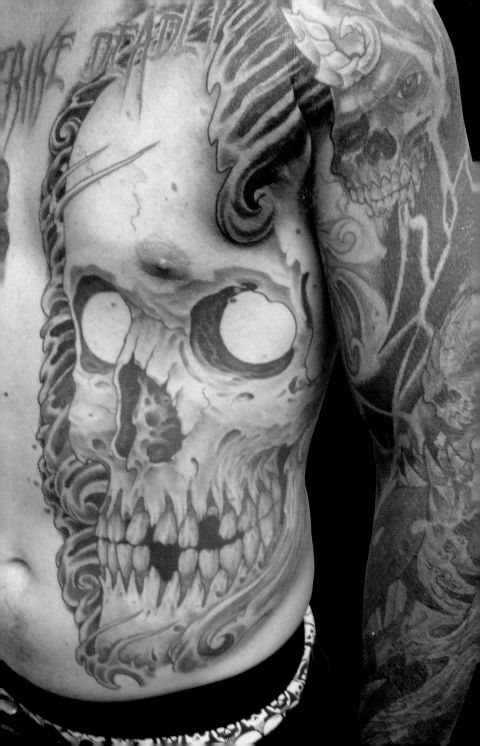

William Yoneyama

"Born in Brazil, lived in Japan and I currently live in Melbourne, where I work at Tattoo Magic. I party hard and work hard in order to fish!"

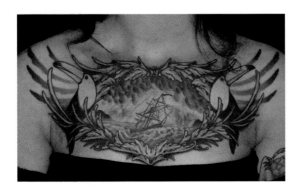

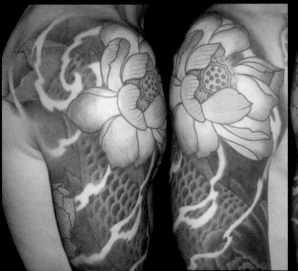

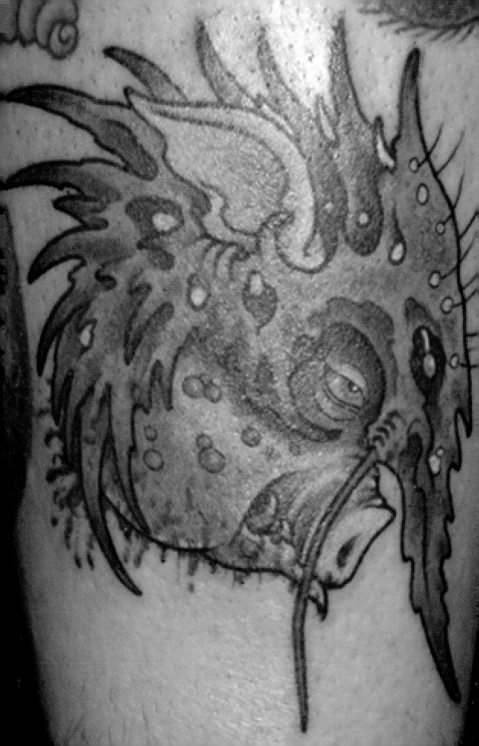

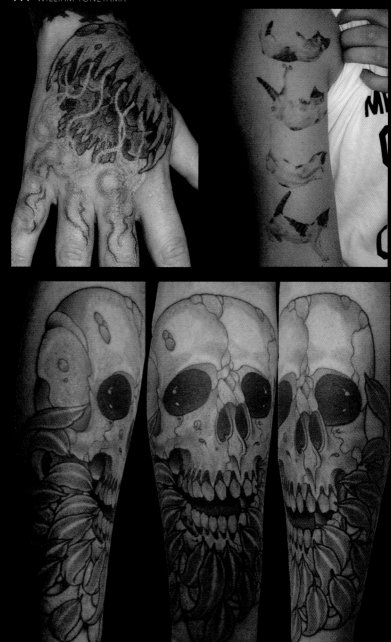

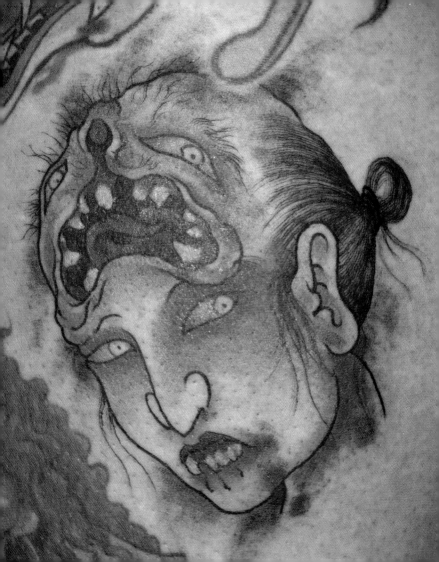

Tattooists

Andrea Afferni
www.afferniandrea.com

Hannah Aitchison
www.hannahaitchison.com

John Anderton
www.nemesistattoo.co.uk

Diego Azaldegui
www.mvltattoos.com

Kari Barba
www.outerlimitstattoo.com

Matt Black
www.myspace.com/mattblacktattoo

Buena Vista Tattoo Club
www.buenavistatattooclub.com

Bugs
www.bugsartwork.com

Martin Clark
www.bluebirdtattoo.co.uk

Geordie Cole
www.tattoomagic.com.au

Adam Collins
www.myspace.com/tattooadam

David Corden
www.davidcordentattoos.com

Keet D'Arms
www.southernstartattoo.com

Mike DeVries
www.mdtattoos.com

Matt Difa
www.myspace.com/jolierougetattoo

Duncan X
www.duncanx.com

Face the Fact
www.facethefact.at

Pat Fish
www.luckyfish.com

Kore Flatmo
www.plurabella.com

Ian Flower
www.newskooltattoos.co.uk

Mark Gibson
www.monkido.net

Jeff Gogue
www.gogueart.com

Dan Gold
www.myspace.com/13inktattoo

Good Times
www.goodtimestattoo.net

Theresa Gordon-Wade
www.theresagordonwade.com

Grace Tattoo
www.myspace.com/waynegrace

Lal Hardy
www.newwavetattoo.co.uk

Jed Harwood
www.myspace.com/scaryteeth

Aaron Hewitt
www.cultclassictattoo.com

Graham Hodgson
www.sevenstartattooing.com

Holy Cow
www.holycowtattoos.com

Megan Hoogland
www.meganhoogland.com

Horiyoshi III
www.horiyoshi-thethird.com

Rob Hoskins
www.myspace.com/thirdeyedermagraphics

Obie Hughes
www.obiehughes.com

Inma
www.myspace.com/vivalasgambas

Sean Jackson
www.tattoomagic.com.au

Ray Johnson
www.rayjohnsonuk.com

Jondix

www.holytrauma.com

Khan

www.khantattoo.com

Emma Kierzek a

uroratattoo.co.uk

Marcus Körling

www.myspace.com/funnyfarmtattoo

Nigel Kurt

www.nigelkurt.com

Kynst

www.kynst.com

Filip Leu

www.leufamilyiron.com

Jime Litwalk

www.jimelitwalk.com

Tony Mancia

www.tonymancia.com

Mark B

www.suckmyink.com

Mick J

www.bluedragontattoo.co.uk

Louis Molloy

www.tattoos.co.uk

Leah Moule

www.spearstudio.co.uk

Lianne Moule

www.immortalink.co.uk

N8 Dogg (Nate Drew)

www.lostarttattoo.com

Paul Naylor

www.indigotattoo.com

Luca Ortis

www.lucaortis.com

Rich Pearson

www.richpearson.net

Robert Pho

www.skindesigntattoos.com

Cecil Porter

www.cecilportertattoos.com

Lucy Pryor

www.into-you.co.uk

Dan Rooke

www.facebook.com/pages/rookstar tattoo

Amanda Ruby

www.squidinktattoo.co.uk

Jamie Ruth

www.myspace.com/jamieruthtattoo

Paul Scarrott

www.mantratattoo.com

Sarah Schor

www.myspace.com/sarahschor

Silvia Z

www.myspace.com/silviazed

Brad Sims

www.myspace.com/simstattoos

Mick Squires

www.micksquires.com

Tom Sugar

www.myspace.com/tomaszcukrowski

Lee Symonds

www.leesymonds.com

Tiny Miss Becca

www.myspace.com/tinymissbecca

Bob Tyrrell

www.bobtyrrell.com

Amanda Wachob

www.amandawachobtattoo.com

Worm

www.facebook.com/wormr

Xed LeHead

www.divine-canvas.com

William Yoneyama

www.tattoomagic.com.au

\mathcal{A}cknowledgements

I would like to thank all my friends and fellow tattoo artists worldwide for their support in the creation of this book. To the artists who submitted photos for this book: thank you. Without you it would not have been possible. T§o those artists who didn't make it into this volume due to lack of space, please rest assured you will be in the next book.

I would like to extend special thanks to Alex Reinke, Loretta Leu, Kim from Plurabella, Claire Innit and Egypt Dave for their help along the way, and to Duncan Proudfoot of Constable & Robinson for his enthusiasm and support with this project.